IMAGES
of America

THE ITALIAN-AMERICAN
IMMIGRANT THEATRE
OF NEW YORK CITY

Mamma mia dammi cento lire
Che nell'America io voglio andar!

Nuovissima Canzonetta popolare

"Mamma, Mamma, Mamma, give me one hundred dollars, to America I would go," is the plaintive wail of the immigrant girl in this folk song that was popular at the turn of the century. The song expresses the hope of young Rosina to escape the hardships of her life for a better one in America; in contrast are the cautious fears of the mother she leaves behind. A treacherous and uncertain sea voyage and apprehension about the unknown dangers of a new land were valid deterrents to departure. The song depicts graphically how the ship sinks and Rosina drowns, becoming food for the fish. Regardless of the dangers, however, the mass migration of Italians to America, and particularly to New York, methodically continued, bringing both the entertainers and the audiences needed to create the Italian-American immigrant theatre.

IMAGES
of America

THE ITALIAN-AMERICAN
IMMIGRANT THEATRE
OF NEW YORK CITY

Emelise Aleandri

ARCADIA
PUBLISHING

Published by Arcadia Publishing
Charleston, South Carolina

Library of Congress Catalog Card Number: 2007938765

For all general information contact Arcadia Publishing at:
Telephone 843-853-2070
Fax 843-853-0044
E-mail sales@arcadiapublishing.com
For customer service and orders:
Toll-Free 1-888-313-2665

Visit us on the Internet at www.arcadiapublishing.com

*Dedicated to the memory of all of the writers, directors,
and performers of the Italian-American stage, the amateurs
and the professionals, the stars and the unsung.*

Churches, such as the Parish of San Gioacchino (St. James) at 26 Roosevelt Street (renamed St. James Street), were the earliest places for musical entertainment usually associated with the street *Festa* that honored a patron saint, such as St. Anthony of Padua in 1890 and St. Vincenzo Martine in 1905. Mutual benefit associations formed by Italian immigrants produced the first amateur theatre productions, usually as benefits for community causes, such as churches, schools, and hospitals, as well as for victims of floods, earthquakes, and disease in Italy. The little theatre in San Gioacchino's Hall was the home, in 1901, for benefits produced for the church itself by La Compagnia Filodrammatica Dante Alighieri (The Dante Alighieri Amateur Dramatic Company). The programs included plays on religious themes by Reverend Lemoyne, the Salesian associated with the parish. Admission cost 25¢.

CONTENTS

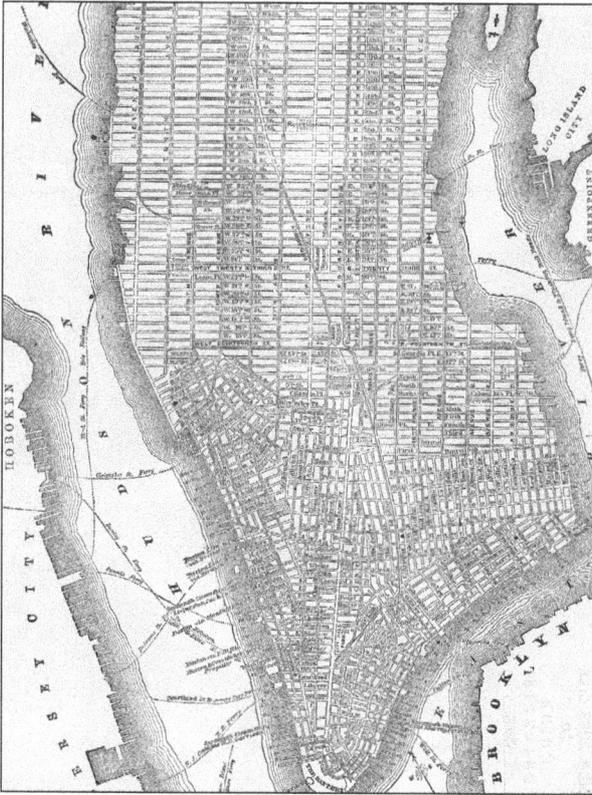

This map of Manhattan in 1876 shows the island as it appeared to early Italian immigrants at the start of the mass migration; there were no bridges, but the gridiron structure was already in place. In lower Manhattan, Mulberry Bend, named for the curve in Mulberry Street in the Chatham District, became the heart of the Italian "colony" as they called themselves. Bordered on the north by Houston Street, on the south by Worth Street, on the west by Broadway, and on the east by the Bowery, "Little Italy" had been mostly Irish until the mid-19th century. When the Italians arrived, they found affordable but incredibly crowded living quarters. The West Village and East Harlem also had large Italian populations. The Italian-American journalist Pasquale De Biasi called New York "la Babele di Manhattan" (the Babel of Manhattan).

Acknowledgments

A book such as this is the result of generosity and support on the part of many friends, colleagues, and institutions. For their generous donation of time and information, pictures or permission for their use, my thanks and appreciation go to the Migliaccio Family: Blanche, Arnie "Mig," and Adele Abolafia; Sal Alba of the Alba Bakery; Olga Barbato, immediate past President of the Italian Actors Union; the late Marietta Maiori-Giovanelli and her daughters Adele Rosato and Olga Cannalonga; Renato Maiori; Rita Romeo and family; Rita Berti; the late Vincent Gardenia and his nephew Vincent Gogliormella; Victoria Zecchino, Robert DeMattia and the late Joseph DeMattia; Mary Jane Phillips-Matz; Nicola Paone; Angelo Gimondo of the Italian Heritage and Culture Committee; the Italian Academy for Advanced Studies in America at Columbia University; Vera Mowry Roberts; Joanne Tedesco and Mark Clayton; Lea Serra, Vice-president of the Italian Actors Union; Angela Marrantino of the American Italian Cultural Roundtable; the late Michael Sisca, publisher of La Follia; Leasa and Aldo Mancusi of The Enrico Caruso Museum; Rudy Vecoli and Joel Wurl of The Immigration History Research Center at the University of Minnesota for inventories and many photographic reproductions; Giuseppe de Falco for assistance with Neapolitan dialect translations; Tom Arkin and Laura Giacomelli for their assistance in taking photographs; and to all Frizzi & Lazzi, past and present, who have helped conjure the magic of the ancestral spirits. Specific picture credits are as follows: the Bella Italia Troupe picture courtesy of The Center for Migration Studies; the Grand Theatre picture courtesy of The Museum of the City of New York; and the Rosa and Carmela Ponselle picture courtesy of The Rosa Ponselle Fund of Meriden, Connecticut. All other photographs come from the research centers, private collections, and the author's personal collection.

INTRODUCTION

An Italian-American actor hesitates before the entrance to a shop in Little Italy at the turn of the century. It is a day in the life of a skillful, practiced ticket-vendor of the Italian-American theatre. To disguise the distress he feels at performing the onerous task that awaits him inside the shop, he assumes a mask of confidence, tinged slightly with arrogance. Summoning up a glib tongue, the actor enters the shop and before the shopkeeper knows what has happened, the actor fires away at him this familiar reprise:

"Good morning! How are you? Is your family well? You are a patron of the arts. You are a benefactor of community. I don't know—whatever is the Italian government doing, sleeping? Whenever are they going to make you a knight? Would you like a ticket for a show we are performing next month: *The Blind Woman of Sorrento*? Spectacular drama!"

With an unsuspecting shop owner, this spiel would almost always successfully sell a ticket, but this merchant has been through this game before, and when he learns that the performance is scheduled for a Thursday evening, he is quick to respond: "Oh! Wait a minute, that's the very Thursday that I am expecting company. With all my heart, I am really sorry!" But the actor is even quicker and has purposefully misinformed the storekeeper: "I made a mistake, it's for Friday." The store owner, stunned, mumbles: "Oh! Friday... I see..." Tricked, and now the reluctant buyer of a ticket, the shop owner spits back, "How annoying you theatre people are!" This anecdote is one example of many colorful stories describing how the artists of the early Italian-American theatre had to resort to their wits to keep themselves and the theatre alive.

Italian-American theatre begins in New York City. The first amateur phase of this vital ethnic theatre emerged when the waves of Italian immigrants poured into the U.S. in the 1870s, bringing both the performers and audiences necessary for theatrical entertainment. The audiences, composed of the displaced men and women of Italy, were hungry for entertainment, recognition, a support system, and social intercourse; the theatres and the nightclubs helped to satisfy these emotional needs. The Italian immigrant community, located in tenement "Little Italies" throughout the city, supported itself through a network of fraternal and benevolent associations that often sponsored dances, concerts, and lectures to celebrate holidays and benefit social causes in New York City and in Italy. Soon amateur theatrical clubs evolved.

During the 19th century, a great variety of dramatic forms and entertainments were essayed on the stages of the Italian-American theatre. Italian and European writers were introduced to immigrant audiences, many of whom had never before experienced the theatre or the classics of literature. They heard the plays of their homeland and other European theatres spoken in Italian or translated into their own Neapolitan, Sicilian, or other regional dialects. They heard the familiar operatic arias and duets, recognized by most Italians, in their local

bistros. Audiences created their own stars; writers, composers, and lyricists emerged. The Italian-American experience furnished the subject matter for original plays written by Italian immigrant playwrights. Among them, Eduardo Migliaccio, known as Farfariello, made the Italian-American immigrant the hero of his dramatic creations; Riccardo Cordiferro, the pen name for journalist and political activist Alessandro Sisca, concerned himself in his plays and philosophical writings with the social conditions of the Italian immigrant. The women in the theatre also enjoyed a freedom and an outlet for creativity that was not shared or available to their sisters who played out their lives in the more traditional domestic roles. Many women became writers, directors, and entrepreneurs in their own right, as well as popular actresses and singers.

By 1900, the community had produced the major forces that created the theatre of the ensuing decades: Antonio Maiori, who introduced Shakespeare to his immigrant audiences in his southern Italian dialect productions; Francesco Ricciardi, who held sway as the "Prince of Pulcinellas" in the nightclub arena; Farfariello, the stage name for Eduardo Migliaccio, who created the unique art form—the Italian immigrant character sketch; Guglielmo Ricciardi, who originated Italian-American theatre in Brooklyn and went on to a successful career in the American theatre and cinema; Antonietta Pisanelli Alessandro, who performed in New York City, toured to Chicago, and then went on to create single-handedly the Italian-American theatre of San Francisco; Paolo Cremonesi; Clemente Giglio; and many more. The abundance of theatrical energy spilled out over the city's boundaries with the effect that professional New York City companies brought professional theatre experiences to Italian immigrants who lived in rural and suburban areas. Most of the major figures made excursions out of town to reach new audiences and get the most mileage out of their productions.

One effect of this theatrical migration was to inspire the formation of amateur theatrical groups in other cities. During the 19th century, several amateur groups existed in New Jersey, Boston, and Philadelphia. By the early 20th century, there were over 80 amateur groups scattered throughout small and large cities all aver the U.S. The progress realized by the Italian-American theatre of the 20th century was outstanding. By 1905, despite the vagaries of artistic life, the Italian-American theatre had persistently, obstinately, devotedly, and lovingly "arrived."

Throughout the first quarter of the 20th century, immigration statistics revealed a steady flow of new immigrant arrivals from which eager new audiences emerged. The major impresarios were still actively engaged in production for the better part of these years. Their ranks were enlarged and infused with the energies of new recruits and entrepreneurs, including Emma Alba and Angelo Gloria; Attilio and Olga Barbato; Ilario Papandrea; Alberto Campobasso; Gennaro Cardenia and his son, Vincent Gardenia; Francesco De Cesare; Gino Caimi; Giuseppe Sterni; Ettore Mainardi; Enrico Costantini; Gennaro Ragazzino; the Marrone brothers; Mimi Imperato; Silvio Minciotti and Esther Cunico; Sandrino Giglio; Giovanni De Rosalia, who created the comic half-wit "Nofrio;" the itinerant actor and singer Rocco De Russo; Orazio Cammi; Rosario Romeo; Teresa Aguglia and Gustavo Cecchini; and a host of amateur clubs as well. But the new immigration quota laws of 1924 restricted the annual importation of new Italian immigrants into the U.S. The theatre gradually began to see the effects of the restrictive quotas in their dwindling audiences. Furthermore, as the second and third generations of Italian-Americans became acculturated, they turned to the new and readily available popular forms of entertainment: radio, the movies, and ,eventually, television. Hence, the Italian-American Theatre is virtually non-existent today.

During the twilight years of the Italian-immigrant theatre, a retired impresario, infirm and advanced in years, was visited by a younger actor. The older actor asked of the younger: "Che se dice? 'O teatro che fa? Chi ce sta mo' 'ncopp' 'e scene?" (What's new? In the theatre what's going on? Who's up there on the stage now?) to which the younger man replied: "Nessuno." (No one.)

—Emelise Aleandri May 1999

One

COMMUNITY THEATRE

In 1805, after time spent in Vienna and London due to political and religious pressures in Italy, Lorenzo Da Ponte, Mozart's librettist, arrived in New York City. He was an indefatigable promoter of Italian language and culture, even into his eighties. To encourage the study of Italian among the students of Columbia College, Da Ponte wrote short plays in Italian to be performed by his students, *c*. 1808. This makes him the first recorded Italian-American playwright. He even constructed a little theatre in his own home on lower Broadway, where he staged Vittorio Alfieri' s play, *Mirra*, for an audience of 150. His home was also a makeshift bookstore and a virtual Italian cultural center, where he sold books on Italian theatre and literature. In 1825, he became the first professor of Italian at Columbia College. In 1832, he was also responsible for bringing the first professional opera company, that of Giacomo Montresor, to New York; he introduced to the literati of the city not only the operas for which he had written the libretti, such as Mozart's *Don Giovanni*, but also the operas of Mercadante, Bellini, and Rossini—the music which became the staple of concerts performed by Italians throughout the century. The energy he exhibited as he almost singlehandedly created an appreciation of Italian literature and music in New York, is the same undaunted persistence that almost a century later will drive the immigrant theatrical pioneers. Da Ponte died in 1838 and is buried in Calvary Cemetery.

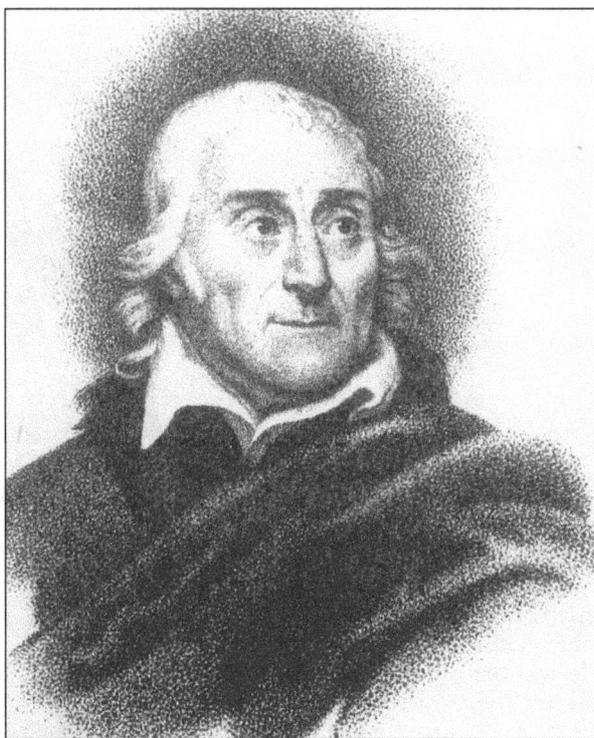

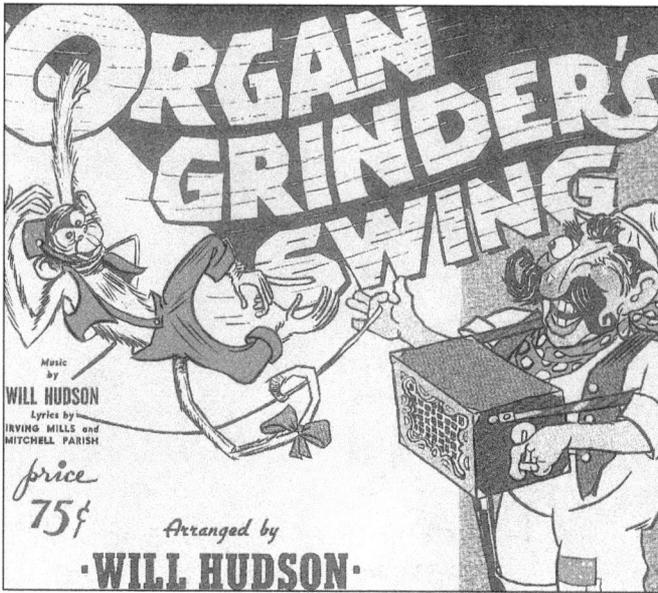

The organ grinder was probably the first entertainer the immigrants experienced as they disembarked in America. Many organ grinders, who were also German, French, Swiss, English, or Irish, rented their instruments and may well have been the only musical entertainment enjoyed by the early poor. This stereotypical cartoon of the organ grinder as a "mustache Pete" on the cover of this song was precisely the "dago" image that so displeased Mayor Fiorello Laguardia, under whose administration these street musicians were banned.

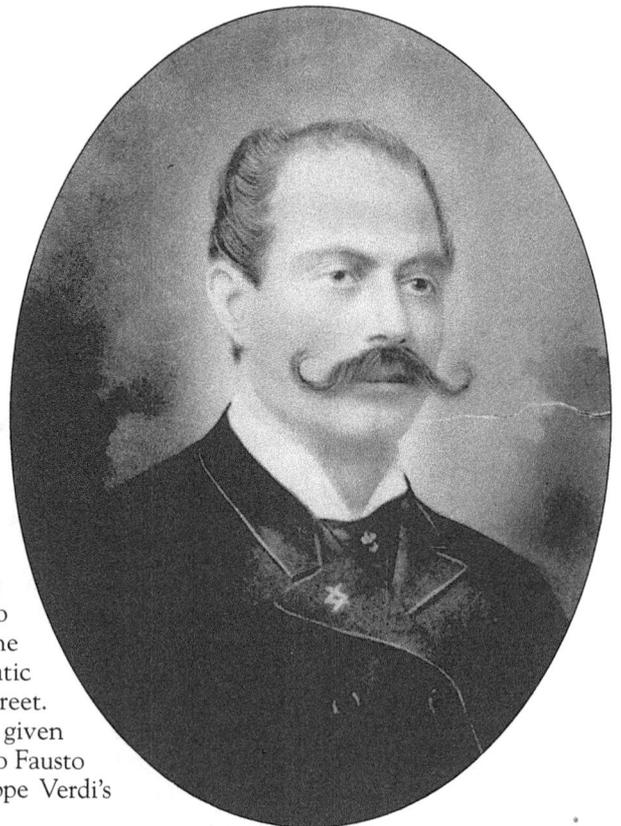

Fausto D. Malzone was born in Castellabate, Italy, and he emigrated to the U.S. in the 1870s. He was the director and major force behind the earliest and most prolific amateur theatre company, Il Circolo Filodrammatico Italo-Americano (The Italian-American Amateur Dramatic Club). Fausto lived on Elizabeth Street. The middle initial D. stands for his given name, Domenico, which he changed to Fausto because his favorite opera was Giuseppe Verdi's *Damnation of Faust*.

10

Turn Hall at 66-68 East 4th Street was the frequent venue for many of the early amateur groups, such as Il Circolo Filodrammatico Italo-Americano, and later professional groups. Known as the Turn Verein in 1876 and Manhattan Lyceum Hall, the name Manhattan Plaza now adorns its entrance; it now houses LaMama ETC, the oldest Off-Off Broadway company, directed by Ellen Stewart, who often features visiting avant-garde companies from Italy.

Faust D. Malzone
BANCHIERE E CAMBIA VALUTA
80 1/2 Mulberry St. N. Y.

Si spedisce moneta a mezzo di vaglia postali, e telegrafici. Passaggi da e per Europa, Sud America, e su tutte le Linee ferroviarie degli Stati Uniti e Canada.

Importatore di Vini Italiani, delle Provincie Meridionali.

Fausto D. Malzone's bank at 88$^1/_2$ Mulberry Street, located between Bayard and Canal Streets in the heart of Mulberry Bend, operated from 1886 to1902 and was also the headquarters of Il Circolo Filodrammatico Italo-Americano. (The 80$^1/_2$ address in this 1892 ad was printed incorrectly.) Malzone advertised money changing, postal services, travel services by ship or rail, and imported Italian wines. Many such banks peppered the Italian colony and assisted illiterate immigrants with letter-writing and legal matters.

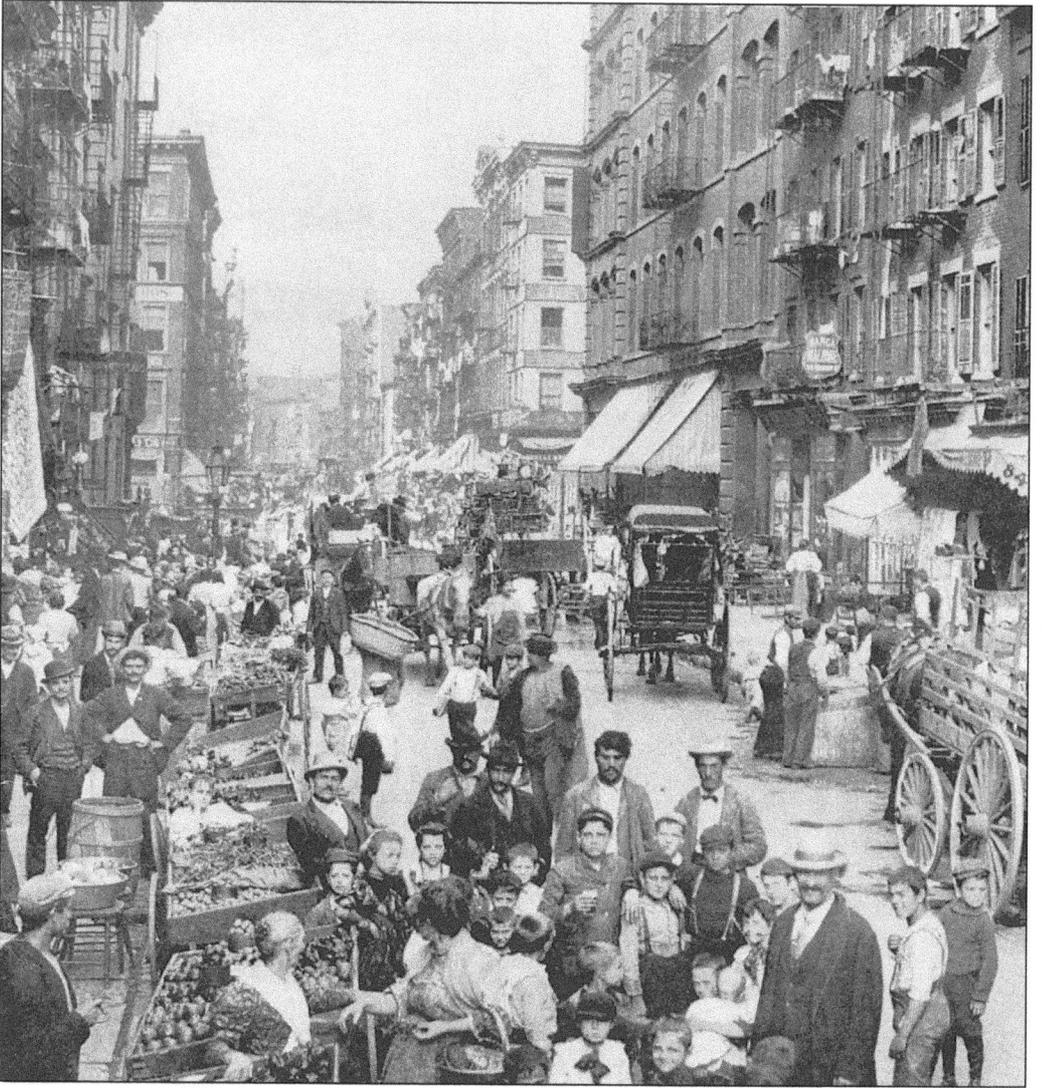

This marvelous picture, taken at a point just north of Mulberry Bend, vividly encapsulates a point in time in the Italian ghetto: the produce laden pushcarts, the sweating horses and carriages, the "old law" tenements with laundry hanging from fire escapes. The crowds of struggling immigrants and laborers made up the audiences for the theatres and nightclubs. From this mass of humanity came the subject matter for original plays, comic skits, and songs as well as composers, writers, and performers. In the middle of it all is the shield shaped sign that heralded the "Banca Malzone" at $88^1/_2$ Mulberry Street, on the east side of the street. As a banker, Fausto D. Malzone was a respected member of the Italian immigrant community. He also served as honorary vice-president of the Stella d'Italia Society, the Italian Barbers Society, and the Sant'Arsenio Military Society. Both the bank and his theatre company were listed at this address until 1902 when Fausto became ill with malaria, of which he died in 1909. After 1902, Il Circolo Filodrammatico Italo-Americano was heard of no more.

The same building that housed the Banca Malzone and the headquarters of Il Circolo Filodrammatico Italo-Americano at 88 Mulberry Street is now a Chinese butcher shop. This store reflects the ethnic change of the old neighborhood, as the Chinese-American community now occupies more and more of the streets and buildings formerly owned and operated by Italian immigrants. The Little Italy of today is relegated primarily to the length of Mulberry Street above Canal Street.

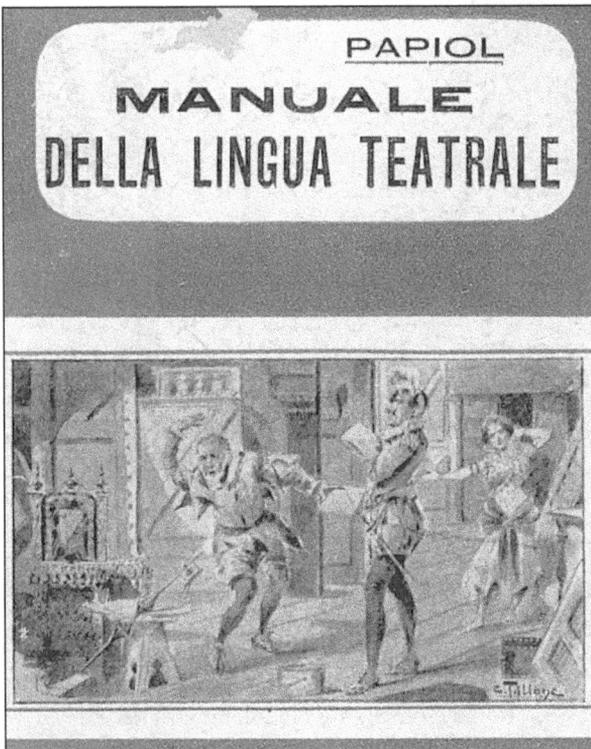

This *Manual of Theatre Terms* was available for the directors and actors of the amateur theatre companies at the Ernesto Rossi Music Store at 191 Grand Street at Mulberry Street. Clearly directed at the amateur, *il figlio di Talia*, (child of the muse of comedy), the book not only explained terms, but also gave advice on conducting rehearsals and producing shows. It began with *affiatamento*, harmony (of the company), and ended with *zittio*, whistling in disapproval.

The Germania Assembly Rooms at 291-293 Bowery between Houston and Bleecker Streets had a lobby and an upstairs spacious room with 448 seats. Called the Teatro Italiano when il Circolo Filodrammatico Italo-Americano produced the drama, *L'Entrata di Garibaldi in Napoli* (Garibaldi's Entrance into Naples) on Wednesday, February 21, 1883, the hall was shared with other Italian-American amateur companies, rifle clubs, marching societies, musical leagues, social and political organizations, and German and French societies.

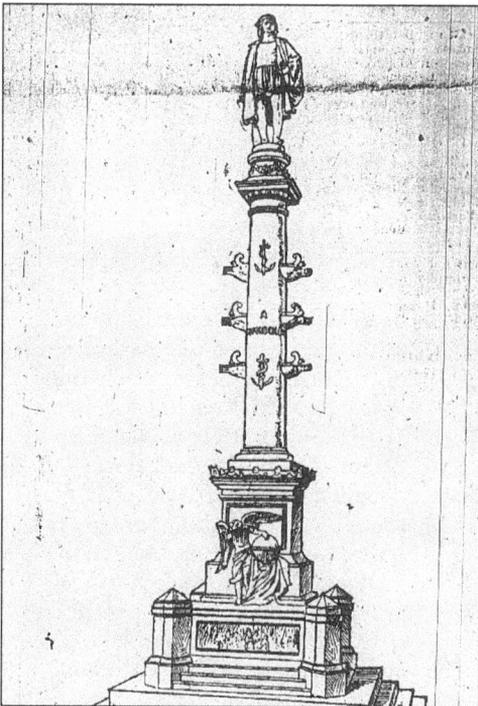

Located at Columbus Circle, this 75-foot monument to Christopher Columbus, sculpted by the Sicilian Gaetano Russo, was financed by the Italians through a campaign in the newspaper *Il Progresso Italo-Americano* and was dedicated October 12, 1892. Italian-American organizations raised money. The following community theatre groups held benefits from 1889 through 1890: the students of the Teodoro Palumbo School at 54 Prince Street, il Circolo Filodrammatico Italo-Americano, and La Compagnia Napoletana (The Neapolitan Company).

GERMANIA ASSEMBLY ROOMS

291-BOWERY-293

MARTEDI 4 APRILE 1893 ALLE ORE 8 POMERIDIANE

CAVALLERIA RUSTICANA

Scene Popolari di G. VERGA

PERSONAGGI	ATTORI	PERSONAGGI	ATTORI
TURIDDU MACCA	Sig V. Badolati	LO ZIO BRASI, stalliere	Sig. C. Mottola
COMPAR ALFIO, il Licodiano	,, L. Zumbo	COMARE CAMILLA, sua moglie	Sig' G. Burron
LA GNA' LOLA, sua moglie	Sig' L. Metelli	LA ZIA FILOMENA	Sign' A. Sambruna
SANTUZZA	,, V. Michelangeli	PIPPUZZA	Sig' A. Ciambelli
LA GNA' NUNZIA, madre di Turiddu	,, L. Sambruna		

IL LUPO DI MARE

DRAMMA IN 2 ATTI

PERSONAGGI	ATTORI	PERSONAGGI	ATTORI
GAERIE, maestro costruttore di barche	Sig. F. D. Malzone	C TANGH', Ing marito di Sofia	Sig I Delicati
SOFIA, sua figlia	Sig' L. Metelli	GIORGIO } figli di Sofia	,, R. Catarsi
MARIA GIOVANNA, sorella di latte di Sofia	Sign' A Sambruna	CARLO }	,, A. Franchi
COCARDEAU, allievo di Gaerie, suo marito	Sig F Rossi	ADONE, negro	,, E. Tozzi

CUOR DI FANCIULLI!

Bozzetto di attualita' scritto da B CIAMBELLI e dedicato alla Lega Toscana F. D. Guerrazzi, che tanto fa per salvare da morte i due disgraziati connazionali Rugini e Pertiga. Il Bozzetto sara' racitato dalla bambina Vanda CATARSI e dai fanciulli Ruggero CATARSI e Enrico RAMPONE.

UFFICIALI DEL CIRCOLO

Presidente Onorario a vita Commendatore TOMMASO SALVINI

Presidente: F. D. Malzone - Vice Presidenti: A. de Yulio - A. Alvino. Segretario N. Juzzolini - Tesoriere: D. Spinelli - Ispettore di Sala: D. Catarsi

L'orchestra sara' diretta dal Maestro R. CODELUPPI

This poster is the earliest extant example for any Italian-American production. The show, for Tuesday, April 4, 1893, at 8 p.m. produced by Il Circolo Filodrammatico Italo-Americano, included Giovanni Verga's drama *Cavalleria Rusticana* and the two act drama *Il Lupo du Mare* (The Sea Wolf), followed by a contemporary children's sketch *Cuor di Fanciulli!* (Children's Hearts!), written by the journalist Bernardino Ciambelli. Maestro Raffaele Codeluppi conducted the music that was customary during intermissions. Under Fausto's artistic direction, this was the first and most prolific theatre company of the 19th century in New York City. From their first recorded show on February 9, 1878 to their last on November 26, 1900, the company performed mostly to benefit the Italian community in New York and Italy, raising money for social causes: cholera epidemics, earthquakes and floods in Italy, funeral and trial expenses, the Italian Home and Hospital, the Columbus Statue fund, and holidays commemorating Italian milestones in history. Fausto and his theatre company paved the way for the professional theatre that followed in the 20th century.

The bands and small orchestras that always performed during the intermissions between acts or plays were usually the students of the local *Maestro Professore*, who would conduct. In 1907, musicians could purchase mandolins and guitars, essential instruments of any band, at the Favilla Brothers Factory at 1 Haward Street or their store at 200 Grand Street. Established in 1894, they sold violins and imported Italian and German accordions, wholesale or retail, and made repairs.

The harp guitars in M. Iucci's ad sold for $15 to $40 and were guaranteed for five years. He also sold mandolins, made repairs, and secured Neapolitan orchestras. Italo-Americanese, the developing English/Italian language mixture, creeps into this 1907 ad. The guarantee in the upper right corner is called a "ticket" and he notes his *Fabbrica e* Store (Factory and Store). By 1921, he sold banjos, crediting himself as the "inventor of the bell tone for snappy sound."

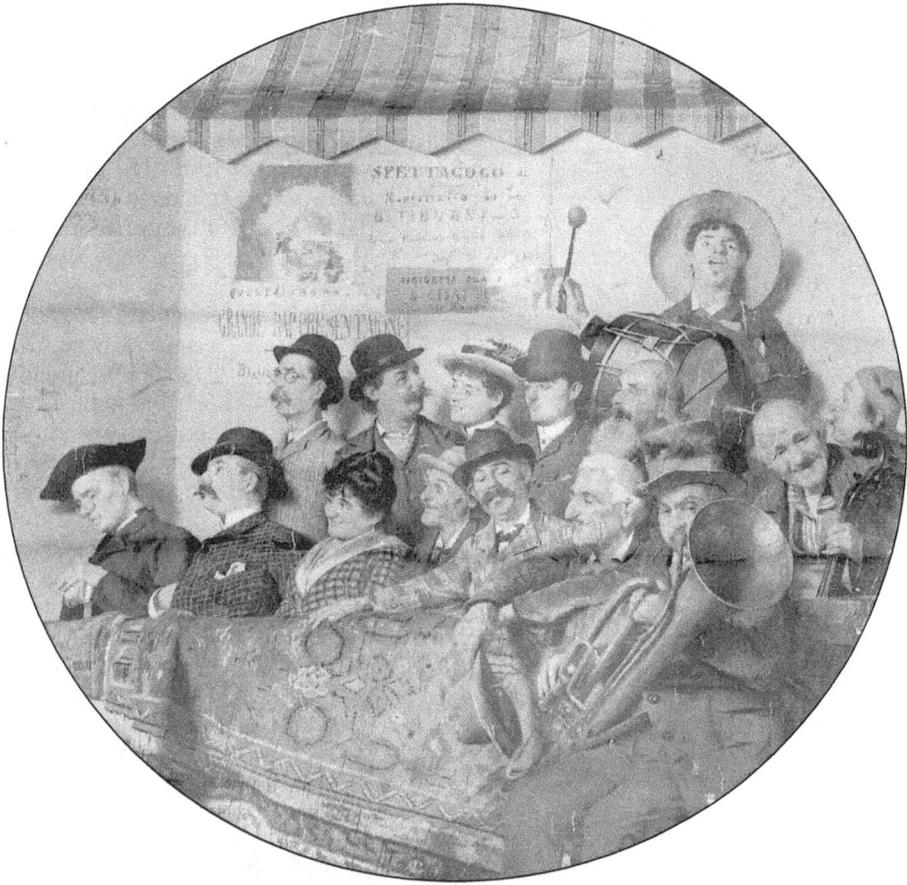

This 1886 drawing depicts a typical Italian audience and band that could be expected at any theatre presentation. Evident and typical is the mixture of character types: all ages of men, women, clergy, and the musicians with the required instruments (drum, horn, trombone, and strings) for the 19th-century sound. On the wall is the usual wording that announced a performance: *Grande Rappresentazione* (Big Show) and *Spettacolo* (Show).

Musicians in need of accordions could purchase them from the Calizi brothers. Mr. E. Calizi and his brother advertised their accordion factory in 1917 as the largest manufacturer of professional accordions of any type. They also promised accurate repairs and were located at 203 Canal Street between Mulberry and Baxter Streets.

Mannaggia 'a mugliera (Damn my Wife) was featured in the Neapolitan songfest, *Piedigrotta*, of 1905. The man in this comic song explains that he married at the counsel of his mother and father, but his bossy wife argues with him daily, and he can not get a word in edgewise. In the end, he is resigned to his situation but still says, "Damn my wife." With lyrics by Aniello Califano and music by R. Segre, the song was published in the U.S. by the Emporium Antonio Mongillo at $131\frac{1}{2}$ Mulberry Street between Grand and Hester Streets. As early as 1901, his music business (possibly the first) published, imported, and sold sheet music, instruction manuals for various instruments of the period, including the solfeggio method of P. Bono, plays, cigars, tobacco, and postcards until at least the 1930s. The sheet music was not returnable.

Two

COMEDY

Guglielmo Ricciardi formed La Compagnia Comico-Drammatica Italiana (The Italian Comedy-Drama Company), which enjoys the distinction of being the first and only 19th-century Italian-American theatre company based in Brooklyn; it catered primarily to Brooklyn audiences. Ricciardi himself enjoys the distinction of being the first of his generation to transcend his humble beginnings in the Italian-American theatre of the 19th century to become a successful actor in the American theatre and cinema as well. He left his hometown Sorrento in 1889 (or 1891, depending on the memoir) arriving in New York, and taking up residence at 21 President Street, in the midst of the South Brooklyn Italian colony where many immigrants from Sorrento lived. He secured employment with the small banking business, travel agency, notary pubic, law office, and Italian bookstore of Don Antonio Sessa at 40 Union Street. Sessa was a pioneer of the Italian-American community of Brooklyn. In the rear of the Banca Sessa, Ricciardi and a group of interested amateurs would often meet to read and try out comedies. One day in a neighborhood cafe, Ricciardi found himself accidentally reunited with an old boarding school companion, Francesco Saverio Savarese. The two former classmates, after learning from their compatriots that no dramatizations in Italian had ever been given for the Italian community in Brooklyn, decided to start a theatre circle with the moral support and advice of friends like Aniello Esposito and Francesco De Maio; they also received some financial assistance from the banker Antonio Sessa.

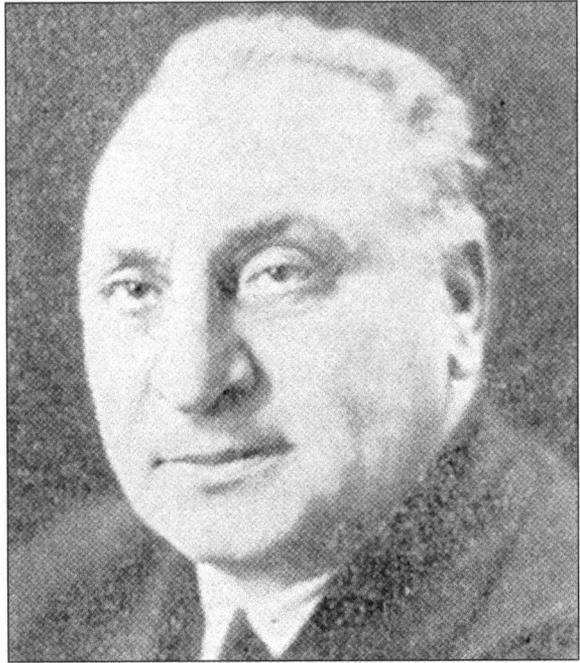

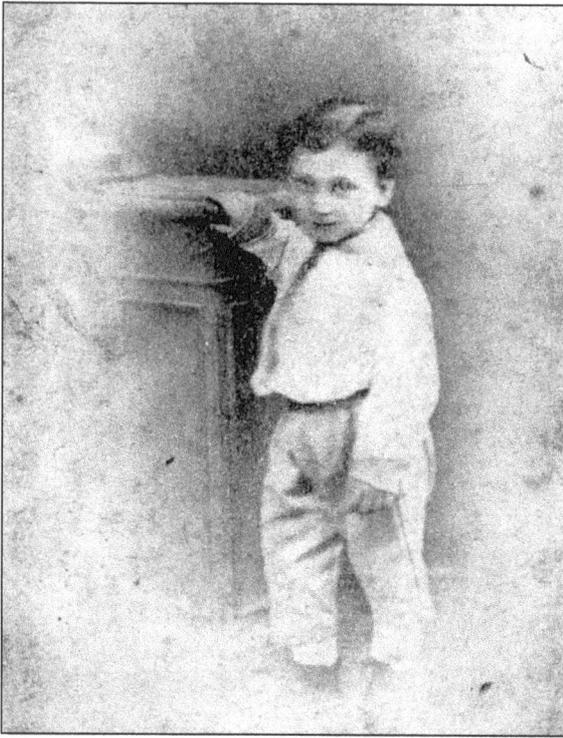

Guglielmo Ricciardi was born on July 12, 1871, at 15 Via Savino in Sorrento, in the province of Naples. Here, he is pictured at the age of four. His father, Antonino Ricciardi, commanded a merchant vessel; his mother, Cristina D'Apreda, was the daughter of the mayor of Sorrento. Guglielmo's first son, Nino, who will figure in the second generation of New York's Italian-immigrant theatre, was his grandfather's namesake.

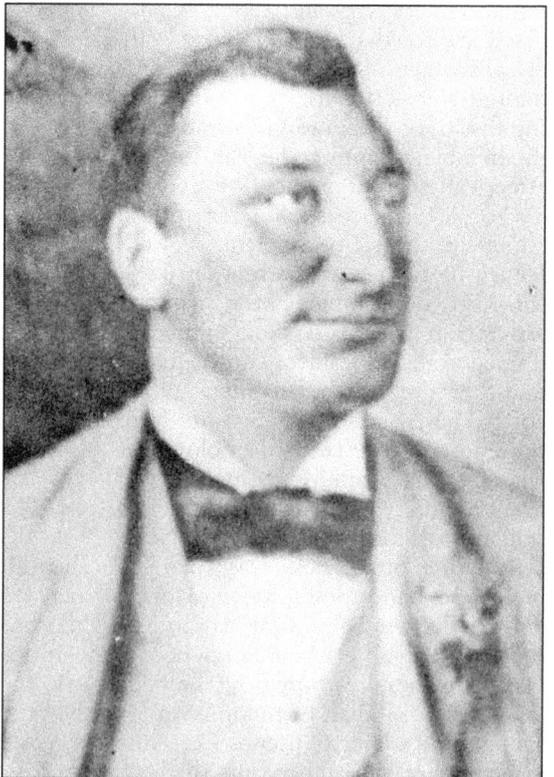

In Italy, Ricciardi attended the Jesuit Collegio Sozi-Carafa, a boarding prep school in the town of Vito Equense, where he and his close friend (and future co-founder of La Compagnia Comico-Drammatica) Francesco Saverio Savarese put together small comic skits for and with his schoolmates. Ricciardi began to feel the theatre bug, which would develop into an obsession. A. Moriani painted this oil portrait in 1896 during Ricciardi's visit to Sorrento.

Concetta Arcamone and her sister Rosina were amateur actresses in their native town of Torre Annunziata. Concetta was 19 when she arrived in America. The bank clerk Francesco De Maio, through his acquaintances at the Banca Sessa, introduced his co-worker Ricciardi to others interested in the theatre; Concetta and her sister and brother-in-law, Rosina and Michele Balsamo, were among them. Ricciardi taught Concetta how to sing and dance and eventually married her.

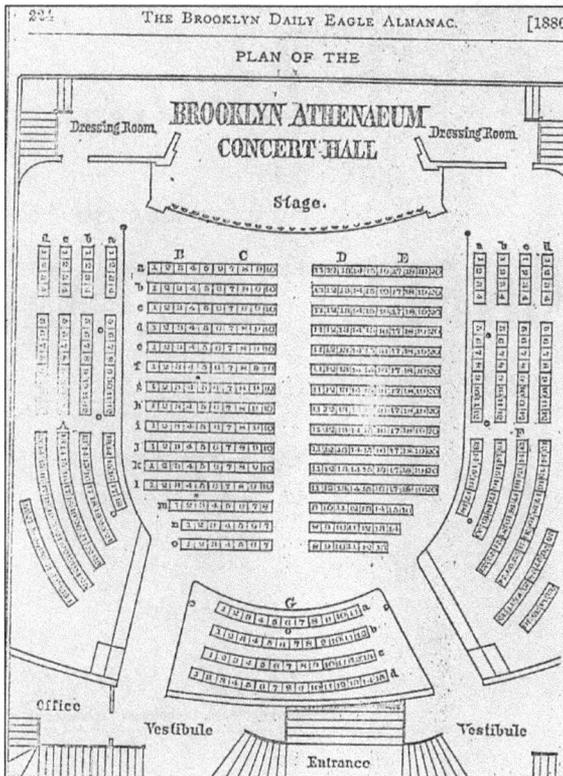

Through the efforts of Francesco De Maio, the company rented the Brooklyn Athenaeum Theatre on the corner of Clinton Street and Atlantic Avenue for $35 and opened to great success on Monday, November 25, 1889. Since the majority of South Brooklyn's Italians originated from Naples and Sicily, the newly formed troupe produced a comedy in the Neopolitan dialect: *Lu Retuorno Da Buenos Aires* (The Return from Buenos Aires) by G. Marulli.

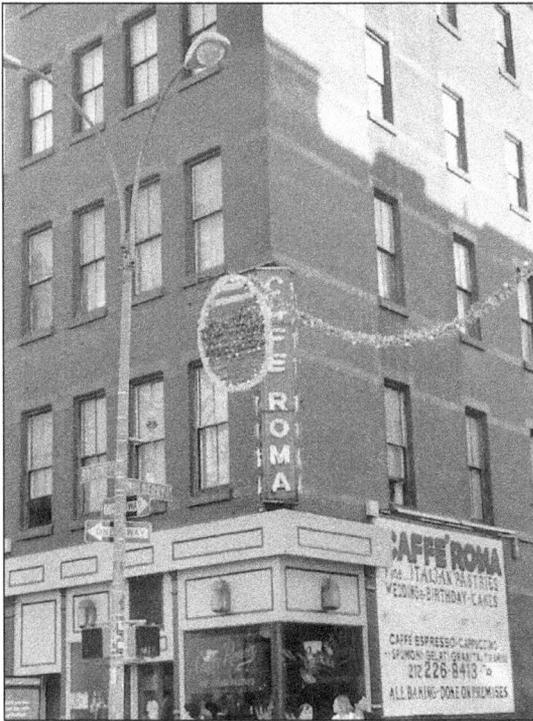

The current Cafe Roma, located at 385 Broome Street on the corner of Mulberry Street, was originally the Caffe Ronca, a pastry shop that was the Sardi's of Little Italy, a hangout for theatre and variety artists. Pasquale T. Ronca was born June 7, 1866 in Solofra, Avellino province. He came to New York in 1891, followed by his brother Giovanni in 1892, with whom he opened the cafe. Guglielmo Ricciardi and the actor Antonio Maiori first met here; the famous Pulcinella, Francesco Ricciardi, and the comedian Giovanni De Rosalia would socialize here on their off hours. The comic impersonator Farfariello, who lived nearby at 57 Kenmare Street, would sit quietly at a corner table, sip his espresso, and study the local characters that he would recreate onstage. Later, c. 1911, Pasquale Ronca imported singers from Italy to perform at the Brooklyn Academy of Music.

P. Ronca & Bro.,

PASTRY & CONFECTIONERY

NEAPOLITAN BRICK

"ICE CREAM"

385 Broome St., NEW YORK

Ricciardi went professional when he joined with Antonio Maiori. Ricciardi was sipping coffee in the Caffe Ronca when he met the Sicilian dancer/pantomimist. They became friends and discussed plans for a tour of the U.S. Pasquale Ronca introduced them to "two other sons of Italy in distress," Papa Giuseppe Zacconi and Pasquale Rapone, both actors; together with Mrs. Concetta Arcamone Ricciardi, they formed the Italian Dramatic Company. Ricciardi once reminisced, "We played in such cities as New York, Philadelphia, Newark, New Haven, Bridgeport and Providence, but with not a bit of luck. There were times when there was nothing but empty chairs, when we did not know where our next meal was coming from. For months we strolled through New York and Connecticut, like men lost in a great desert, always in need of 90¢ to make a dollar."

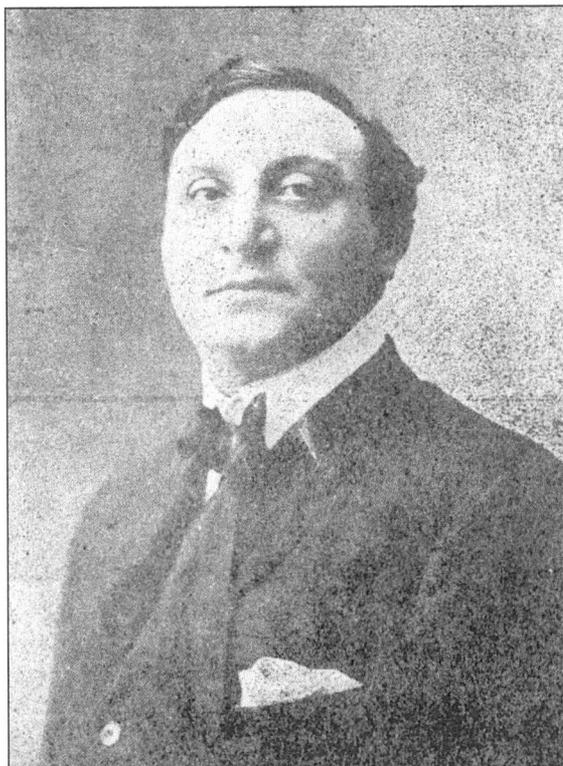

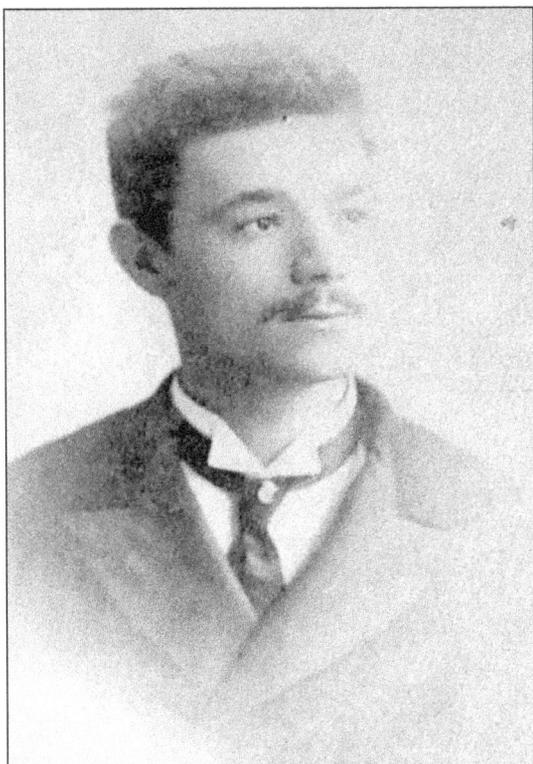

Guglielmo Ricciardi was an easy subject for cartoons and caricatures, with his intense features and big, oversized nose. He was referred to as the Cyrano de Bergerac of the Italian theatre and "Nasone" (Big Nose). This caricature, which was sketched by Gianni Viafora, c. 1901, depicts Ricciardi singing during one of his most famous *macchiette* (character impersonations), *'O Zampugnaro* (The Bagpipe Player).

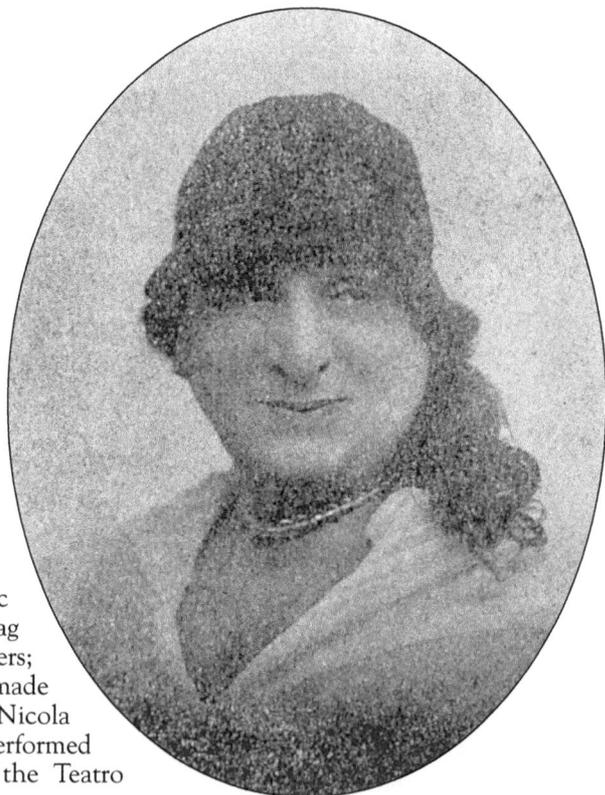

The Italian version of *Charley's Aunt* (*La Zia di Carlo*) featured Guglielmo Ricciardi both as Charley and his aunt, as the title role requires. A typical *macchiettista* (the traditional Neapolitan impersonator of comic characters) sometimes dressed in drag costume to impersonate female characters; this tradition was perfected and made famous by the Neapolitan *macchiettista* Nicola Maldacea. In Italy in 1894, Ricciardi performed much of the Maldacea repertory at the Teatro Rossini of Naples.

Guglielmo Ricciardi was first and foremost a character actor. As such, he played many different *macchiette* and stage types, including the traditional Neapolitan mask of Pulcinella from the Commedia Dell'Arte, Don Vicienzo 'o purtugallero (Sir Vincent the Portuguese), 'O guappo (The Dandy), Fra Bisanzio (Friar Bisanzio), Don Felice (Sir Felix) from Eduardo Scarpetta's play *La Santarella* (The Hypocrite), character sketches from the Maldacea repertoire, and many others.

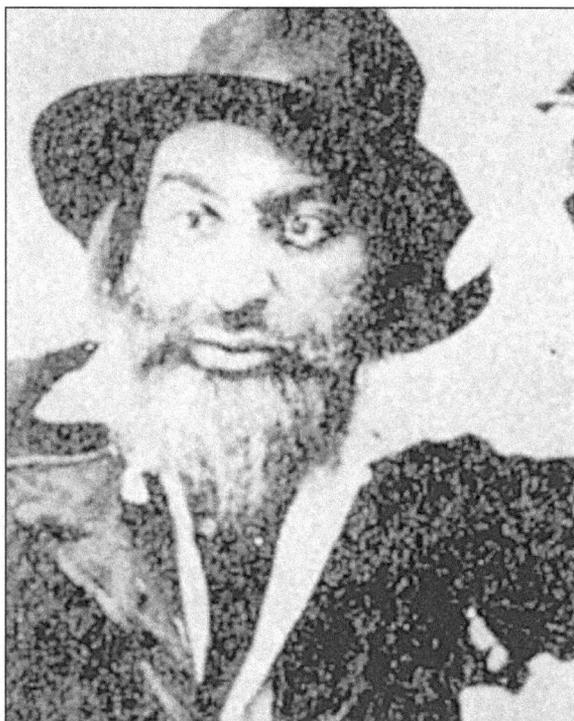

At the age of 83, Ricciardi wrote his memoirs, the full title of which is *Ricciardiana: Raccolta di scritti, racconti, memorie, ecc. del veterano attore e scrittore* (Ricciardiana: Collection of writings, stories, memories, etc. of the veteran actor and writer.) This picture graces the cover. Dedicated to his mother, Cristina D'Apreda Ricciardi, the book is a valuable resource for the earliest days of the Italian-immigrant theatre, particularly for its insight into the psyche of the actor.

25

This incident, narrated by Ricciardi, terminated his partnership with Maiori, Rapone (below), and Concetta Arcamone (above): "One night Maiori and Rapone, both dancers and pantomimists, agreed to revive an old pantomime, 'Love in the Garden.' The characters were Harlequin, Pierrot, Pantalone and Columbine, played by Maiori, Rapone, Ricciardi and the beautiful Neapolitan girl, who was Mrs. Ricciardi. The love scene between Columbine and Pierrot was so natural and realistic that next day they ran away with each other, leaving the poor Pantalone to himself. At times I think that the great Leoncavallo must have taken the idea of his opera from that disheartening experience of mine. The only reason I did not kill Pierrot is because I have always believed in happy endings. After that I took the next boat for Naples and tried my best to forget."

The Grand Eden Theatre, also called Ricciardi's Grand Eden Caffe, Verga's Music Hall, or Mrs. Mary Marino's Nickelodeon in later years, was located at 2157 First Avenue between 111th and 112th Streets in Italian East Harlem. It was constructed by the building contractors, Mr. D. Karp and Mr. F. Hill, two German Jews who had enjoyed Ricciardi's performances, although they understood neither Italian nor the Neapolitan dialect. Ricciardi leased the theatre, which was essentially a nightclub with a stage, and functioned as manager and director. The Marchese Achille Di Landri painted portraits of Ricciardi and King Umberto I of Italy for the lobby. After Umberto's assassination in July 1900, the women patrons of the theatre would kneel in prayer before the good king's image. Described by the newspaper L'Araldo as a "very elegant spot," the theatre sat 70 people. Thursday, July 19, 1900, saw the grand opening.

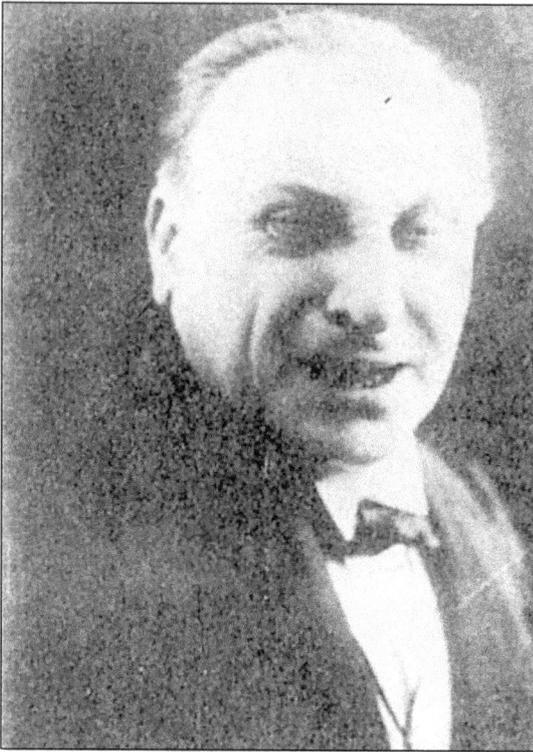

On Thursday, May 1, 1902, under
the Eden's new owner, M.K. Reussen,
Ricciardi continued to perform his
characterizations in plays, skits, and vocal
concerts in Italian and English until
his last association with the theatre on
July 25, 1902; he had already begun his
transition into the American theatre
during these years. Whenever Ricciardi
organized his own group of actors,
he invariably directed them himself.
Spontaneous, haphazard, improvisational,
unpredictable, inventive, impulsive—all
these words describe not only Ricciardi's
lively directing style, but also the usual
modus operandi of the Italian-immigrant
theatre. Unorganized as it may seem
at first, the improvisational technique
has kept the Italian theatre together
for centuries, since the time of the
Commedia dell'Arte.

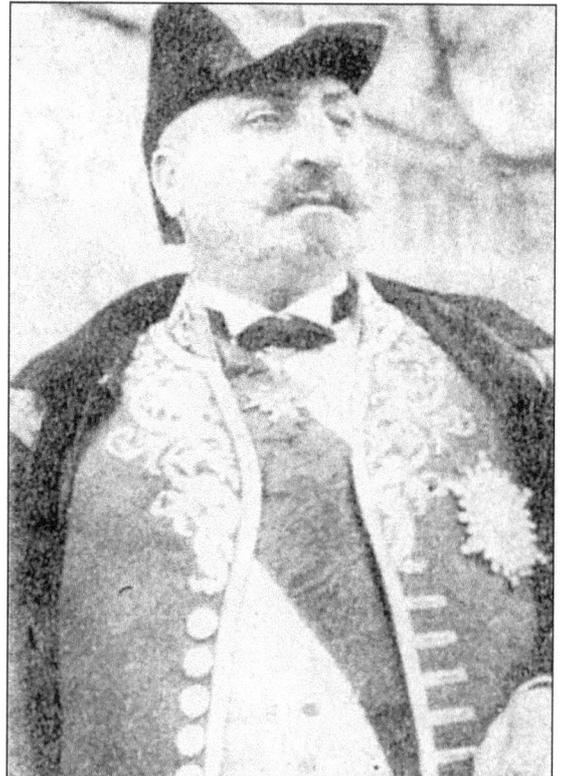

The couple Gina and Giuseppe "Pippo" Pozzi performed with Ricciardi's company; they also toured to San Francisco and Philadelphia with the company of Granese Calabrese. Toto Lanza, the editor of the 1917 theatre souvenir booklet *Strenna Miluccia*, praised them this way: "She too is the first of those who cast the first building blocks for the cult of the Italian Theatre in America. She shared with her 'Pippo' the unhappy days of struggling between New York and S. Francisco and from San Francisco to New York, supported always, despite adversity, by her unshakable faith in her artistic dream. She is an esteemed actress and has great ability.... He is the oldest in the family of art in America and perhaps one of the pioneers. In his by now worn out body, there is an entire life of grief and disillusionment, stirred up because of the Theatre. And, nevertheless, he doesn't tire of it, he continues to be an actor, active and disciplined, always a poet, a conscientious actor."

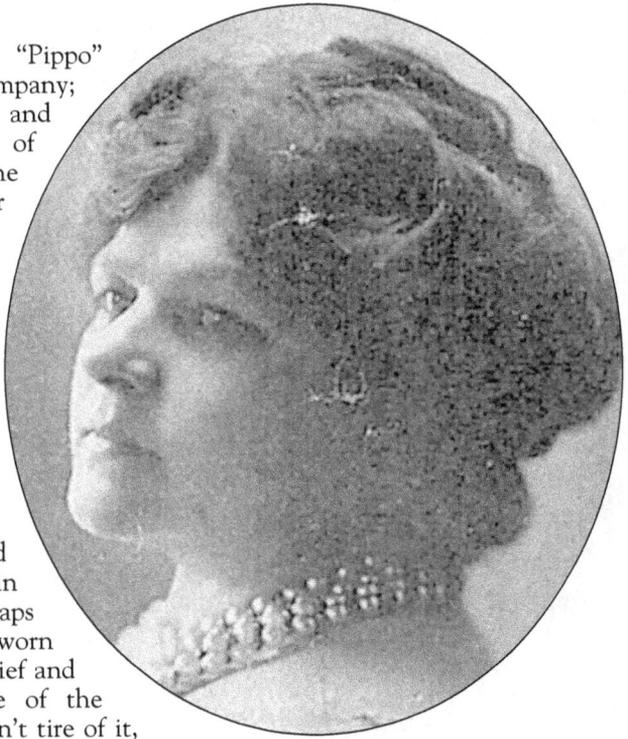

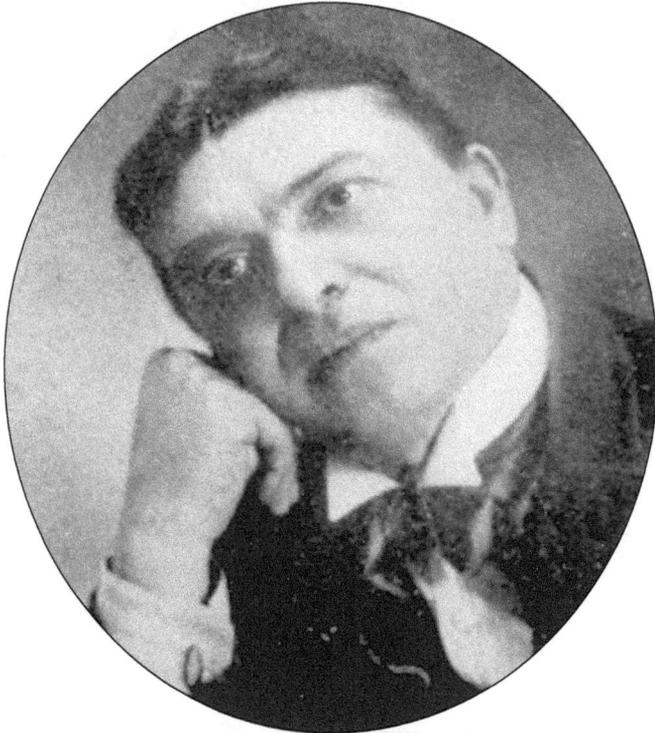

Ester (Esterina) Cunico also performed in Ricciardi's company in such roles as Enrichetta in Carlo Roti's *I Due Sergenti* (The Two Sergeants), Ada in Paolo Giacometti's *La Morte Civile ossia Corrado il Siciliano* (Civil Death or Corrado the Sicilian), and both the Mother Superior and leading lady in Scarpetta's *La Santarella* (The Hypocrite). Ester later married the actor/director Silvio Minciotti in 1911; together they formed a professional company.

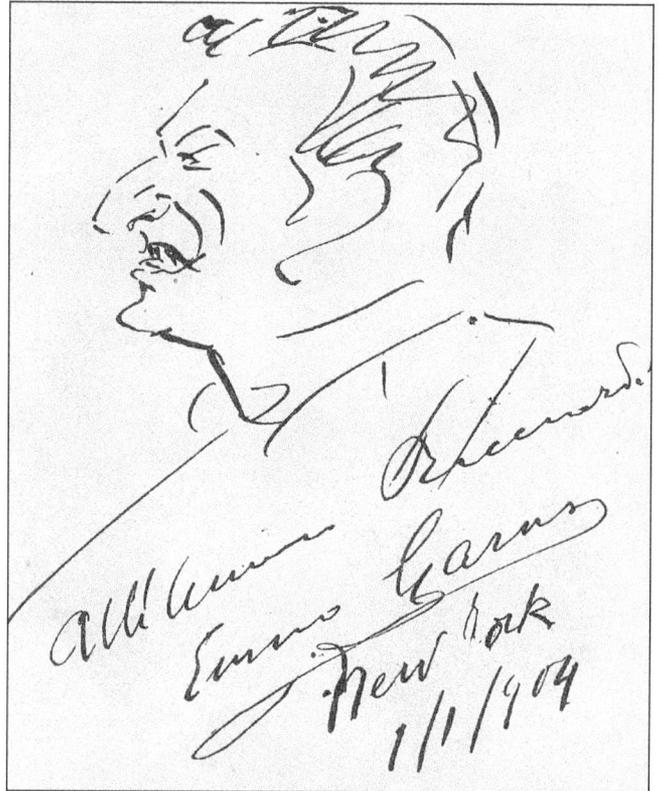

On January 1, 1904, Enrico Caruso drew Ricciardi's caricature, now in the Sorrento Museum, at the annual New Year's Eve supper given by Don Angelo Legniti for Little Italy's prominent figures (including the Consul General) at Legniti's elegant new residence at 325 East 13th Street. Ricciardi sang duets with Caruso. Don Angelo Legniti, the banker, lawyer, and notary public had introduced Caruso to Ricciardi in 1900— Caruso's first year in New York.

Maestra Contessa Gilda Ruta, of the
Ricciardi and Maiori Companies,
and her daughter Anna performed
at music halls and gave classical
concerts in her upper eastside home.
At Legniti's 1899 New Year's Eve
party in his home at 12th Street
and 2nd Avenue, she accompanied
the Ricciardi/Caruso Neapolitan
duets on piano for *A Serenata ' e nu
Sturente* (The Student's Serenade).
She composed music for the ballad,
Te ne ricordi piu!

The home of popular actress Maria
Prete, located at 229 East 11th Street,
was damaged by fire. The businessmen
Antonio Ferrara and Mr. R. Iandosca
and the actor Icilio Delicati produced a
benefit for her Monday, May 25, 1903,
at the Drammatico Nazionale Theatre
at 138 Bowery. Called "the Eleonora
Duse of the colonial stage," she appeared
with Ricciardi and other companies,
including La Compagnia Magica (The
Magic Company) of Professor G. Prete.

31

At La Villa di Sorrento nightclub, during his production of *Un Bacio di Sangue ovvero lo Scheletro Avvelenatore* (A Bloody Kiss or the Poisonous Skeleton), c. 1900, Ricciardi was introduced by club owner Fabio D'Alessio to his future wife, German 16-year-old Adelaide Triber. When Ricciardi landed the role of the Sicilian miner Pietro Randazza in *The Great White Diamond*, a melodrama in English by the producer Walter Fessler, Adelaide helped him memorize his 50-page role.

President of the Actor's Union Ralph Delmore (Raffaele Donnarumma from Salerno) helped Ricciardi secure his first role in the American theatre. Here, he appears in a third act scene of *Mister Malatesta*, written by himself, directed by Mr. Fagan, and produced by David Seligman and his brother at the Cort Theatre in London. George Bernard Shaw praised his performance. The play ran in New York's Princess Theatre as *Papa Joe*.

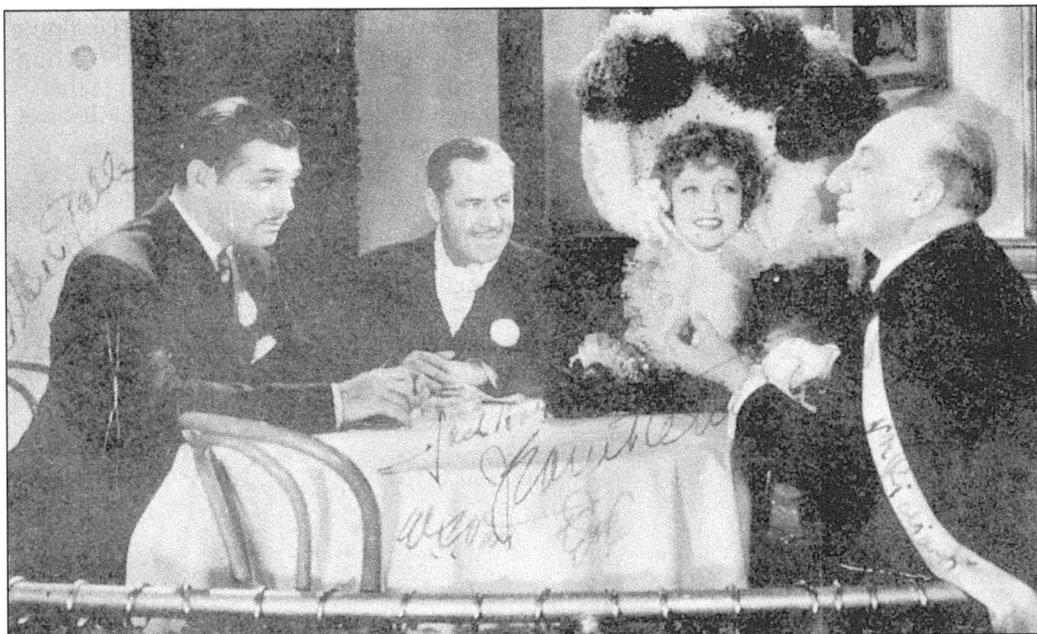

Eventually, Guglielmo Ricciardi made it to Hollywood and secured a contract with Universal Studios. He plays the opera impresario in the classic, *San Francisco*, with Clark Gable, Jack Holt, and Jeanette McDonald. Director George Fitzmaurice had seen Ricciardi as Papa Joe in *Mister Malatesta* in London and hired him for the American film adaptation of Luigi Pirandello's play *Come Tu Mi Vuoi* (*As You Desire Me*) with Greta Garbo at the MGM Studio in Culver City. Always the character actor, he also appears as Abdul in *Under Two Flags* with Claudette Colbert; as the maestro in *Stars over Broadway* with James Melton and Pat O'Brien; as the Judge in *Treat 'Em Rough* with Lola Shore; and in the silent film *The Humming Bird* with Gloria Swanson and his friend from Sorrento, the Italian actor Cesare Gravina.

The first to make the transition from the confining immigrant milieu, Ricciardi, here at age 84, had a successful career in the greener pastures of the American theatre and cinema. But Ricciardi never completely abandoned the Italian-American theatre. Throughout his career, during his time off from touring, he returned to perform and produce; he always remained a fan, recalling the work, successes, and failures of his pioneering days with undisguised affection.

In 1896, 24 Spring Street had a basement saloon, the Caffe Eldorado, owned by the partners Pagliuca and G. Selvaggi. After his brokenhearted departure, they brought Ricciardi back from Sorrento to entertain at the Caffe. Above it was Maiori's tiny Teatro Italiano, built in 1899. Formerly a store, the ticket booth was near the window over a stoop of six steps. The actors played cards downstairs. Maiori, Concetta Arcamone, and Rapone lived upstairs.

Three

TRAGEDY

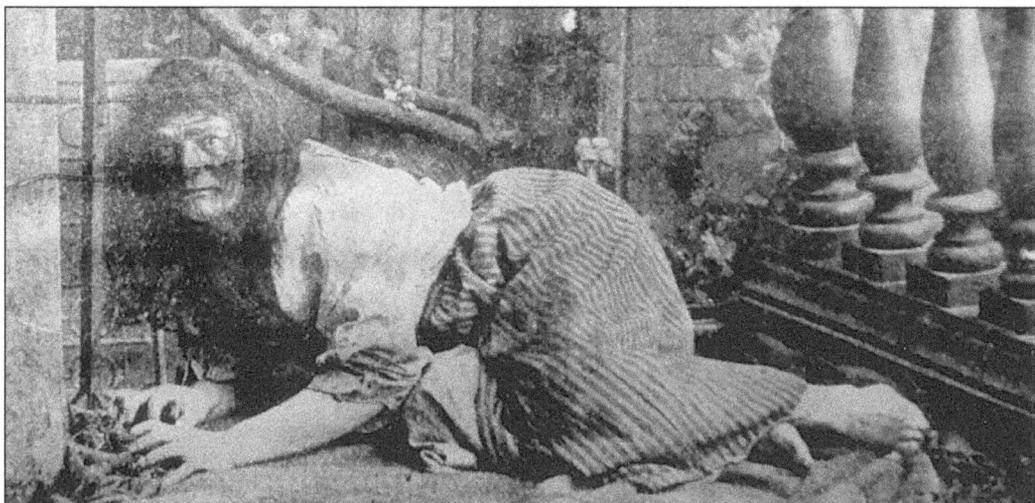

Antonio Maiori was not a comic *macchiettista*, but he too could be called upon to play a female role. In this picture, he plays the mother in the melodramatic Italian play by E. Menechino, *La Jena del Cimitero* (The Hyena of the Cemetery), which enjoyed 18 successful consecutive performances at the Teatro Italiano of 24 Spring Street and many more throughout Maiori's career. The play tells the story of a mother whose young daughter was stolen. The mother wanders through cemeteries, digging up new graves in search of her child. After Ricciardi's unhappy departure for Italy in 1895, Rapone and Maiori continued their partnership, but Ricciardi never worked with either of them again. Maiori and Rapone worked together under the title La Compagnia Comico-Drammatica Italiana di Antonio Maiori e Pasquale Rapone(The Italian Comic and Dramatic Company of Antonio Maiori and Pasquale Rapone) until July 16, 1903, when, for unknown reasons, they too parted ways. Rapone produced independently under the title La Compagnia Comico Drammatica Pasquale Rapone. During the early years after 1900, Antonio Maiori was by far the most prolific producer-director in the Italian-American theatre. He entertained collaborations with other producers and directors and enjoyed the singular distinction of bringing, for a time, large American audiences to his theatre. Erroneously, he thought this event would bring him financial security and fame. He was the first to produce Shakespeare in Italian as well as French and Italian classics; eventually, he capitulated to producing variety theatre.

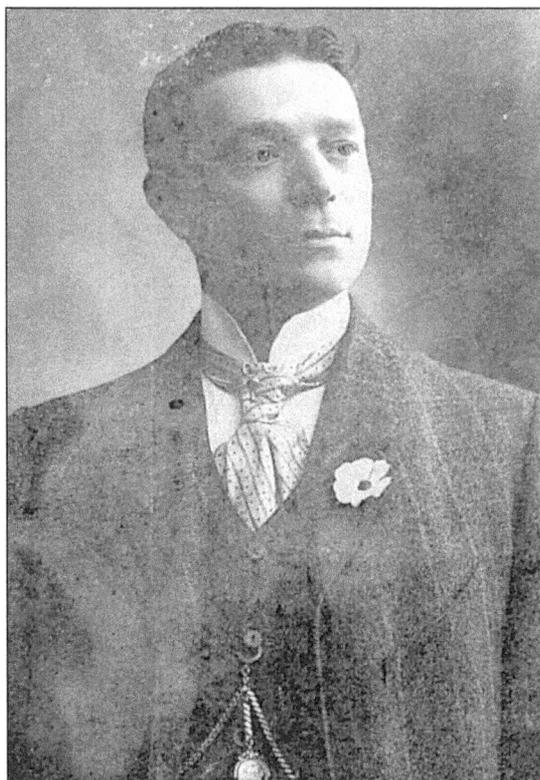

Antonio Maiori was born at Castroreale, Sicily, in 1870. At age 14, he studied mime and dancing in Naples and performed as "O Sicilianello"(The Little Sicilian). He toured Sicily with Italian companies but left for France to avoid military conscription. While working as a mime/dancer in Marseilles and Cannes, he was hired to perform with Ermete Zacconi. He then toured Southern France with his own Italian troupe. He arrived in New York in 1890.

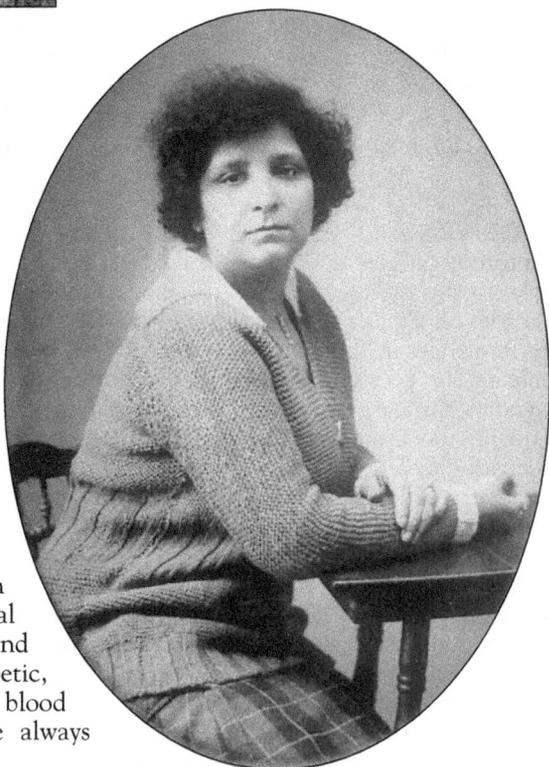

Concetta Arcamone was Maiori's wife and leading lady. The American journalist Hutchins Hapgood described her Shakespearean roles and her role in *La Statue di Carne* (The Statue of Flesh) in 1900: "An actress very pleasing in emotional and humorous situations. As Ophelia and Desdemona she is graceful, touching and poetic, and in the Italian plays of passion and blood her dark face and Southern manner are always adequately expressive."

Maiori wears the uniform of Scarpia in the play *Tosca* by the French dramatist Vittorien Sardou. In France, Antonio Maiori was exposed to the French repertoire, which he produced in America in Italian. The number of French playwrights was second only to the Italians: Philippe Francois Pinel Dumanoir, Alexandre Dumas, pere and fils, Fournier, Meyer, Halevy Meilhac, Victor Hugo, Eugene Cormon, Eugene Grange, D'Aubigny, Adolphe Dennery, Henri Murger, Georges Ohnet, and Eugene Sue.

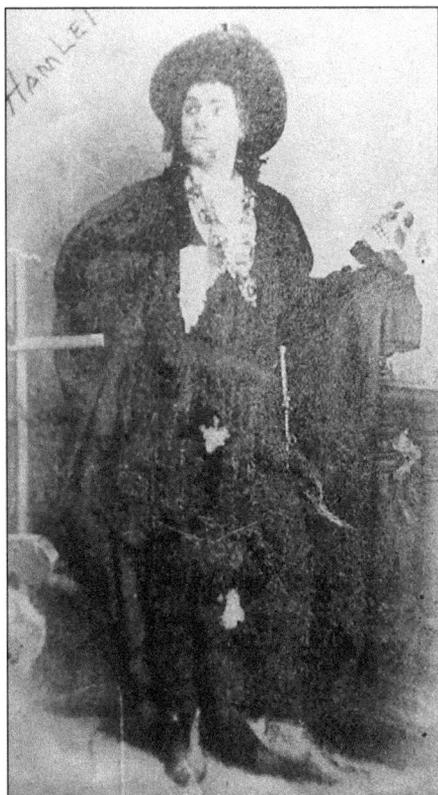

Hamlet was one of the first of Shakespeare's plays produced by Maiori in New York. The *Puerto Rico Herald* reviewer in 1903 said that in 13 years of seeing Hamlets, none had made such a impression on him: "Maiori's Hamlet is an original interpretation, beautiful, full of passion, impressive and strong. He is not a weak thinker, without blood and judgment. He is the real strong thinker capable of putting in action his own ideas."

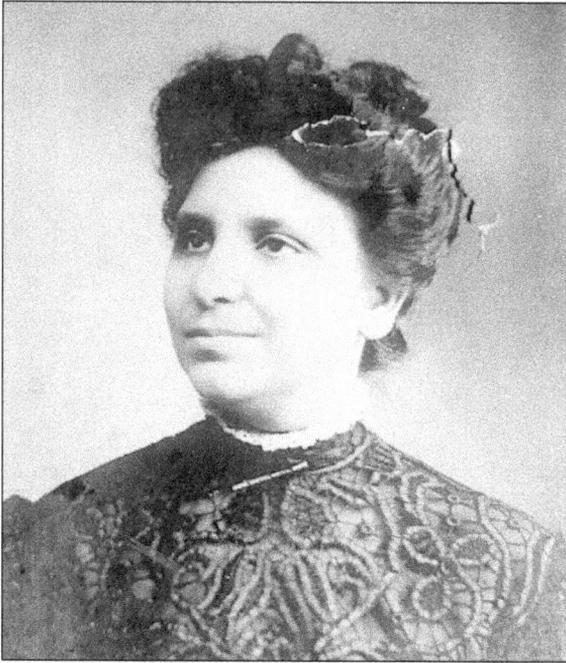

Besides the Ricciardi and Maiori troupes, Concetta performed with the companies of Francesco Ricciardi and Nicola Briganti. She played leading roles in *La Consegna e di Russare* (The Instructions are to Snore), Sardou's *Fedora*, Montepin's *La Portatrice di Pane*, and Dumas fils's *La Moglie di Claudio*. She also played Magda in *Casa Paterna*, Leonora in Sudermann's *L'Onore*, Gemma in *La Jena del Cimitero*, Atta in Cossa's *Nerone*, and Luisa in *Le Due Orfanelle*.

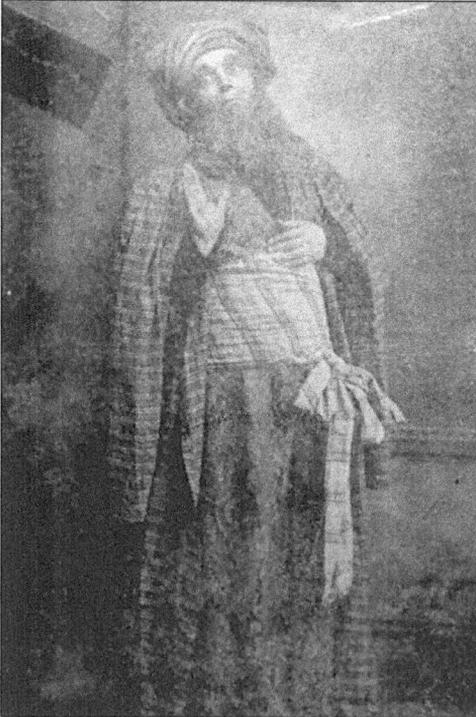

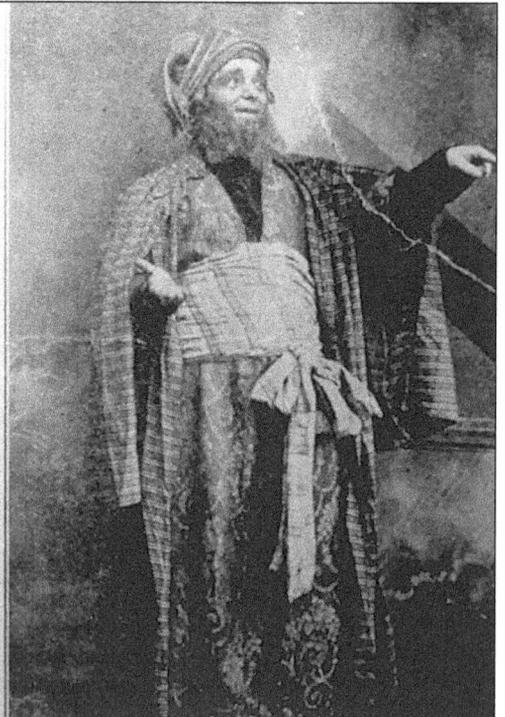

When, in 1906, Maiori played Shylock in Shakespeare's *Il Mercante di Venezia* (*The Merchant of Venice*) at the People's Theatre (formerly the Windsor Theatre) at 43-47 Bowery, Yiddish actor Jacob P. Adler was performing his Shylock at Proctor's New Fifth Avenue Theatre on 28th Street. The critics couldn't resist the inevitable comparisons; there was much racing back and forth to catch one act uptown and another downtown to review both stars.

Antonio Maiori and Concetta Arcamone resided at 190 Grand Street between Mott and Mulberry Streets in 1902. Giuseppe (sometimes "J.") Maiori, the photographer who took many pictures of not just Maiori and family, but of other stars of the Italian immigrant theatre and vaudeville, also lived in the building. The Maiori family probably shopped in Francesco Alleva's store on the ground floor for liquors, candy, and cheese.

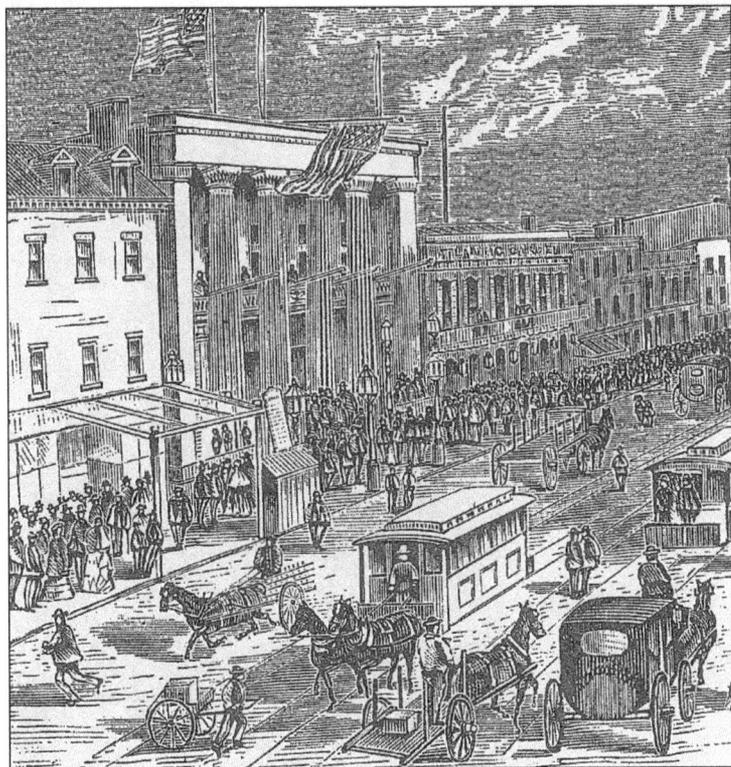

The Bowery Theatre at 46-48 Bowery, c. 1876, was renamed the Thalia Theatre in 1879. Maiori performed here. The journalist Giuseppe Cautela observed it firsthand: "The massive columns at the entrance give the impression that a revolution has been fought around them. Time and the hand of man have written legends that speak in huge black and gray patches like blows received in heroic combats." Italians also performed next door at the Atlantic Garden. Both houses sat 2,000.

On Monday, April 21, 1902, Maiori staged the biographical drama *Benevenuto Cellini* by Paolo Meurice at the Windsor Theatre, located at 43-47 Bowery. Maiori was discovered by New York's affluent social elite; Owen Kildare, in *The New York Herald*, recounts how artist William Sartain "just for a diversion and a 'lark' got up a party of society folk to go down in the slums…. Mrs. [H.O.] Havemeyer and some sixty or seventy of her friends went to see Maiori perform…. The play was a seven act drama, given with wretched scenery and costumes and a very poor supporting company, besides being played in Italian, a language which not more that one in twenty of the party understood, probably, yet the genius of this poor Italian held them so thoroughly that they sat breathless until after one o'clock in the plain Bowery theatre."

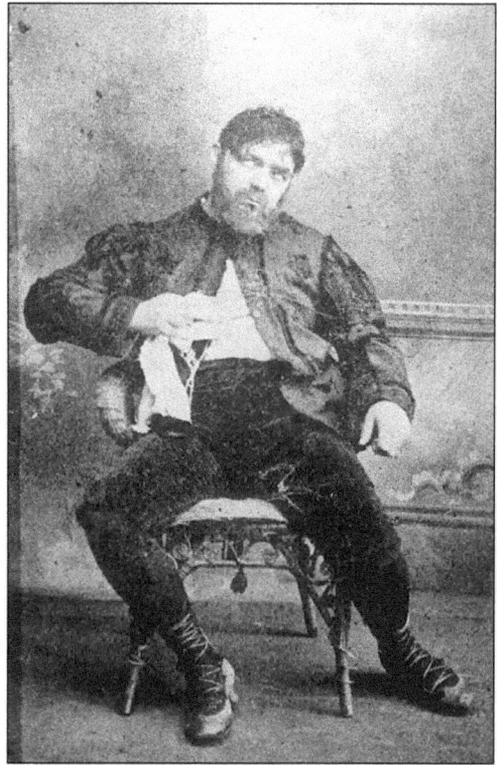

Here, Maiori plays the title roles of *Lo Spagnoletto* (The Spaniard) by M. Cuciniello and *Kean ovvero Genio e Sregolatezza* (Kean or Genius and Disorder) by Alexandre Dumas, pere. For about a year, going to the Bowery to see Maiori perform plays such as these was the novelty of the famous Four Hundred. "Mrs. Havemeyer and her friends say he is the greatest tragedian in the world." He was called "Salvini of the Bowery" in the press, after the Italian tragedian Tommaso Salvini, who had made American tours and was familiar even to the American theatre-going crowd. Among Maiori's fans at the time were Mr. and Mrs. Richard Hunt, Mr. and Mrs. J. Wells Champney, Mr. and Mrs. Edwin M. Blashfield, Mr. and Mrs. Thomas Shields Clark, Mr. and Mrs. John Eldeskin, J. Alden Weir, and W. Marion Crawford, the son of the famous novelist.

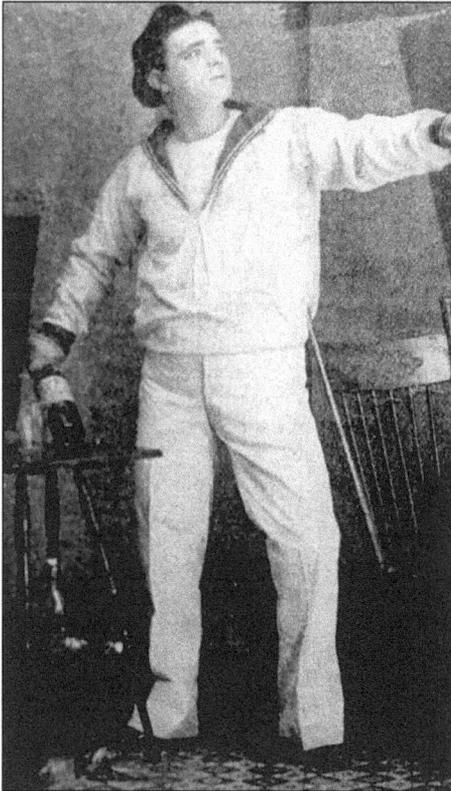

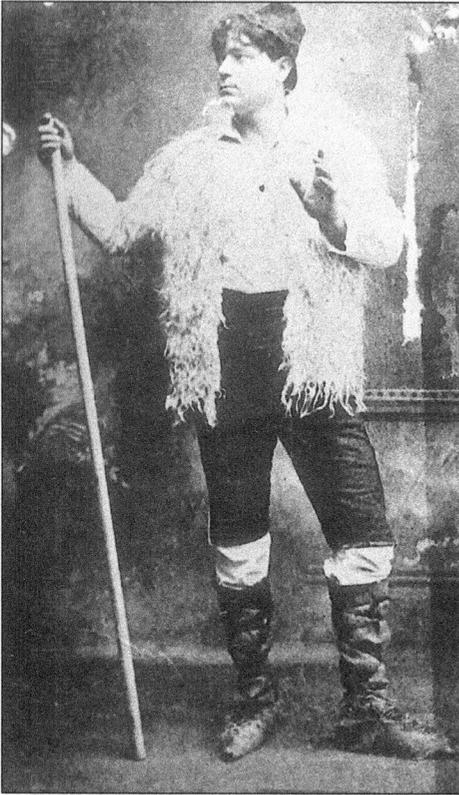

Maiori, costumed as a shepherd, produced and starred in the New York premiere of Gabriele D'Annunzio's intense drama, *La Figlia di Jorio* (The Daughter of Jorio), which was so well received that an American producer arranged a tour for the vehicle through several Eastern states in 1905, including Connecticut, Massachusetts, and New Jersey. The Newark periodical *L'Ora* noted: "None other than Mr. Antonio Maiori is capable of preparing such a difficult work, and of achieving such success."

Built in 1886, Webster Hall, located at 119-125 East 11th Street between 3rd and 4th Avenues, was another theatre occupied by Maiori and other Italian companies. Here, Maiori mounted the spectacular historical drama *Quo Vadis*, which had six acts, 11 scene changes, period sets and costumes, and a masked ball with prizes afterwards for the best costumes, on February 1, 1905. In the 1920s, playwright Eugene O'Neill called the theatre "The Jewel of the Village."

Silvio Minciotti was born "Francesco" at Citta di Castello, Perugia, in 1882 and immigrated to New York in 1896. He started with the Maiori-Rapone Company at the Spring Street Teatro Italiano in 1900 as Carlo in *La Jena del Cimitero* (The Hyena of the Cemetery) and Odoardo, son of Elizabeth the Queen, in *Riccardo Cuor Di Leone* (*Richard the Lionhearted*). In 1909, he joined Maiori's U.S. tour arranged by Edwin Balkin.

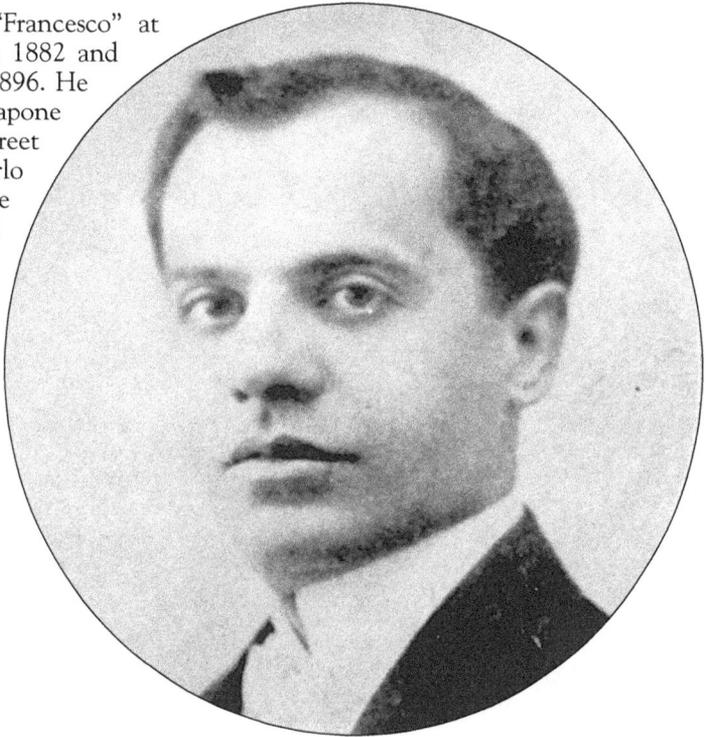

Maiori's major efforts during the spring of 1905 were fund-raisers for the construction of an Italian theatre, for which he staged benefits at the London Theatre and Webster Hall. Antonio Ferrara, of Ferrara's Caffe at 195 Grand Street, supported Maiori in this project. Ferrara was a very active community member; he served as president of the Italian Barbers Supply and Perfumery Company and chairman for the Festival of the Tiro a Segno Nazionale Italiana.

In 1903 and 1904, under Maiori and Rapone, 138 Bowery was called by the generic Teatro Italiano or the Drammatico Nazionale. The company of Francesco Vela and Enrico Costantini also played there in 1903, as did the amateur group, Il Circolo Bellini in 1904. The Drammatico Nazionale closed operations in January 1904 to implement alterations to correspond to the new city fire regulations. Shortly before the closing, a fire started in a pharmacy and spread to the People's Theatre at 199-201 Bowery, nearby. The Drammatico Nazionale was supposed to reopen in a week, but Maiori didn't perform again for a month. Not long after, Maiori put on his last shows at the theatre, for reasons unknown; they were probably financial. Currently, the Chinese Musical and Theatrical Association occupies the building.

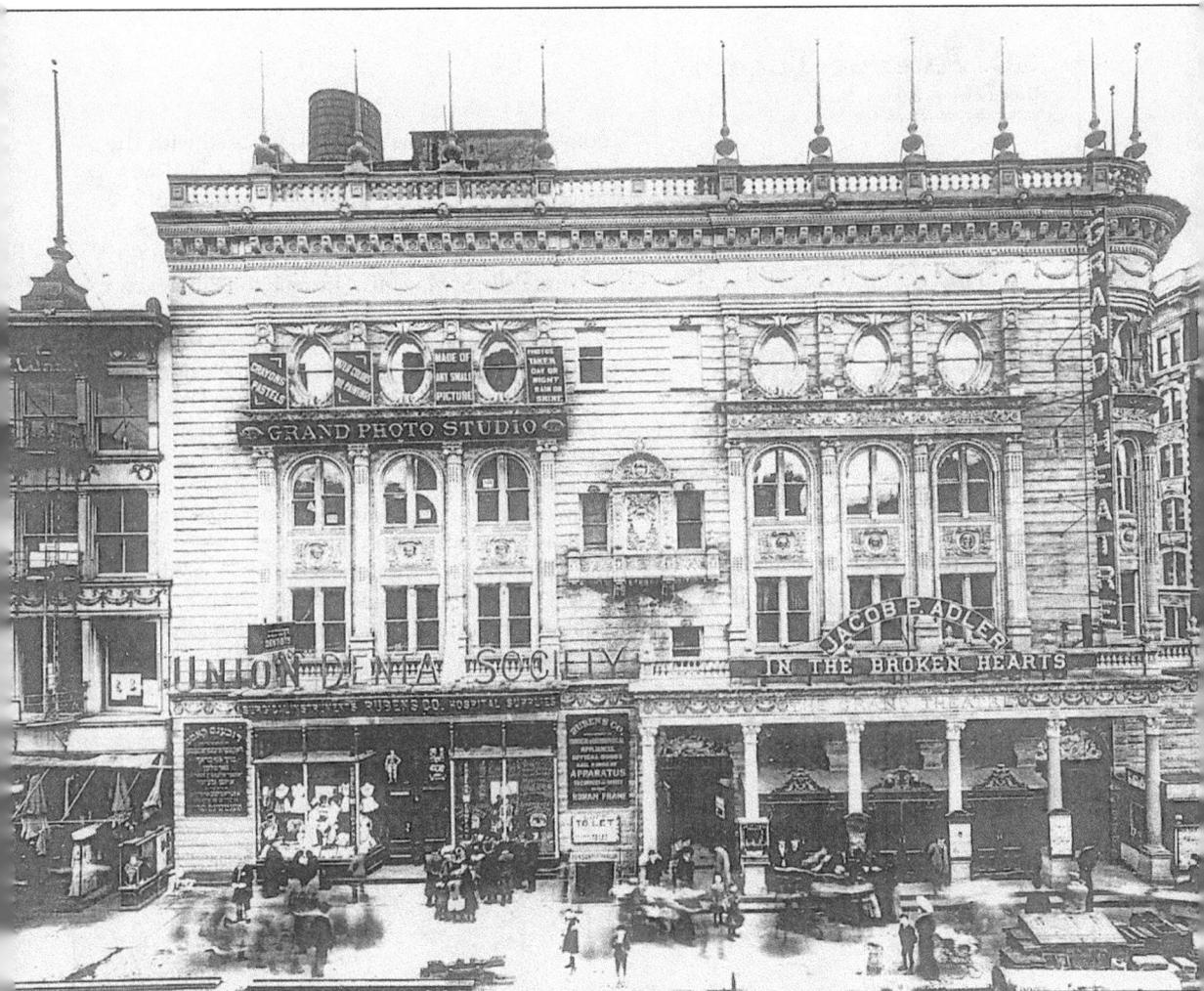

The Grand Theatre is located at 255 Grand Street at Chrystie Street. Antonio Maiori put on theatre there after he left the Teatro Italiano-Drammatico Nazionale. In later years, other Italian-American stars would appear here, such as Eduardo Migliaccio in 1929. Antonio Ferrara and Tony Bacarozi also collaborated on Italian opera production at the Grand Theatre. In 1903, Maestro Salvatore Avitabile, who ran a music school on East 16th Street where he taught music and theatrical art, was co-director of La Compagnia Lirica Italo-Americana (The Italian-American Lyric Company) with Salvatore Nunziato in the production of opera at the Grand Theatre. Avitabile directed the orchestra. In the picture, the Yiddish actor Jacob Adler is currently appearing at the Grand. Maiori and Adler had a symbiotic relationship in the theatre; they would share the theatre using the same sets and costumes and perform the same plays; Italians performed when the Yiddish actors did not. Billboards for such productions were half in Italian, half in Yiddish. The actors in both ethnic theatres would go to see each other's shows on their off hours.

5th Avenue Theatre
Broadway e 28.ma Strada, New York

Giovedi 16 Gennaio 1936

LA

Lega di Miglioramento fra gli Artisti della Scena, Inc.

PRESENTA

Il Primo Grande Spettacolo di Gala

★ DRAMMA

★ COMMEDIA

★ VARIETA'

★ FARSA

Questo spettacolo di eccezionale importanza è l'evidente dimostrazione della fede e dell'entusiasmo che ha riuniti tutti gli Artisti Italiani sotto l'istessa bandiera.

Noi portiamo un sentito ringraziamento a tutti i frequentatori dei teatri italiani, a gli abbonati del nostro giornale "IL PALCOSCENICO" a tutti quelli insomma, che seguendo con simpatia il nostro movimento, l'appoggiano in una forma o nell'altra e che perciò sono da noi considerati "Gli amici dell'Arte."

IL CONSIGLIO

Today's Italian Actors Union (affiliated with the Associated Actors and Artistes, AFL-CIO) was started in 1933, largely through the efforts of Antonio Maiori and other theatre impresarios. The original name was *Lega di Miglioramento fra gli Artisti della Scena, Inc.* (League for Progress for Theatre Artists, Inc.); they had offices at 1697 Broadway between 53rd and 54th Streets. All the major performers were involved in the endeavor: the Aguglia-Cecchini family, Gennaro Cardenia, Giuseppe Sterni, Silvio and Ester Minciotti, Aristide Sigismondi, Ralph Manfra, many of whom would become future presidents of the organization. Its jurisdiction includes Italian language dramatic and musical productions. Their first gala show took place Thursday, January 16, 1936, at the 5th Avenue Theatre on Broadway and 28th Street; it featured practically the entire professional theatrical community of the period. The *Lega* also published a journal titled *Il Palcoscenico* (The Stage).

The Maiori Theatrical Enterprises took a new direction, although not what Maiori had hoped. The glorious new season for which Maiori had been waiting arrived; he was performing private dramatic readings in Italian in theatres which Mrs. Havemeyer and friends had built in their homes. Affluent New Yorkers rented the Carnegie Lyceum for a week in March 1903. After this run, no more was heard of the famous 400, and Maiori embarked on a new venture. La Compagnia Antonio Maiori debuted at Ferrando's Music Hall at 184 Sullivan Street in Greenwich Village in September. In the nightclub arena, the emphasis was not on plays alone, but variety shows. By 1915, he completely abandoned the Italian prose theatre and went into the variety theatre business exclusively. His business manager, Nino Ricciardi, whom Maiori raised, was the son of Concetta Arcamone and Guglielmo Ricciardi.

THE FOUNDER OF THE ITALIAN THEATRE IN AMERICA

MAIORI

THEATRICAL ENTERPRISES

ANTONIO MAIORI GENERAL DIRECTOR

NINO RICCIARDI, Business Manager

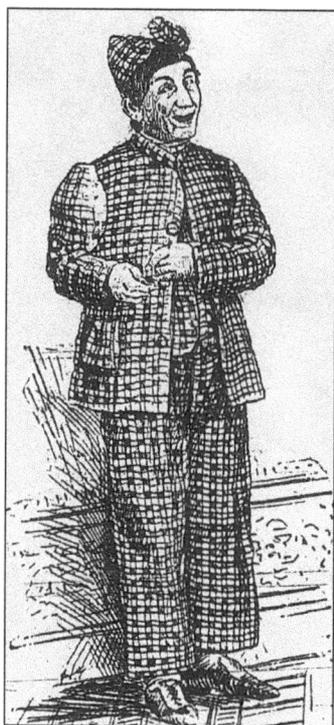

Pasquale Rapone, in his checkered suit, interpreted the role of the Italian stock character Pascariello. The name means "Little Pasquale" and derives from the Commedia dell'Arte mask, Pasquariello Trunno, who, according to Pierre Louis Duchartre, "belonged undoubtedly to a variety of Captains, acrobats, and dancers in vogue during the sixteenth century. They all wore swords. 'Trunno' means 'terrible.' He was a tight-rope performer and acted as valet or double for Scaramouche and Scapin."

Concetta Maiori continued to act with the company when she was not pregnant, as in this picture, with one of the 19 children she bore. Eventually, she left the theatre to care for her large family. In later years, she and Maiori separated. Antonio Maiori, the giant actor/director/manager of the Italian-American stage from 1900 to 1905, drifted further and further away from the immigrant community that spawned his most significant work.

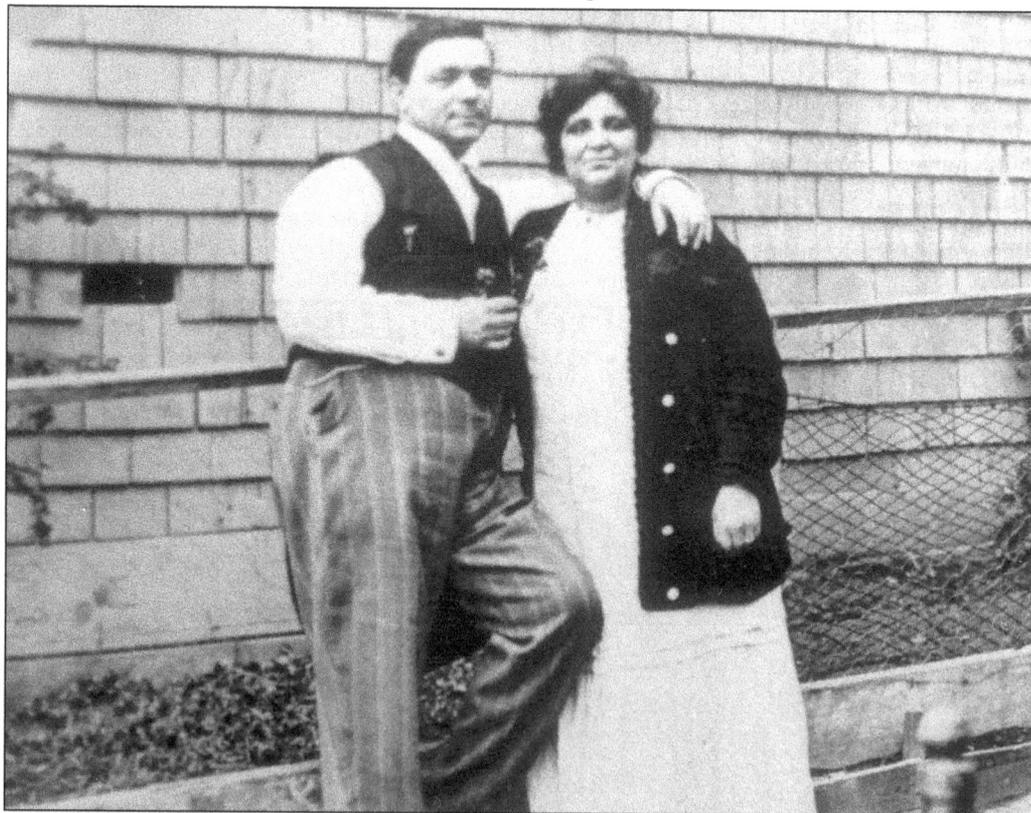

In 1907, Maiori joined Marcus Loewe in producing Shakespeare at Brooklyn's Royal Theatre. In 1909, Edwin Balkin arranged a U.S. road tour, after which he remained in Chicago for two years. Returning to New York, he produced variety theatre unsuccessfully. After traveling to Italy in 1919, he was back by 1927. When he died of pneumonia at age 69, in 1938, he was vice-president of the Federazione Attori Italiani (Federation of Italian Actors.)

RICCARDO CORDIFERRO
(Alessandro Sisca)

POESIE SCELTE

EDIZIONI PUNGOLO VERDE - CAMPOBASSO
- 1957 -

Maiori's repertoire was essentially classical, but he did produce his share of original Italian-American writers, including the best-known and most prolific playwright, poet, lyricist, journalist, publisher, editor, satirist, lecturer, and political activist of this era—Riccardo Cordiferro. Cordiferro was born Alessandro Sisca on October 27, 1875, in San Pietro in Guarano, Cosenza province. In 1886, he entered a seminary but left the religious life for a career in letters.

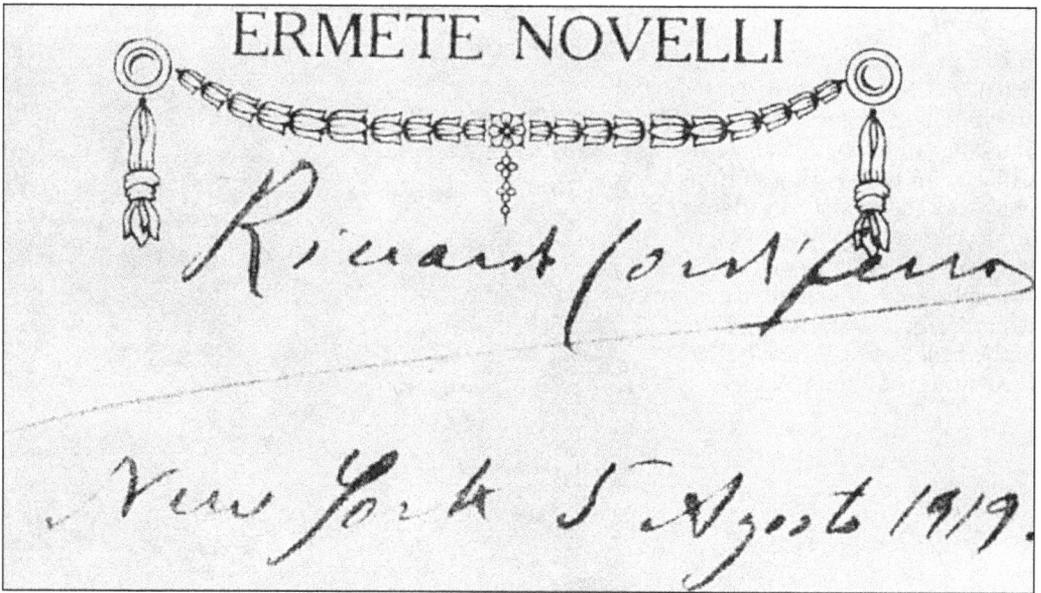

ERMETE NOVELLI

Ricardo Cordiferro

New York 5 Agosto 1919.

In Naples, Cordiferro published his early poetry, assuming the pen name of Riccardo Cordiferro (which means Richard Heart of Iron). It all but supplanted his real name in the literature and politics of this period. In 1892, he immigrated to the U.S., and in January 1893, together with his father and his brother, Marziale, he founded the literary newspaper *La Follia* in New York City. The paper was widely read, not only in New York, but also by the literati of the Italian colonies in major eastern cities. Through his plays, literary articles, and political commentary, which usually expounded socialist doctrine, the name of Cordiferro was familiar to literate Italians from New Jersey to Vermont. He was invited out of town frequently to give lectures. The intense socialist views in his speeches to labor organizations and political rallies sometimes landed him in jail.

LA FOLLIA DI NEW YORK. LA TROMBA
LA SENTINELLA GAZZETTA DEI LAVORATORI ITALIANI · LA GAZZETTA DEL MASSACHUSETTS 169
L'INTERNAZ... La Gazzett...

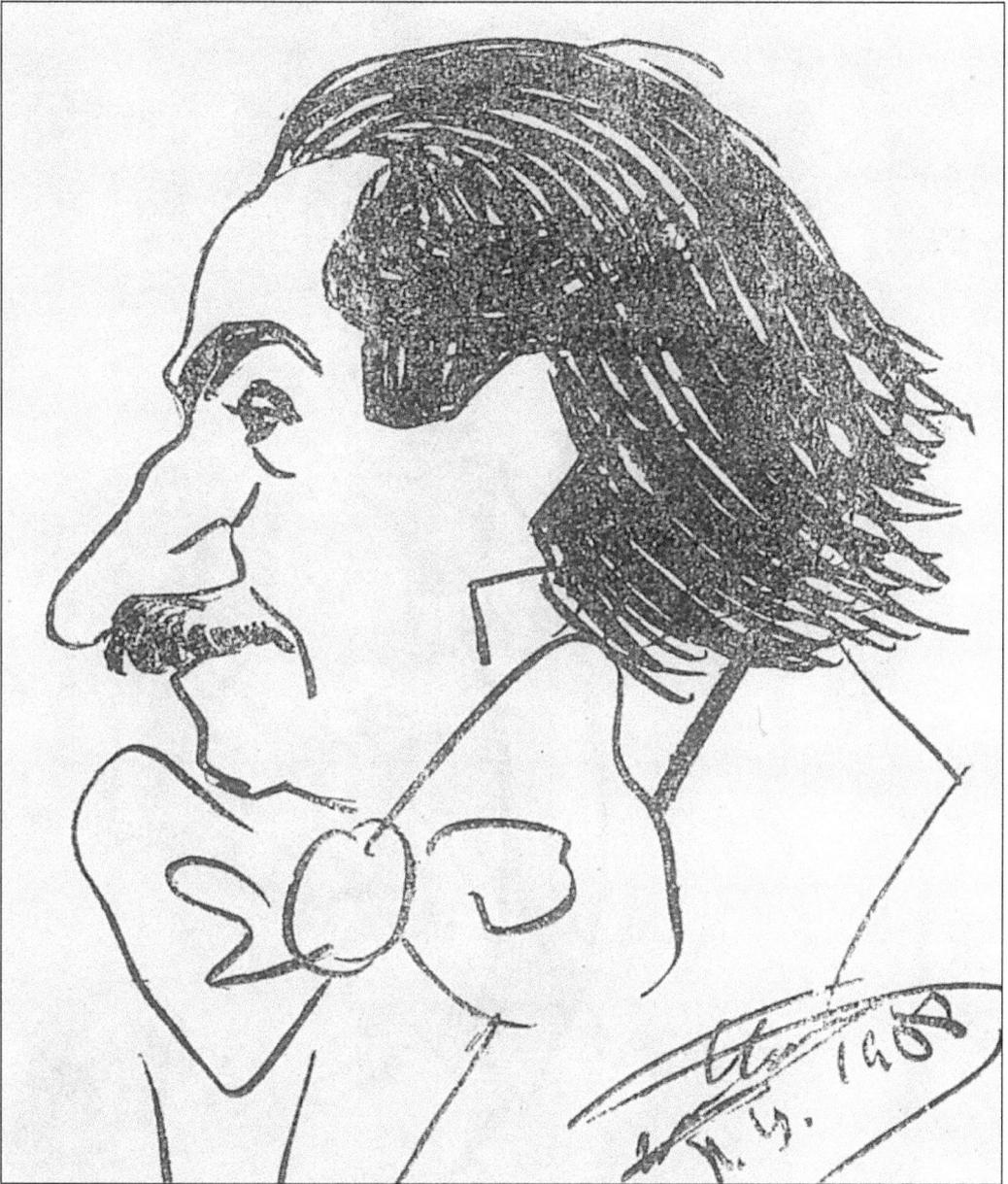

Enrico Caruso created this caricature of Riccardo Cordiferro. Caruso was a good friend and often dined with the Siscas. Caruso had an arrangement with Marziale Sisca to send him a caricature weekly, even when on tour, and Marziale would publish it in *La Follia*. Caruso drew caricatures of many famous people. Some of the most charming are those he drew of himself. Thanks to *La Follia*, they still exist.

The building located at 149 Mulberry Street between Hester and Grand Streets, an example of Federalist merchant house architecture, was the home of Stephen Van Rensselaer in 1816. The first floor was a shop. In 1903, it became the Italian Free Library, where Cordiferro undoubtedly spent time. The library was open Monday through Saturday from 10 a.m. to 10 p.m. and Sundays from 11 a.m. to 4 p.m. Its president and librarian were both Italians.

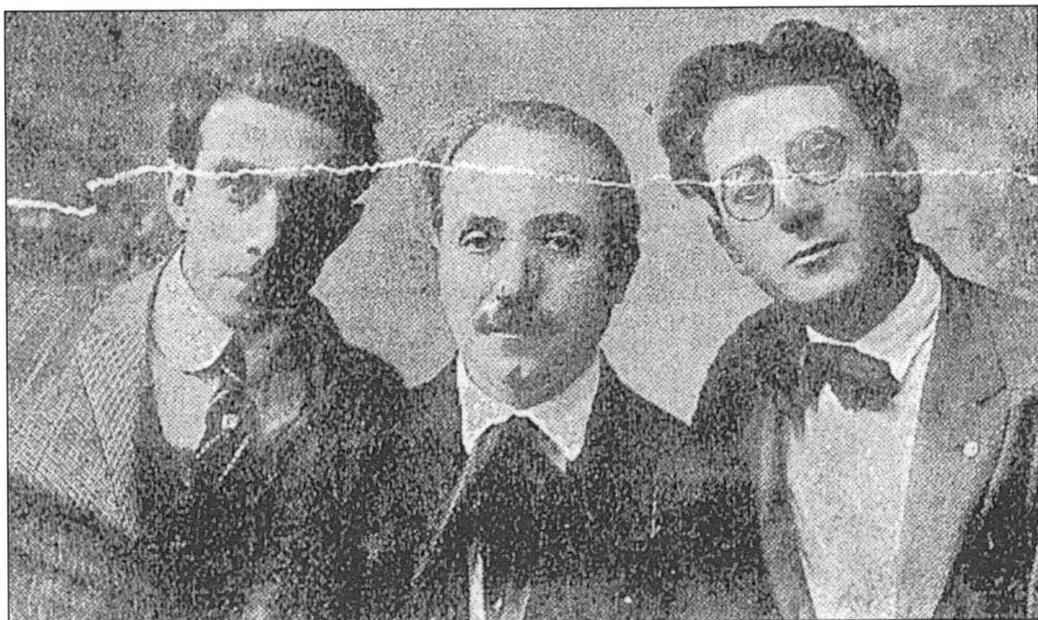

Riccardo Cordiferro is flanked by two actors, Armando Cenerazzo and Scipio Di Dario. Di Dario performed with La Compagnia Comico Drammatica Italiana of Gennaro Ragazzino. Cenerazzo was born January 3, 1889, in Naples. He worked with Mimi Aguglia in Florida in 1926. *La Follia* published his songs in the Neapolitan dialect. He acted on Italian-American radio stations WBNX, WOV, WHOM, and WMCA. He was also the director of the Teatro Italia, the former Comedy Theatre on West 41st Street.

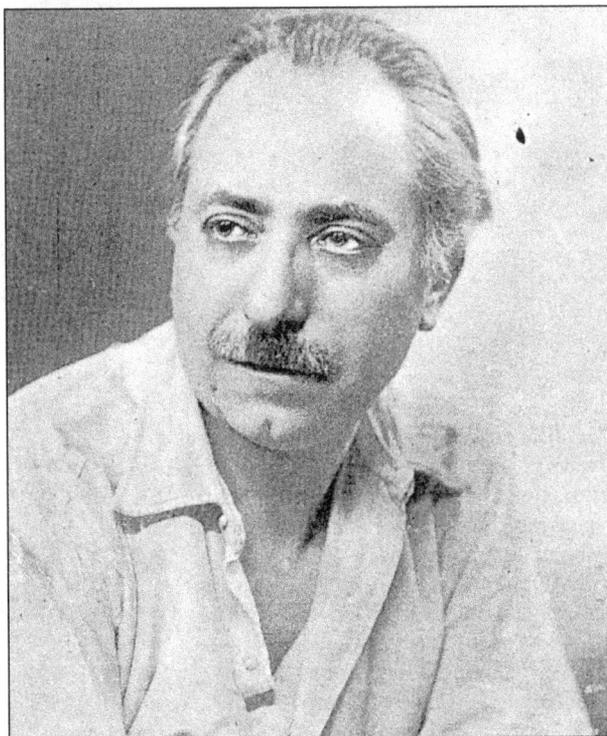

When Cordiferro wanted his own plays heard, he picked the most reputable professional company at the time—the Maiori-Rapone-Ricciardi troupe. Maiori mounted Cordiferro's first plays in 1894 at the Germania Assembly Rooms: *Mbruoglie 'e femmene* (Feminine Intrigues), a one-act comedy in the Neapolitan dialect, and *Il genio incompreso* (The Misunderstood Genius), a one-act comic skit in verse. The latter was a satire on the immigrant theatre.

'O RITORNO D'A GUERRA

Dramma napoletano in un atto

DI

RICCARDO CORDIFERRO

Stampato a cura de
"LA FOLLIA DI NEW YORK"
410 Lafayette Street
New York, N. Y.

Cordiferro's Neapolitan drama in one act, 'O Ritorno d'a Guerra (The Return from the War) was published in 1928 by La Follia's publishing house, which published not just the newspaper, but much of Cordiferro's work. He wrote lyrics for the Italian song "Cor 'Ngrato" (Ungrateful Heart) popularized by Caruso and recorded by countless Italian singers. His controversial four act social drama L'Onore Perduto (Lost Honor) was staged many times in the East.

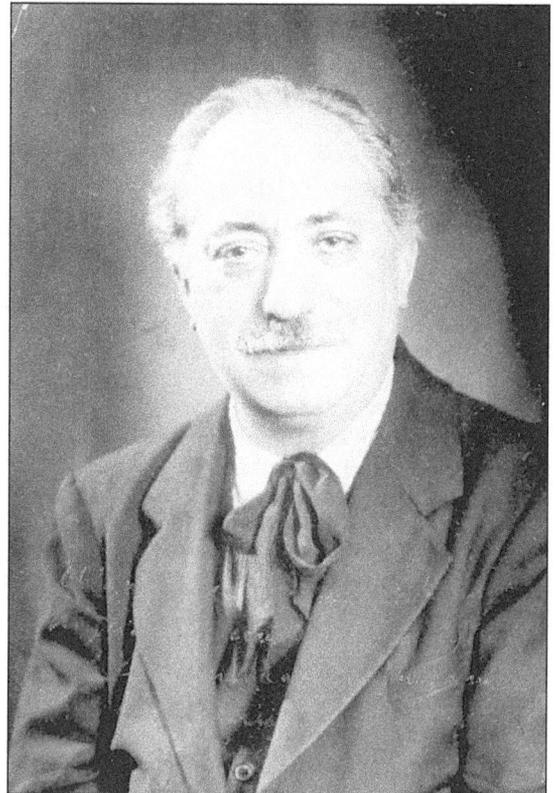

Because of his versatile literary and dramatic activities, Cordiferro remains the most important playwright to emerge from the early Italian-American theatre. He enjoyed wide popularity not only in New York, but also in other regions. In his final years, he fell on hard times. On August 24, 1940, Alessandro Sisca, alias Riccardo Cordiferro, "the Singer of the Red Muse," succumbed due to poor health, probably brought on by the hardships of the Depression.

Four

THE LEGACY ENDURES

Following the pioneering efforts of figures like Fausto Malzone, Guglielmo Ricciardi, Antonio Maiori, and Riccardo Cordiferro, a second generation of actors, writers, and directors carried on the legacy of the Italian immigrant theatre. Of all the Maiori children, Marietta Maiori (pictured here), the daughter of Antonio Maiori and Concetta Arcamone, was the one that carried the gauntlet highest. Toto Lanza, the editor of *Strenna Miluccia*, describes her: "She is the hereditary princess of the Italian prose theatre in America, but she is also our sweet, and good friend who shares with us the hours of our work, the many problems and the very few joys of the life of the stage. Nothing can be said of this intuitive creature that the public doesn't know, or that has not already been said. Not yet twenty years old, endowed with a rare sensitivity and a great intelligence, she has already covered so much ground on the road of art that she is destined for success and fame." Marietta regarded her father as her idol, who taught her everything about the stage. Marietta, also known as Maria Giovanelli, had a wonderful career on the stage as long as there was an Italian-American immigrant theatre in which to perform. She also worked on Italian radio. Marietta passed away in March 1999, just two months short of her 100th birthday and as this book was in preparation.

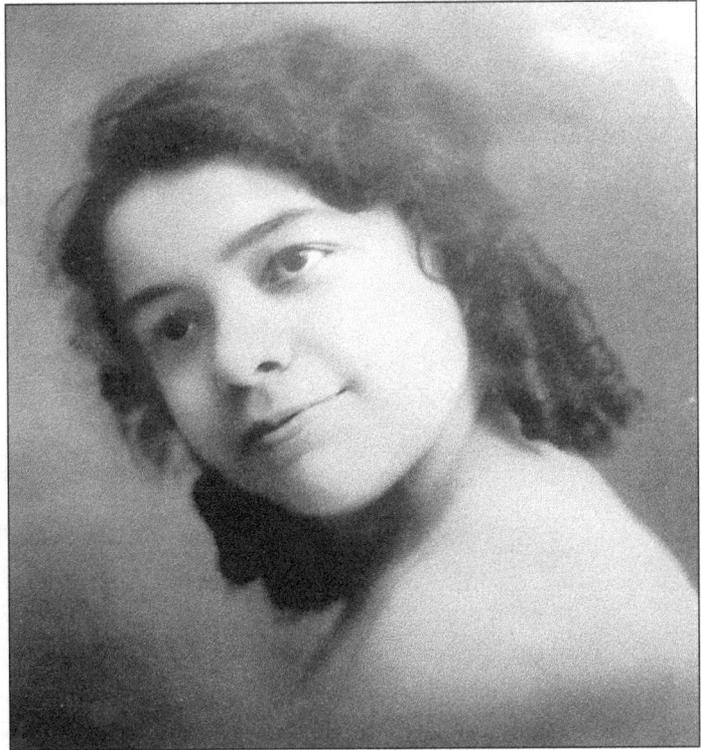

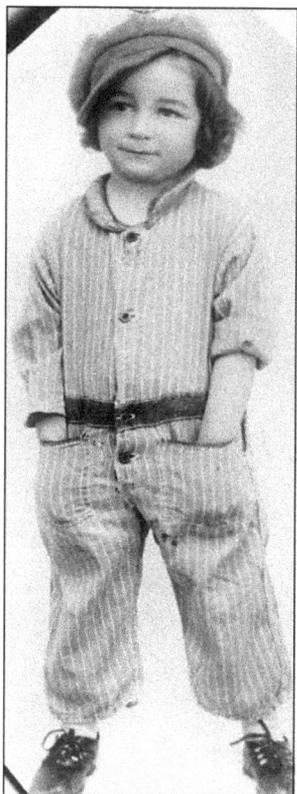

Marietta Maiori started out as a child actress with her parents, Antonio Maiori and Concetta Arcamone, and with the whole Maiori-Rapone Company. By the time she was born, Guglielmo Ricciardi had already left the company and was working in the American sphere. Marietta grew up playing all the children's roles in the Maiori repertory, including, as we see here, little boys as well as little girls. She made her debut on the Italian-American stage at 3 p.m. on Sunday, March 5, 1905, at the 1,800-seat London Theatre, located at 235-237 Bowery at Prince Street. She appeared with her father in the premiere of Nicola Misasi's dramatic work *Mastro Giorgio* (Master George). Marietta's show was repeated again at 8 p.m. that evening. Both performances were followed by another play, a comedy in the afternoon and a drama in the evening. Marietta was not quite six years old.

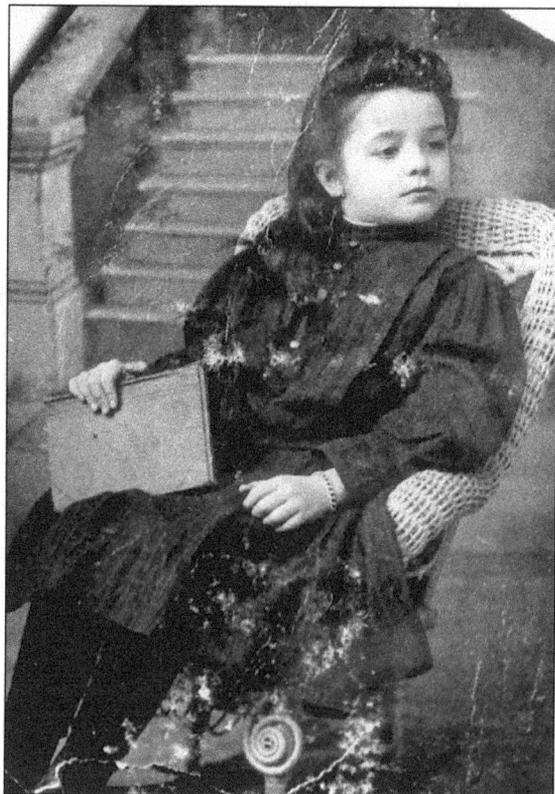

Marietta played the role of Suor Celeste (Sister Celeste) in *La Preghiera di Pompei—La Canzone della Speranza* (The Prayer of Pompei—The Song of Hope). This "sensational drama of faith and sublime martyrdom" in a prologue and ten acts was one of the many plays with religious themes, written and directed by Orazio Cammi, which starred Marietta. It played on radio, on the stage, and on the road.

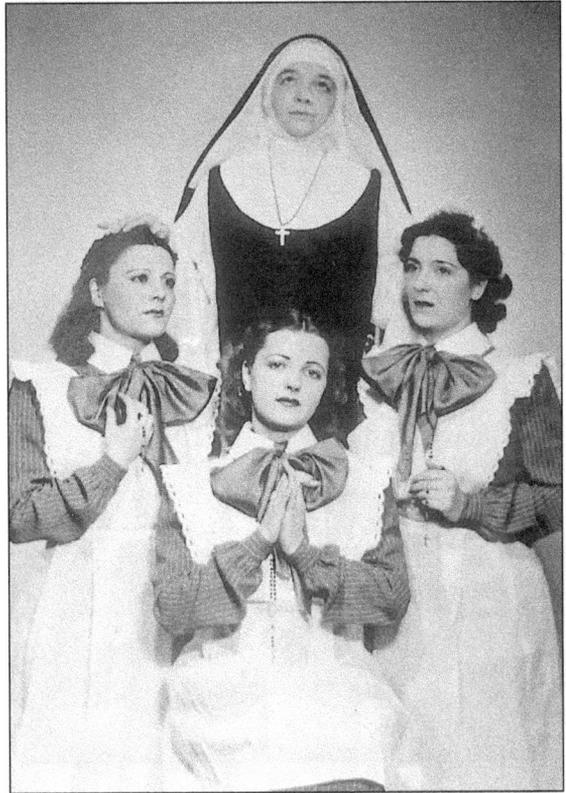

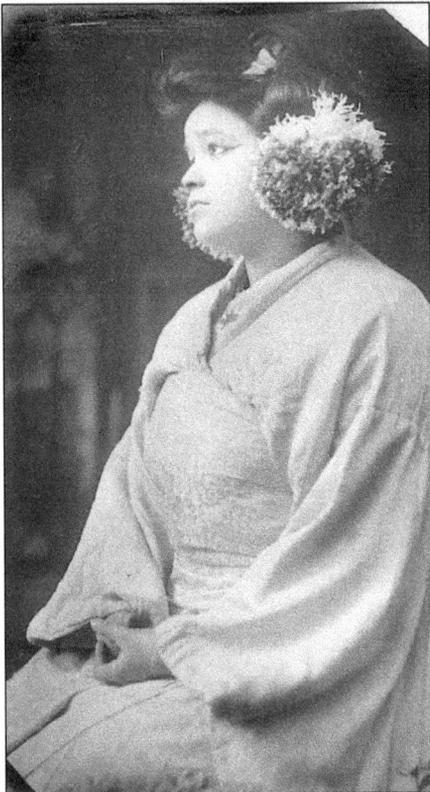

For Armando Romano's dramatic stage version in four acts of *Madama Butterfly*, Marietta played the role of Cho-Cho-San. Directed by Luigi Tancredi, the show promised big sets and period costumes. Marietta was joined by some familiar names: Gina Pozzi and Pasquale Rapone from the old Ricciardi days, and Francesco, now billing himself as Silvio Minciotti, in the role of Pinkerton. Attilio Giovanelli conducted the orchestra. This show also played out of town.

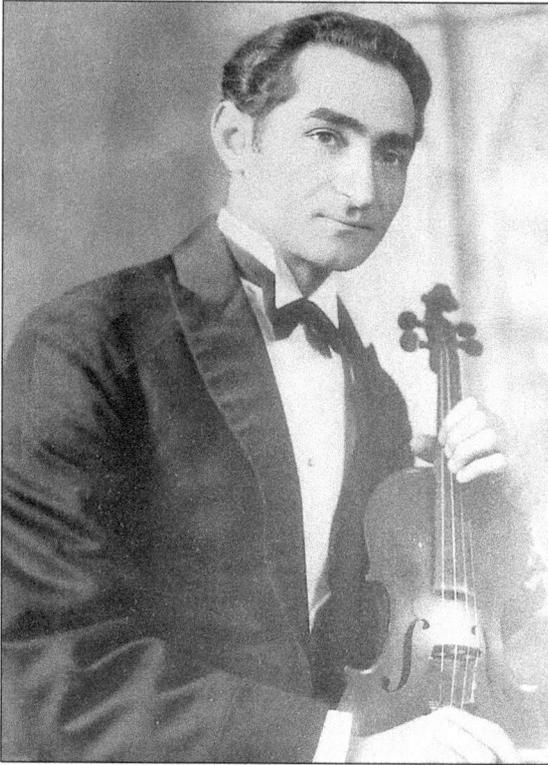

Marietta Maiori and Attilio Giovanelli, the distinguished violinist and concert master, were married Saturday, October 7, 1916, at the Church of the Most Precious Blood on Baxter Street in Little Italy. They had their reception and celebration at the Buona Vista Hotel in Bath Beach, Brooklyn. The newlyweds took up residence at 8778 Bay 24th Street, Bath Beach. They had three children: Arthur, Adele, and Olga. They were determined that their family should have a normal life, despite their own careers in the theatre. Their daughters, Olga and Adele, remember that their parents never encouraged their children to enter the theatre profession and that Marietta always made sure that her family's needs prevailed, regardless of her theatrical responsibilities.

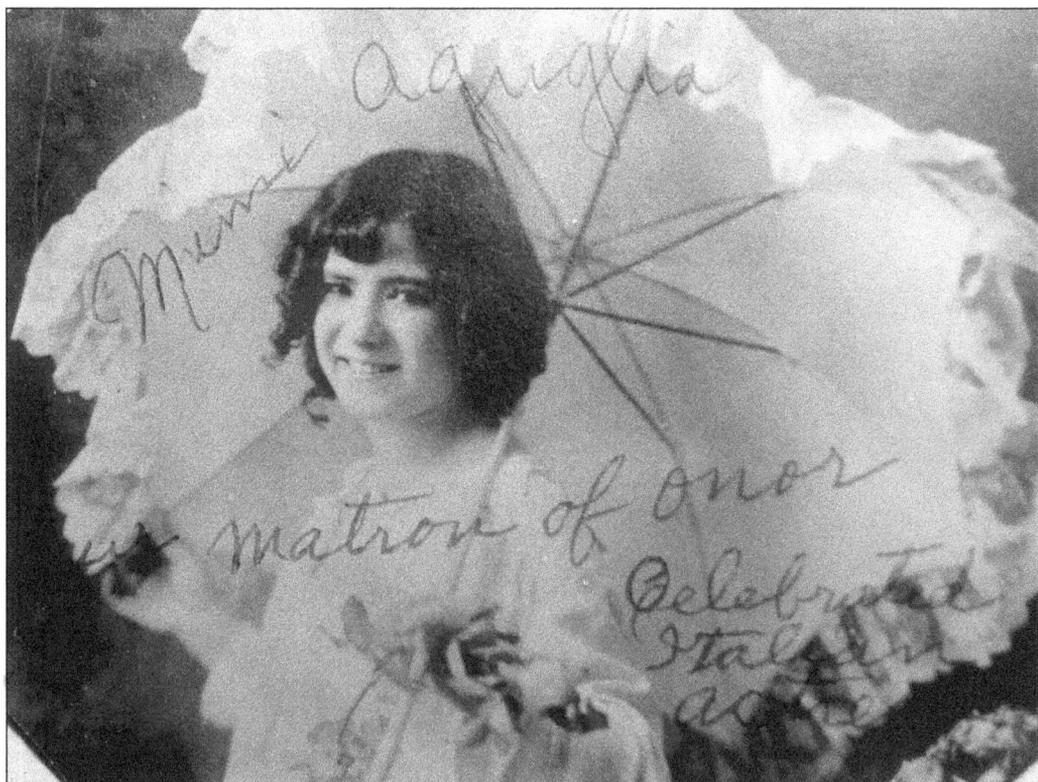

Mimi Aguglia served as matron of honor at the wedding of Attilio and Marietta. A well-known Italian actress, Mimi had emigrated from Italy to tour the States with the Italian tragedian Giovanni Grasso in their Compagnia Drammatica Dialettale Siciliana (Sicilian Dialect Drama Company). Because she disliked her stepmother, she brought her two younger sisters, Sara and Teresa Aguglia, and her one younger brother, Luigi Aguglia, along with her to the U.S.

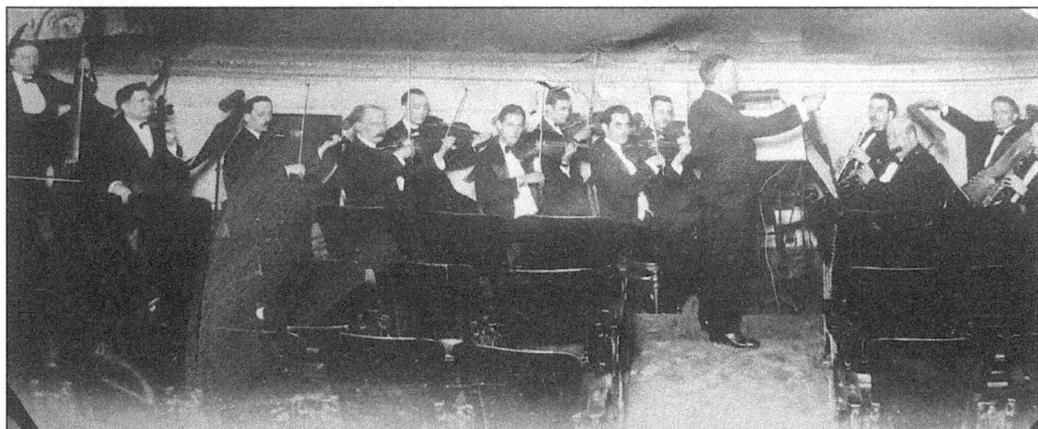

The orchestra shows Attilito Giovanelli in the front row, directly behind the conductor. Attilio was born in Italy and became a naturalized citizen in 1927. He wrote the music for the march "Nu riservista d'America" ("The American Reservist"), with lyrics by L. Napolitano, and sung for the first time at Maiori's Royal Theatre by the chanteuse Mrs. A. Bruno. Attilio was an "Honor Member" of the Associated Musicians of Greater New York.

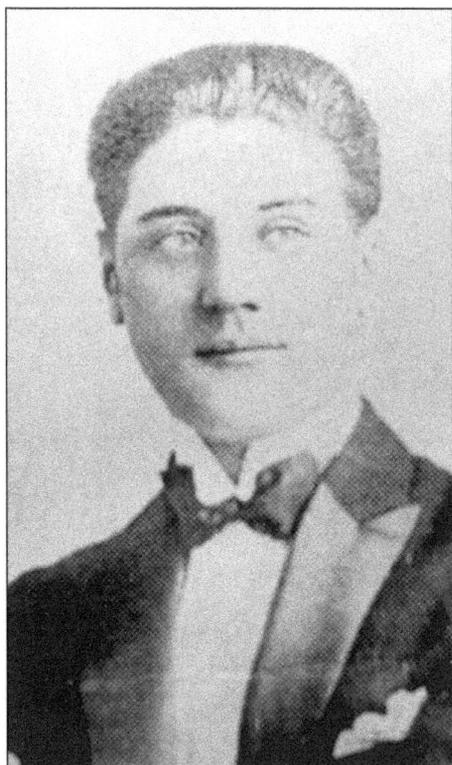

Luigi (also Louis) Badolati performed on the same bill with Marietta Maiori and Attilio Giovanelli at the Brooklyn Academy of Music on the occasion of a special performance by Marietta. She had been in semi-retirement and returned to recite scenes in Italian from her play repertoire. Luigi was a character actor and, because he spoke English very well, worked in American films. His brother Mario was also an actor and director.

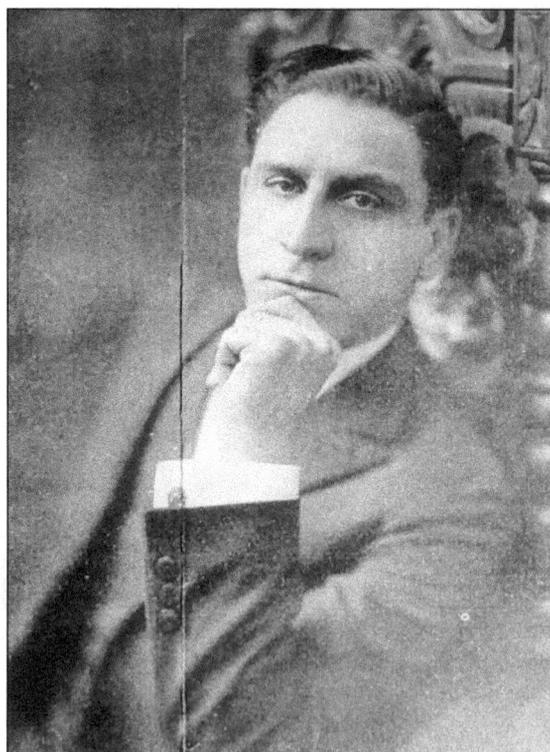

Nino (Antonino) Ricciardi, named after his paternal grandfather, was the son of Guglielmo Ricciardi and Concetta Arcamone. Nino, Guglielmo stated in his memoirs, was another reason he came back to the states after his unhappy departure for Sorrento. Nino grew up as part of the Maiori family and became the business manager for the Maiori Theatrical Enterprises.

Attilio Giovanelli was a working musician all his life, but he also performed in his share of benefits in the Italian-American theatre as well. He played violin in the orchestra or conducted and often prepared the orchestrations used for the musical portions of the show. He taught violin privately throughout the years; he also played violin on radio station WHOM. Maestro Professore Giovanelli passed away February 26, 1963, at the age of 70.

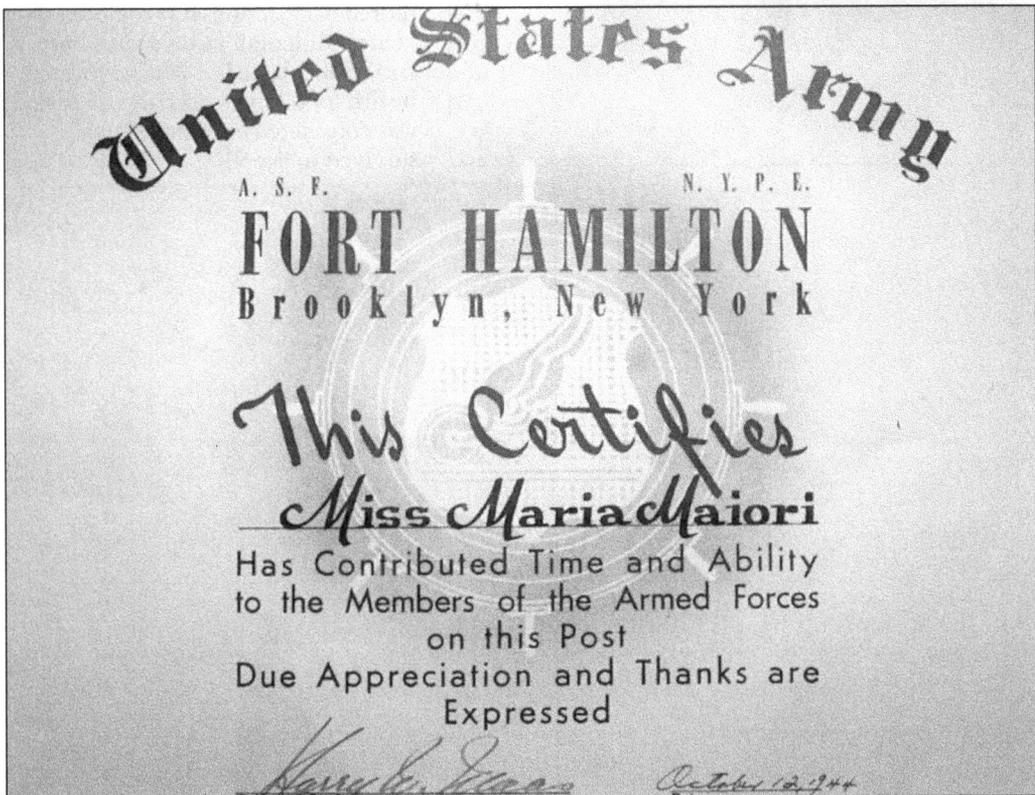

United States Army

A. S. F. N. Y. P. E.

FORT HAMILTON
B r o o k l y n , N e w Y o r k

This Certifies

Miss Maria Maiori

Has Contributed Time and Ability
to the Members of the Armed Forces
on this Post
Due Appreciation and Thanks are
Expressed

This U.S. Army certificate was awarded to Marietta and Attilio when they performed at the Fort Hamilton Armed Forces Post in October 1944, during WWII, after Italy had already joined the Allies. In 1942, however, with Italy at war with the U.S., Italians were interned as enemy aliens. Fingerprinting was required of broadcasters of Italian programs, as well as Marietta, who worked with the Orazio Cammi Company on radio station WOV.

In 1922, Mimi Aguglia toured with Giovanni Grasso to Chicago and California. Toto Lanza describes her in *Strenna Miluccia*: "She debuted in the art of theatre, almost accidentally, with the *Cavalleria Rusticana* (Rustic Chivalry) of Verga; she established herself with the *Figlia di Iorio* (Daughter of Iorio) of Gabriele D'Annunzio; she became well known with *Malia* (Witchcraft) by Capuana. Today, she is simply great. Mimi Aguglia, strong-willed and exquisitely good, deserves the fame she has acquired. Now she lives alone, near the sea, far from those who participated in her triumphs, almost lost, but entirely dedicated to study." She settled in California, worked in films, and eventually retired from acting. It is rumored that Henry Miller fell in love with her and wrote about her. She advocated health food long before the craze and was considered eccentric, but she survived to age 91.

Teresa Aguglia was also an actress. She was born in Sicily. Her mother, Giuseppina DiLorenzo Agulia, died when she was very young. When her father, Ignazio Aguglia, decided to remarry, her oldest sister, the actress Mimi Aguglia, took Teresa, the youngest, and her other siblings, Luigi and Sara, with her on tour. Gustavo Cecchini was the booking agent for the tour. Teresa and Gustavo met and married, though she was much younger than her husband. They eventually settled in New York, moved to California, then returned to New York and resided in Brooklyn. The Aguglia-Cecchini partnership created a multi-generational web of performers for the Italian-American Theatre. When Gustavo, Teresa, and Mimi traveled to California, Luigi and Sara stayed in New York and acted briefly. Sara married Carmelo Lizio, the bookkeeper for Gustavo Cecchini's theatre company. Luigi married Italian-American actress Gina DiAngelis.

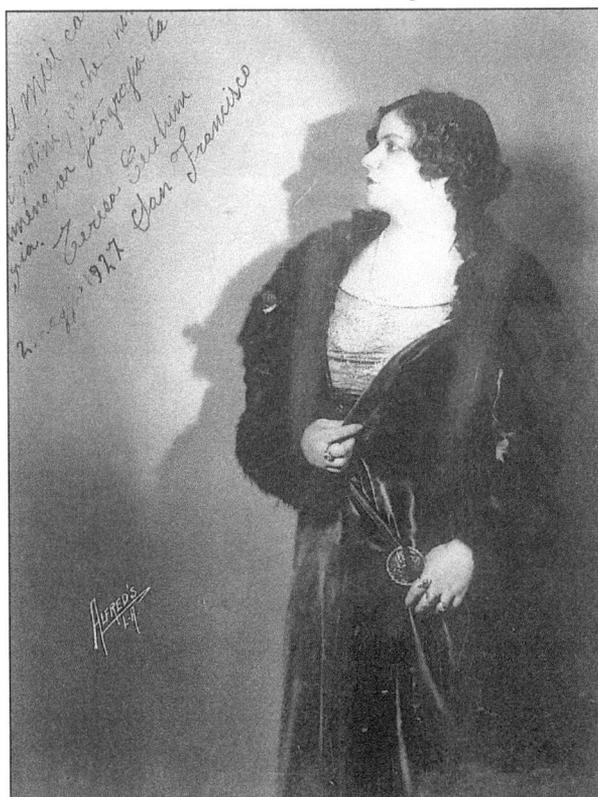

The union between Teresa and Gustavo Cecchini resulted in the formation of La Compagnia Drammatica Siciliana (Sicilian Dramatic Company) Aguglia-Cecchini. The company produced a staple of the Aguglia repertoire, the Sicilian drama in three acts *Malia* (Witchcraft), in the early 1900s at Maiori's Royal Theatre at 165-169 Bowery at Broome Street. Preceded by a vocal concert, it was billed as an "extraordinary spectacle" as a benefit for Mr. Carmelo Gargano. It featured Teresa in the role of Jana, Sara as Zza Pina, Luigi as Cola, and Toto Lanza (the editor of *Strenna Miluccia*) in the role of Massaru Paulu. Teresa continued to work in the Italian-American theatre and on Italian radio. Teresa's daughter Mimi Cecchini, named for her Aunt Mimi Aguglia, became a leading figure on the Italian-American theatre scene. Sara's children, Giannina, Mimi, and John, also became actors.

Clemente Giglio was born February 4, 1886, in Naples to Alessandro Giglio and Adele Gravieri. In 1891, they immigrated to New York City and lived at 246 Elizabeth Street. Don Alessandro was a magician/juggler in Italy, and earned a few dollars in the U.S. conjuring tricks in the bars and at community events. Clemente was the magician's assistant, but he preferred music. He sang all the Neapolitan hits in cafes and at festivals. At age seven, in 1893, he saw the Maiori-Rapone Company at the Germania Assembly Rooms and crashed one of their shows by playing the piano. He stayed with the company, playing the young boy roles. He had a long career in the theatre and on radio. In this satirical cartoon, he is refused entrance to heaven and threatens to make a formal protest on his next radio show.

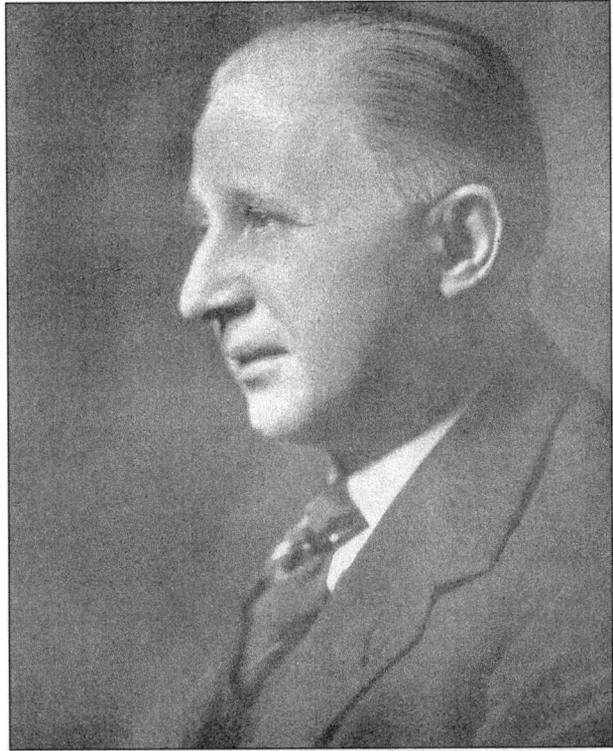

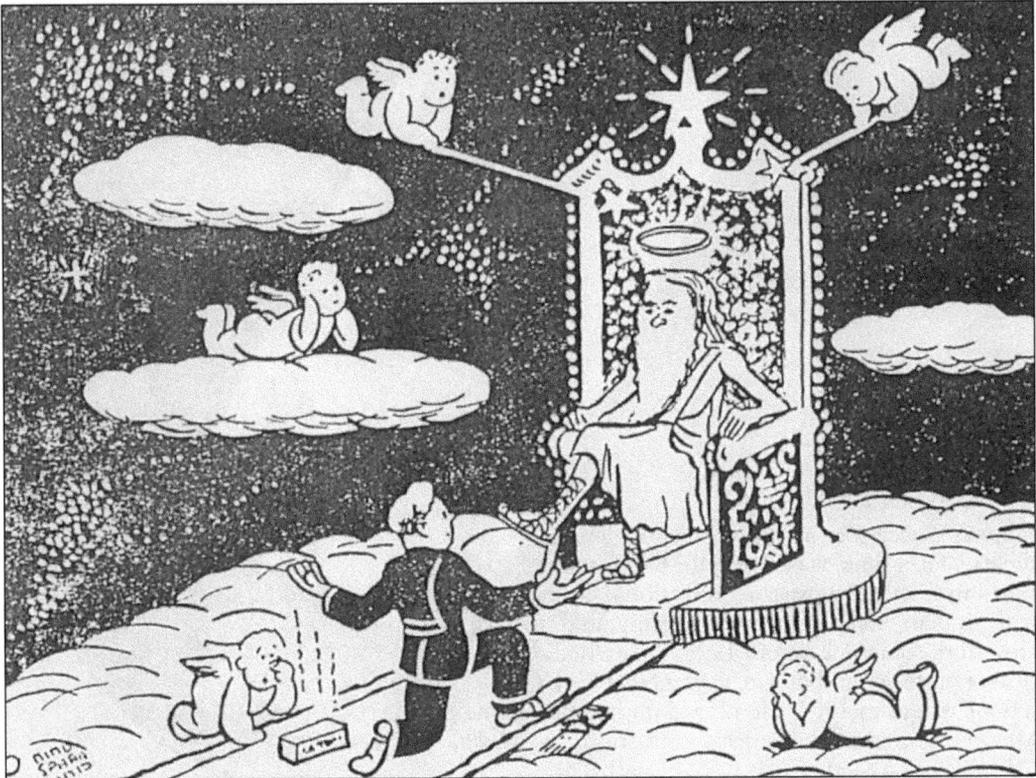

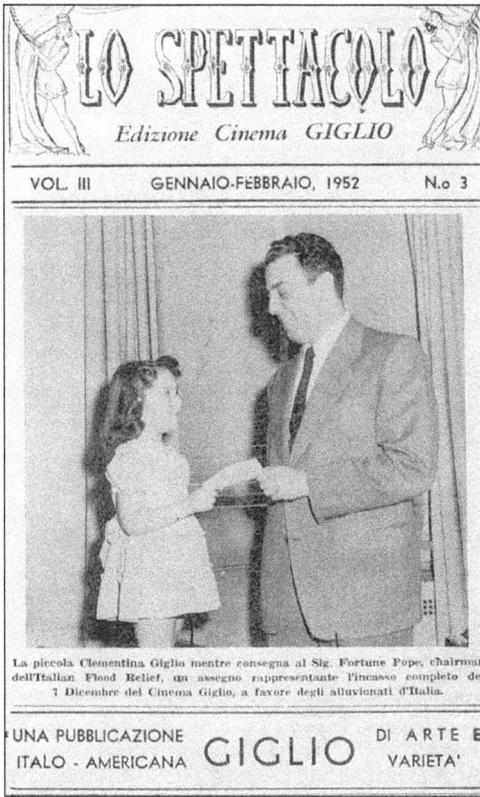

LO SPETTACOLO
Edizione Cinema GIGLIO

VOL. III GENNAIO-FEBBRAIO, 1952 N.o 3

La piccola Clementina Giglio mentre consegna al Sig. Fortune Pope, chairman dell'Italian Flood Relief, un assegno rappresentante l'incasso completo del 7 Dicembre del Cinema Giglio, a favore degli alluvionati d'Italia.

UNA PUBBLICAZIONE DI ARTE E
ITALO - AMERICANA GIGLIO VARIETA'

Clemente Giglio married actress Gemma Cunico (sister of Esterina Cunico Minciotti) in 1905. They eventually had two children, Sandrino and Adelina (stage name Perzechella), who performed an act together in the Giglio company, in vaudeville, and on radio. After Clemente Giglio died in 1943, his son Sandrino became director of Giglio Theatrical Enterprises and the Casolaro-Giglio Film Distributing Corporation. He ran the Cinema Giglio and published the movie journal *Lo Spettacolo*.

Maiori's successor in the dramatic prose theatre, for a time, was Giovanni De Rosalia. Born in Sicily, he was a professional actor with Italian companies, then immigrated to New York sometime before 1903. He earned the title of professor and taught in the New York City school system in 1904. He played minor roles with Maiori and starred in his own productions of *Othello*, *Oreste*, and *La Morte Civile* (Civil Death).

66

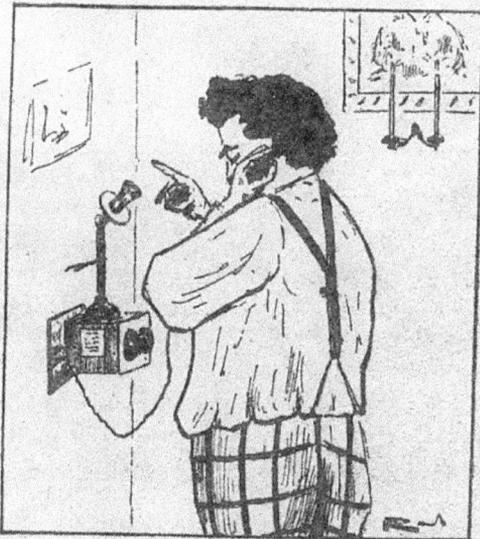

Although De Rosalia had limited success in the dramatic arena, Nofrio, the half-wit comic character he created, made him very popular and became synonymous with his identity. Nofrio wore shabby clothes, a large false nose, and no mask. Toto Lanza describes Nofrio: "At the forefront of a multitude of comedians, Giovanni De Rosalia is the only one who exhibits something striking and distinct: original appearance, powerful and harmonious voice, and an artistic nature all his own. A good-natured person, but precisely poised, he has advanced himself little by little, without posturing and without pretensions, overcoming a great difficulty, the greatest that is encountered on the thorny path of art: he was not the idol of a moment and he never passed out of style!" His farce *Nofrio al Telefono* (Nofrio on the Telephone) exploits the humor in the immigrant's confusion over the new invention.

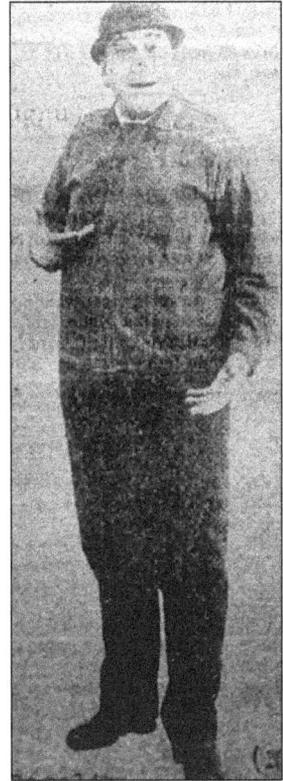

Nofrio al Telefono

Farsa di G. DE ROSALIA

Copyright 1918 by ITALIAN BOOK CO. — N. Y.

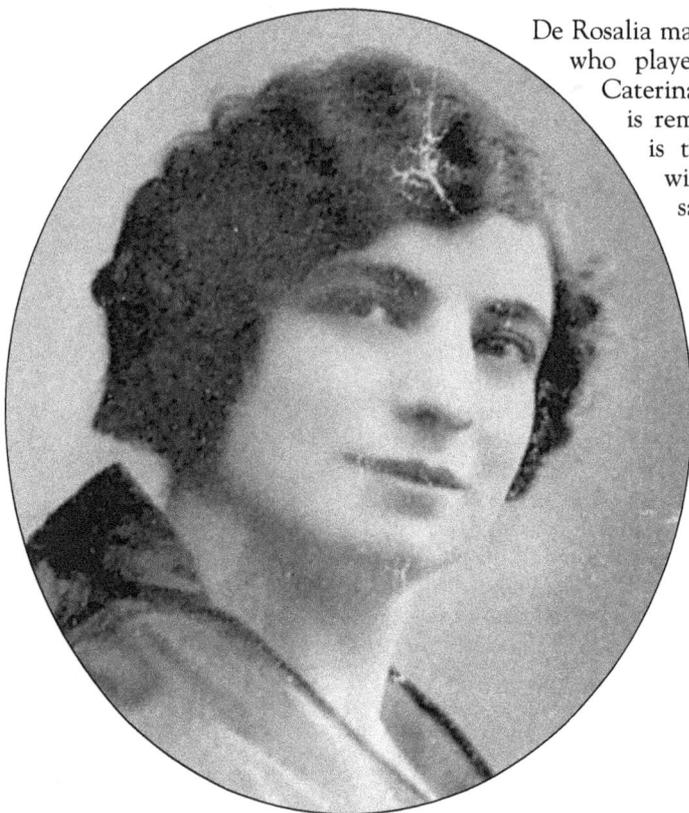

De Rosalia married actress Francesca Gaudio, who played Elisa to Marietta Maiori's Caterina in *Madama Sans Gene*. She is remembered by Toto Lanza: "She is the worthy companion of the wizard,—'Nofrio'—one might say a fairy, and in her voice, in her gesture, in her glance, it is always the wizard who speaks, him completely! She is young, intelligent, elegant, and succeeds marvelously whether in comedy or in drama."

De Rosalia wrote many farces. His own handwriting describes the requirements for his comedy in three acts, *Il Sindaco Don Calogero* (The Mayor Don Calogero): "Three valises—Two false beards, one red and one white—Two blankets—Two candleholders with candles—Box of matches. Telegram." *La Follia* published his novel in the Sicilian dialect, *Litteriu Trantulia ovvero Lu nobili sfasulatu* (Litteriu Trantulia or The Fall of the Nobles). De Rosalia died in 1935.

Both of these actors performed with De
Rosalia. Nino Orlando (above) was
born in Palermo and worked as an
assistant at the Teatro Massimo.
He started with a good tenor
voice but, abusing it, decided
to become a Sicilian dialect
macchiettista. He worked with
De Rosalia in the Company of
Cavaliere Scandurra in Italy.
After immigrating to New
York in 1906, he also worked
with Clemente Giglio and on
Italian-American radio. Toto
Lanza evaluates O. Rondinone
(below): "Simple and modest,
lovable and jovial,—in art as in
life—he is. . .the most charming
element of the 'de Rosalia' group.
Endowed with an inexorable spirit,
ready and spontaneous, he invests his
role with dignity and decorum, in this
way making himself a very fortunate actor,
unreservedly praised and admired by the public
and by his friends."

Arlington Hall, located at 19-23 Saint Mark's Place between 2nd and 3rd Avenues, was the venue for the first production by the newly merged group La Nuova Compagnia Filodrammatica (The New Amateur Dramatic Company) De Rosalia-Perez-Picciotto. This group resulted from the partnership of Giovanni De Rosalia, Mrs. Pia Perez-Picciotto, and Giuseppe Perez. They performed Paolo Giacometti's *La Morte Civile ossia Corrado il Siciliano* (Civil Death or Corrado the Sicilian) on Wednesday, December 13, 1905.

Strenna Miluccia Pasqua 1917 was the 1917 Italian-American version of today's *Players Guide*. However, instead of just clinically listing actors' credits, the editor Toto (nickname for Salvatore) Lanza, gave a subjective evaluation from personal observation and a description of each performer, some of whom have no other extant record of their work in the Italian-American immigrant theatre. Toto also appeared in *Malia* (Witchcraft) with the Aguglia-Cecchini Company.

Silvio Minciotti's first independent production was his friend Cordiferro's *L'Onore Perduto* (Lost Honor) in 1904. In 1905, Minciotti was the director at the Villa Vittorio Emanuele III nightclub. In 1906, Minciotti performed with the Italian actor Ermete Novelli on his European tour to France, Germany, Russia, Hungary, and Romania and acted with the Italian Virgilio Talli company. Returning home, he formed a professional company with his wife, Ester Cunico.

Ascanio De Rosa performed in Marietta Maiori's *Madama Sans Gene* alongside Minciotti and later became his right-hand man. Toto Lanza describes him: "He has been an Artist for some time, on the rebound, so to speak, but wherever he has been, under whatever direction and in whatever partnership, he has always invariably contributed his own total ability, even in the most disparate works. He is a gentleman always and a valuable friend."

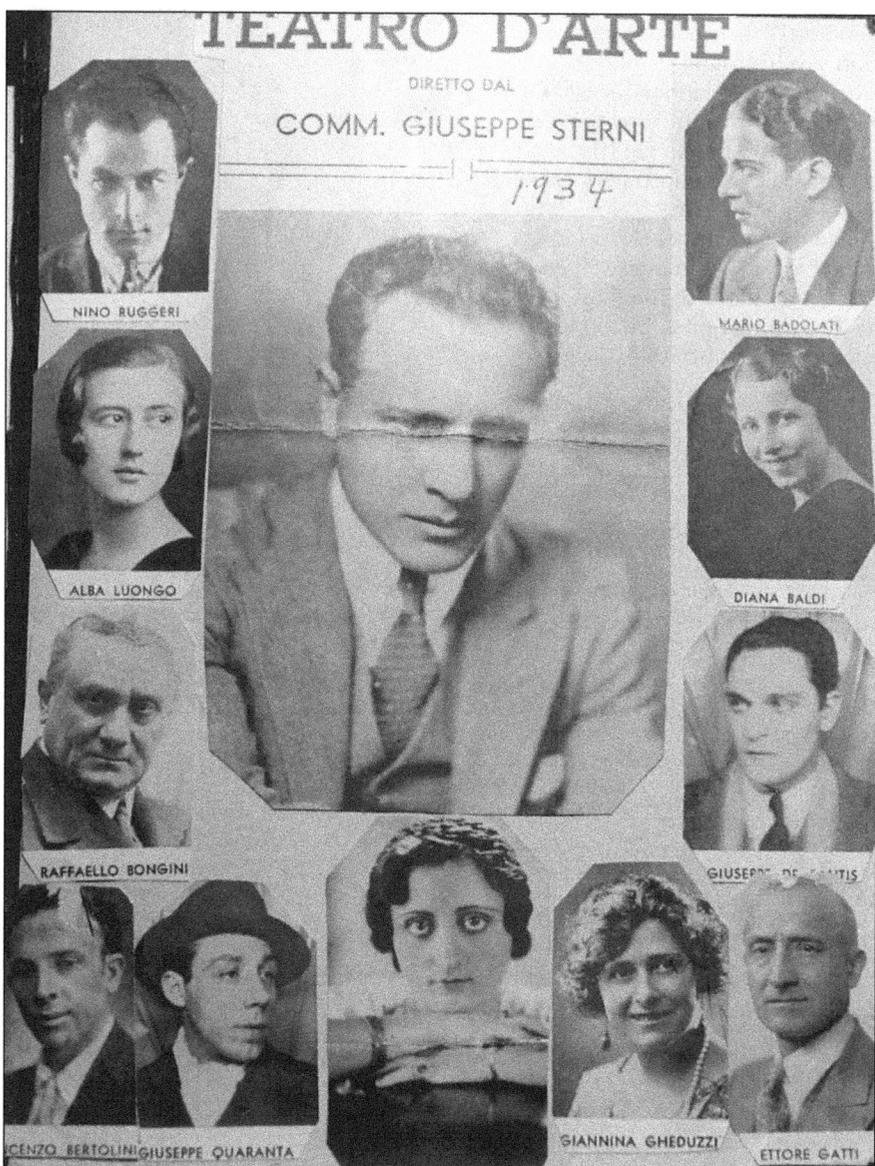

TEATRO D'ARTE

DIRETTO DAL

COMM. GIUSEPPE STERNI

1934

NINO RUGGERI

MARIO BADOLATI

ALBA LUONGO

DIANA BALDI

RAFFAELLO BONGINI

GIUSEPPE DE SANTIS

CENZO BERTOLINI GIUSEPPE QUARANTA

GIANNINA GHEDUZZI

ETTORE GATTI

Giuseppe Sterni emigrated from Northern Italy. From 1929 to 1949, his Teatro D'Arte (Art Theatre) tried to revive the serious drama that Maiori initiated and abandoned years before. Sterni brought it to radio station WOV. His repertory consisted of Shakespeare, Luigi Pirandello's *Sei Personnagi in Cerca d'Un Autore* (Six Characters in Search of an Author), *Figlia di Iorio* (Daughter of Iorio) of Gabriele D'Annunzio, and the plays of Giovanni Verga. In the ranks of the Teatro D'Arte were many actors from the Italian-American arena, who lent their talents to this endeavor: Yolanda D'Este played Serena di Montaldo in the theatre and on the radio with Giorgio Mauri's company in the radio drama *Matrigna* (The Stepmother), by Alberta Santangelo; Nino Ruggeri appeared with Mario Badolati's La Compagnia La Perla (The Pearl Company) and worked alongside the famous vaudevillian Farfariello; Diana Baldi also had a career on Italian radio and starred in the colossal religious production at the Brooklyn Academy of Music, *Passione e Morte di Nostre Signore Gesu Cristo* (Passion and Death of Our Lord Jesus Christ) in 1945.

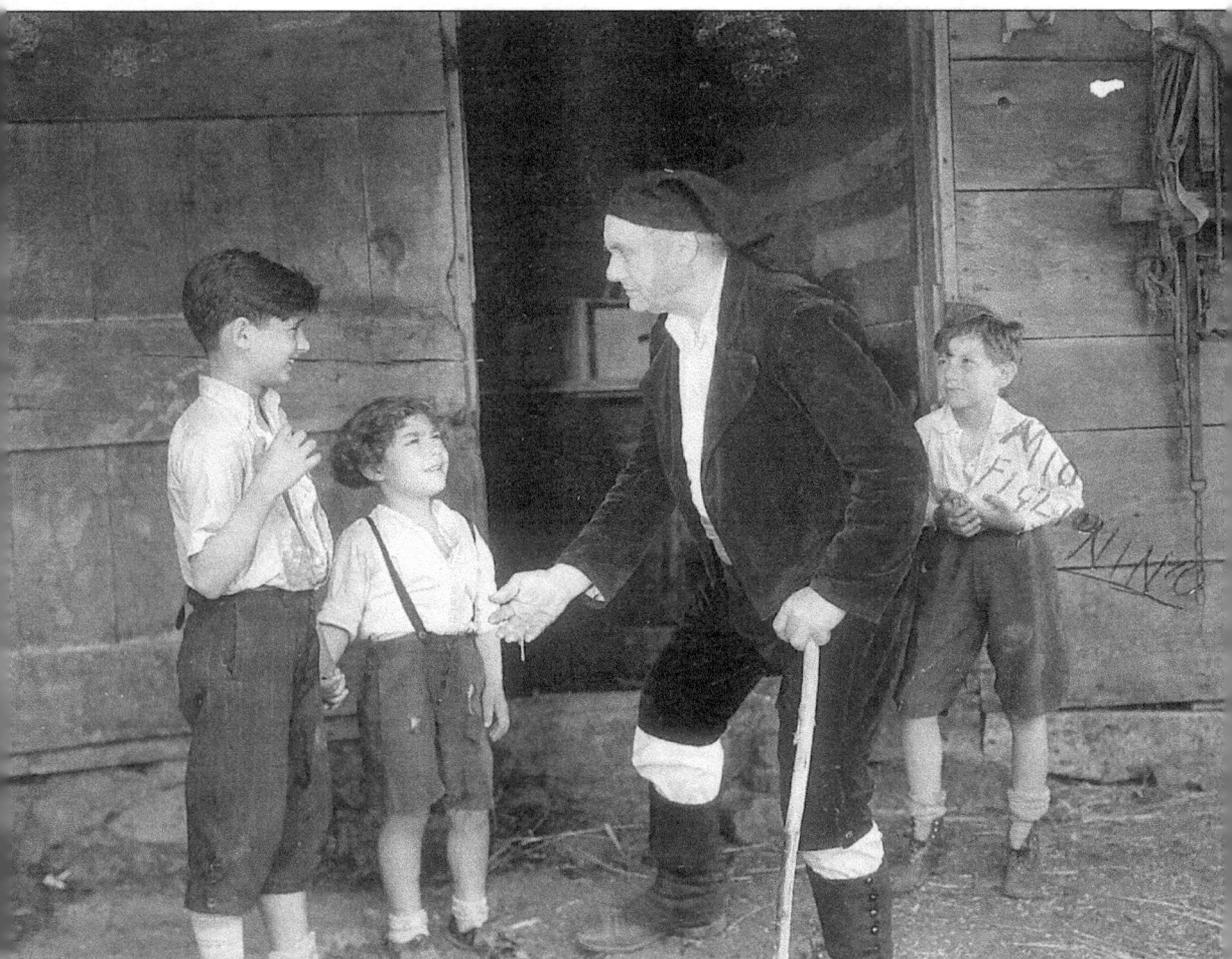

Raffaele Bongini also worked in the serious dramatic efforts of Giuseppe Sterni's Teatro D'Arte. In the early 1900s, he appeared on the stage with La Compagnia Drammatica Siciliana (Sicilian Dramatic Company) Aguglia-Cecchini, playing the role of Don Sciaveriu in their production of the Sicilian drama in three acts *Malia* (Witchcraft) at Maiori's Royal Theatre on the Bowery. In later years, he worked with the impresario Rosario Romeo, performing in his stage productions and radio dramas. He is shown here playing a supporting role in Romeo's Italian-American film *Amore e Morte* (Love and Death), the first and possibly the only Italian language film that emerged from the Italian-American milieu.

Born in Italy, Mario Badolati of the Teatro D'Arte and brother of Luigi, was an actor and directed his own stage company and radio program, La Compagnia La Perla (The Pearl Company) on station WOV. In 1944, he produced stage shows at the Brooklyn Academy of Music and wrote lyrics for songs. He was a spiffy dresser and insisted the same from his actors. He also played on the American radio soaps, *Stella Dallas* and *Margie*.

By 1902, Ernesto Rossi immigrated from Naples and sold books in his general store, which, *c.* 1910, he relocated to 191 Grand Street, at the corner of Mulberry Street, as Rossi's Libreria (not to be confused with his brother Edward's enterprise at 127 Mulberry Street). Ernesto's store sold the plays and sheet music used by the Italian immigrant producers and performers. The family business still endures, with Rossi's son Luigi and grandson Ernie.

Five

ITALIAN-AMERICAN
VAUDEVILLE

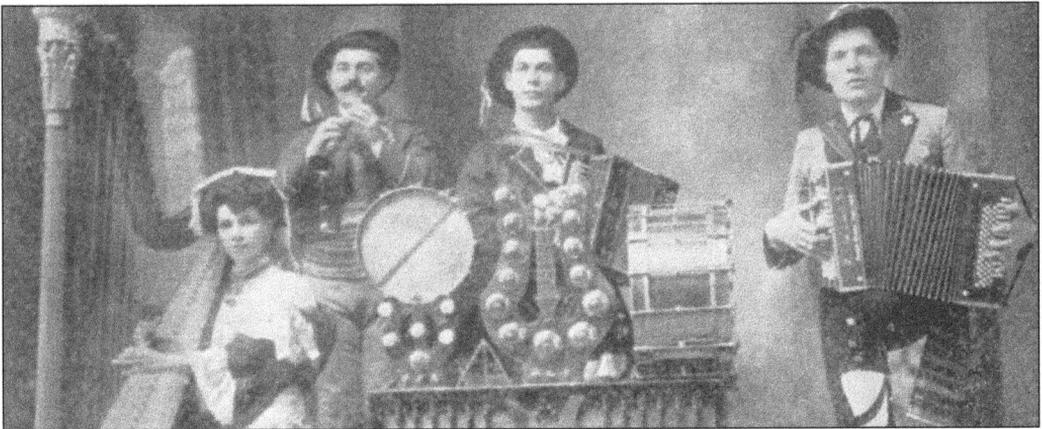

"Try & C The Original No.1 Bella Italia Troupe The Unique European Novelty Musical Act Original Singers And Dancers Most Difficult And Appropriate Music First Class Picturesque Costumes And Stage Apparatus Twelve Instruments Value $2,000.00." Thus, husband and wife team Pietro Donatella and Maria Rosa Faccenda advertised their variety act, typical of the fare on the Italian-American vaudeville stage. The genre was originally referred to as the *caffe concerto* or sometimes, mimicking the French, *cafe chantant*. The *caffe concerto* was simply a coffeehouse, or *caffe/bar* where, as in Italy, alcoholic beverages were served in addition to *caffe* (coffee) and where the working-class Italian immigrants convened in their leisure time. As with the theatre, the *caffe* was very much a social affair, like a nightclub. In addition to friends and refreshments, a singing guitarist performing favorite Italian folk songs and romantic ballads served to lessen the traumas of big city living in a strange country. On Sundays, such entertainment was advertised under the name "sacred concert" to avoid difficulty with the civil authorities. Francesco de Fina operated the Caffe Cosmopolitan at 30 West 4th Street (corner of Greene Street) as early as January 1885. As more immigrants arrived and the genre became more popular, bigger and better *caffes* emerged and the format made its way into larger theatres and music halls. Italian-American vaudeville was synonymous with the final years of the old-time theatre and continued into the 1960s, long after it had died out in the American theatre.

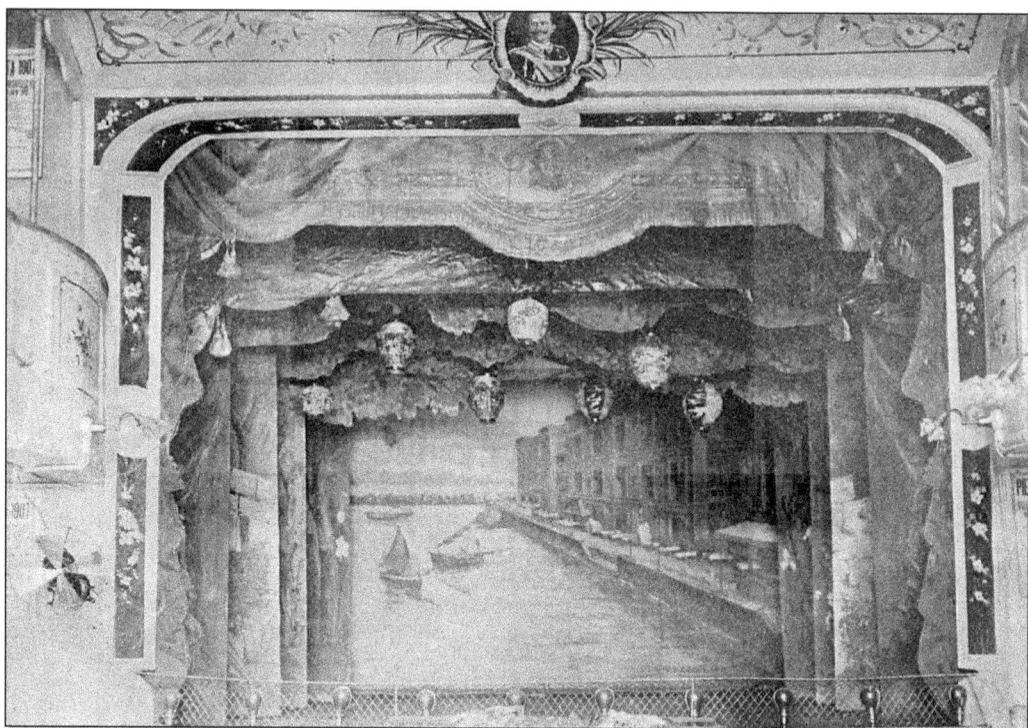

The Villa Vittorio Emanuele III, named after the reigning King of Italy, was a very popular early *caffe concerto*. A portrait of the king adorns the top of the proscenium. Here, it is decorated for the *Piedigrotta* of September 9, 1907. The *Piedigrotta* was the annual song competition (something like the Grammys) in Naples, which they copied in New York for some years. The villa was located at 109 Mulberry Street between Canal and Hester Streets.

The artist Gaetano Sorrentino redesigned the interior of the Villa Vittorio Emanuele III in time for the September 1907 *Piedigrotta* festival; he also created the cover design for the souvenir program. He was born in Naples, where he studied at L'Istituto delle Belle Arti (The Institute of Fine Arts), and married the October prior to his arrival in the U.S. He arrived in New York just months before the festival and settled down at 15 Goles Street in Brooklyn with his new wife.

Maestro Professore Giovanni Leotti served as judge on the examining commission of the *Piedigrotta*. In 1905, he worked as musical director for the Villa Penza *caffe concerto* at 196-198 Grand Street between Mott and Mulberry Streets. He wrote music for *O Signore scaduto in America* (The Old Fashioned Gentleman in America) with lyrics by Farfariello, and he wrote the musical arrangement for *Rimorso* (Remorse), the moving dramatic duet in verse by Mr. G. Cantalupo.

This image of the Spanish act *La Modistilla* was actually a postcard from the Villa Vittorio Emanuele III that was used for their publicity. The Bella Italia Troupe had advertised similarly with their stationary. Sometimes an international act might be featured in the Italian-American nightclub arena. One nightclub, Ferrando's Hall, actually specialized in multicultural entertainment, while remaining primarily an Italian venue.

Ciccio 'o Spagnuolo (Ciccio the Spaniard), the seafood vendor, had a stand near the entrance to the Villa Vittorio Emanuele III. The stand's sign, *"Allo Scoglio di Frisio"* (From the Rocks of Frisio) attested to the freshness of his merchandise. Much like the vendor in the cartoon, during a performance, one heard Ciccio's barking as he made the rounds of tables with plates of *"cozzecche ' e Taranto, ostriche e biscotti, cozzeche ca pummarola, clams con limone … mangiate, tutta roba fresca"* (mussels a la Taranto, oysters and crackers, mussels with tomato sauce, clams with lemon, eat, everything fresh). Customers called out: *"Ciccio, purtate nu piatto 'e cozzeche ca pummarola; Ciccio, na dozzana d'ostreghe"* (Ciccio, bring a plate of mussels with tomato sauce; Ciccio, a dozen oysters). Meanwhile, a singer accompanied by a mandolinist and guitarist performed songs from old Napoli.

ALLO SCOGLIO DI FRISIO

Grande rivendita di frutti di mare di qualsiasi specie tenuta dal cosidetto

"Ciccio 'o Spagnuolo"

in 109 Mulberry St. New York

Ch'e' stato il primo, se non l'unico, che ha riportati gli usi proprio napoletani, per lo smercio dei frutti di mare.

Si ricevono ordini e commissioni di dualunque impartanza.

Mr. G. Ingegnieros was both a vaudeville agent and an actor. In Italy, he had performed with the troupe of the famous Italian actor Angelo Musco and earned a reputation as a good actor. In New York, he worked again as an actor, but became a respected agent, who was said to understand the needs of his clients and was well liked by his colleagues. He worked out of 145 West 45th Street.

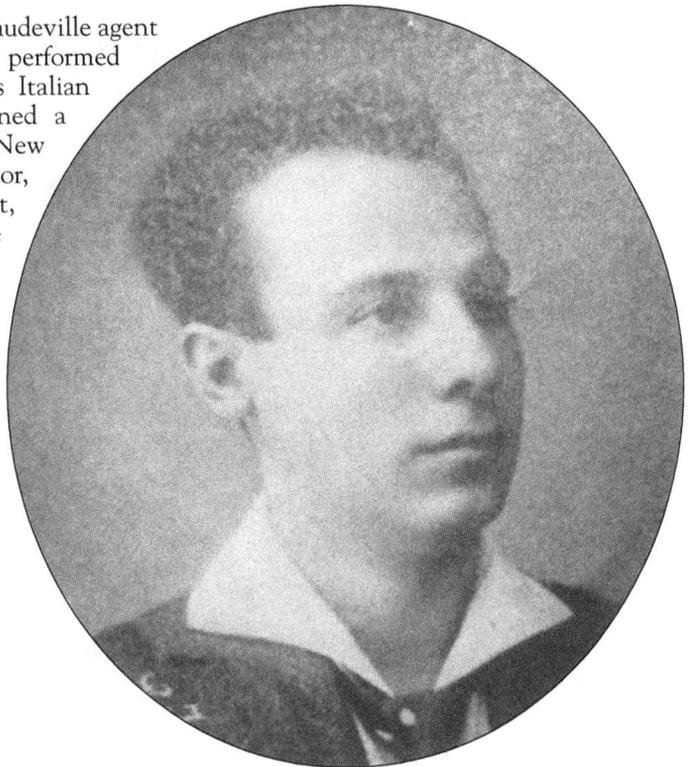

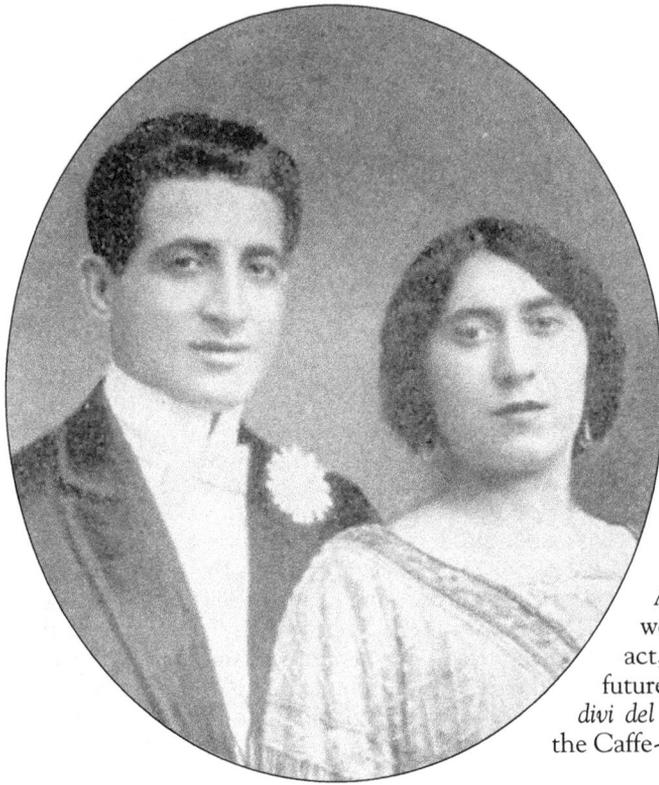

The Iris-Palange couple, a duet that performed in the Italian-American vaudeville circuit, were dancer/mimes. Toto Lanza observed in 1917 that they were the rage, very popular, afraid of no challenge and made their way despite envy on the part of others. As character performers, they were a fascinating, colorful novelty act, good-looking, with a promising future. Lanza called them the *due divi del Caffe-concerto* (two superstars of the Caffe-concerto).

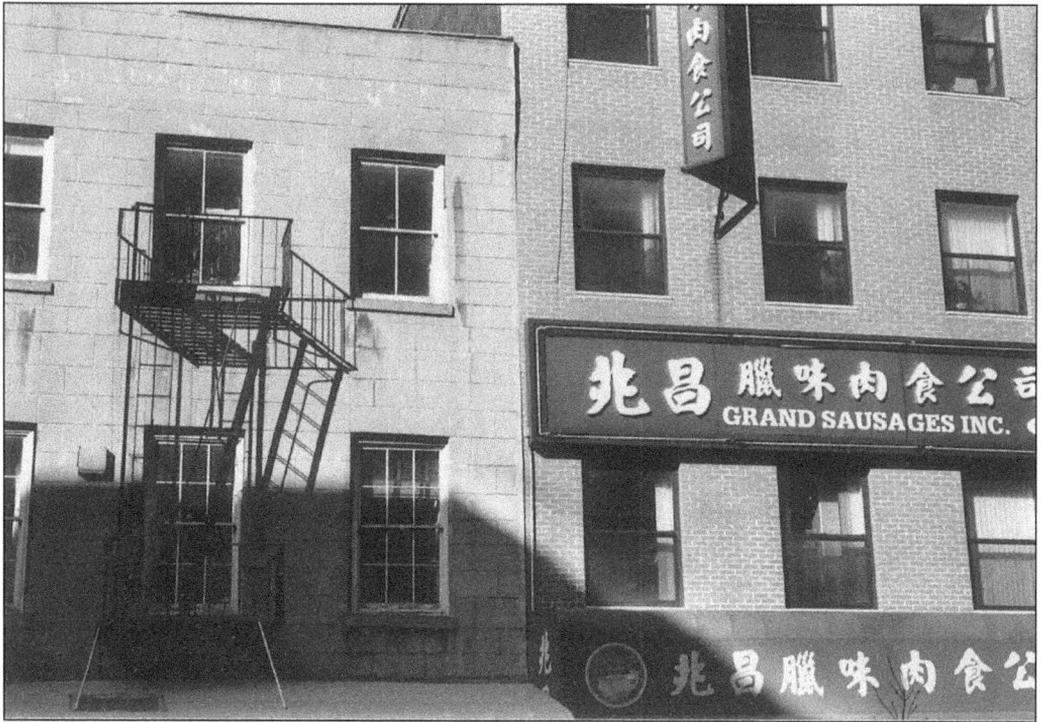

The Villa Penza began its nightlife as the Villa Giulia Concert Hall in November 1900. Domenico Volpe was the proprietor. The Compagnia Drammatica, under the direction of manager, Nicola Brigante, provided the entertainment. Located at 196 Grand Street, between Mott and Mulberry Streets, the villa was able to take advantage of the restaurant service of Antonio Ferrara's Ristorante across the street at 195 Grand Street. It was also called the Villa Napoli for a time.

The actor, singer, playwright, and impresario Rocco De Russo was a professional entertainer since childhood. He was born in Santo Arsenio, province of Salerno, in 1885. By the age of six, he had learned to sing popular songs and accompany himself on a little barrel organ. He represents the quintessential itinerant performer, who toured all over Italy and the U.S. He wrote and/or adapted many plays and songs; he also left very informative memoirs.

Luigi Marmorino and his wife de Paolo were a comic duet that performed with the Giglio company, the Rocco de Russo company, and in other clubs on the Italian-American vaudeville circuit. They were well liked by the *caffe concerto* audiences. Luigi Marmorino's forte was the musical comedy scene in dialect. He trained his wife to play opposite him in the genre; their skilled synchronized communication during performance was the reason for their popularity.

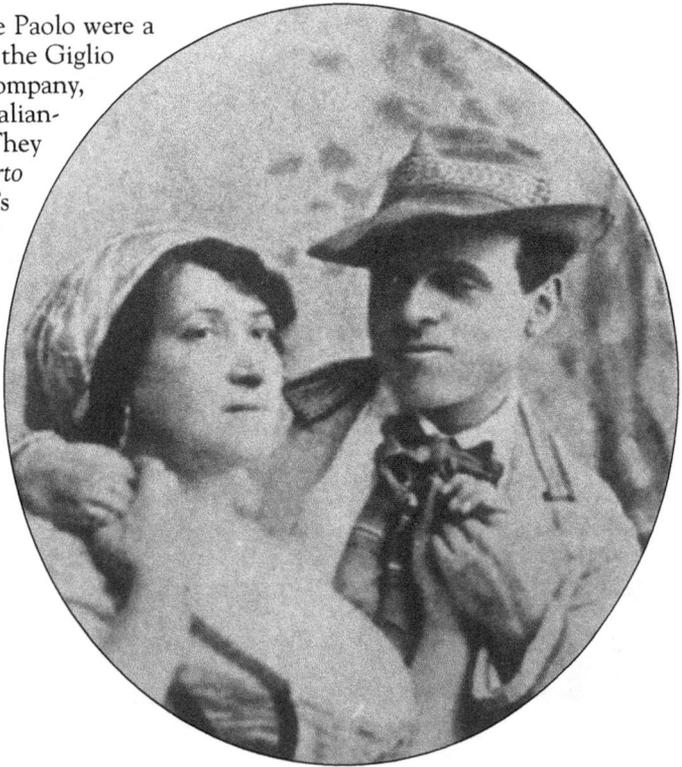

Not many comedians could make a success of playing the Neapolitan character from the Commedia dell'Arte called Pulcinella. Guglielmo Ricciardi, Edoardo De Pascale, Rocco de Russo, and the "Prince of Pulcinellas" Francesco Ricciardi are among the few. The stock character Pulcinella has been traced to the Atellanae (satirical farces from the Roman Campagna). However, Pulcinella became associated with the city of Naples, which explains his popularity among the Neapolitan immigrants in New York.

The Cosmopolitan Hotel and Concert Hall became the Teatro Pozzo at 90 MacDougall Street between Bleecker and Houston Streets. The owners, Max Pozzo and Mr. P. Biasetti, and the manager, Mr. R.J. Ramella, celebrated the reopening of the *caffe* in March 1900, thus implying it must have existed earlier. Capable of seating 500, the bistro had been completely renovated. The concert room had been furnished with a gallery especially for family groups.

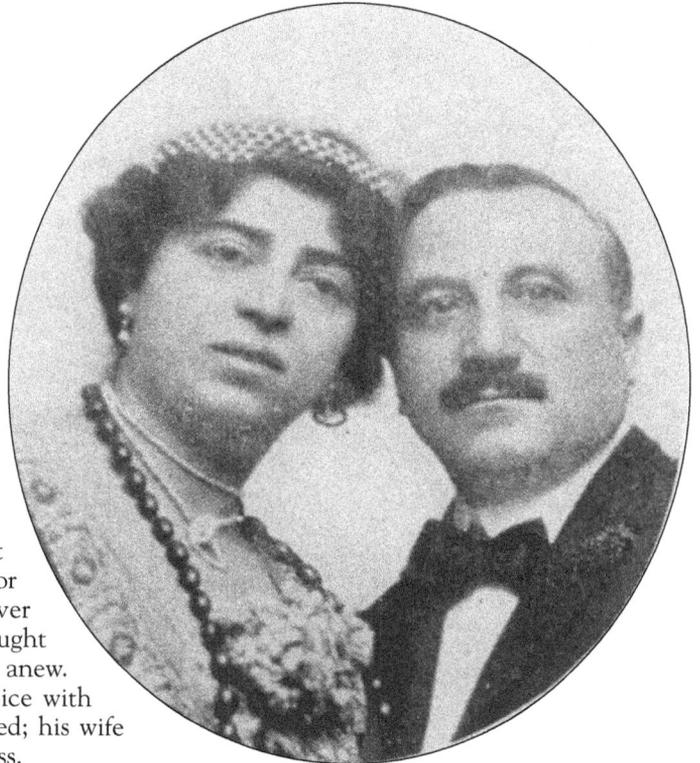

The Trapani couple performed duets in the *caffe concerto* arena. Toto Lanza maintains that they were known as "indefatigable" in their pursuit of entertaining material for the variety theatre. They never rested on their laurels, but sought always to please the audience anew. Mr. Trapani had a powerful voice with which he was naturally endowed; his wife was an intelligent, proven actress.

Ferrando ran his *caffe concerto*, Ferrando's Music Hall, located at 184 Sullivan Street from 1902 to 1905, when it became the Villa Manganaro. The variety shows ran the gamut of vaudeville acts, cinematic expositions, trapeze and acrobatic artists, cyclists, magic shows, international singers and dancers, vocalists performing ballads, duets, opera selections, and folk songs. Ferrando's, located in the West Village, was unique in that it offered plays in the Piedmontese and Milanese dialects.

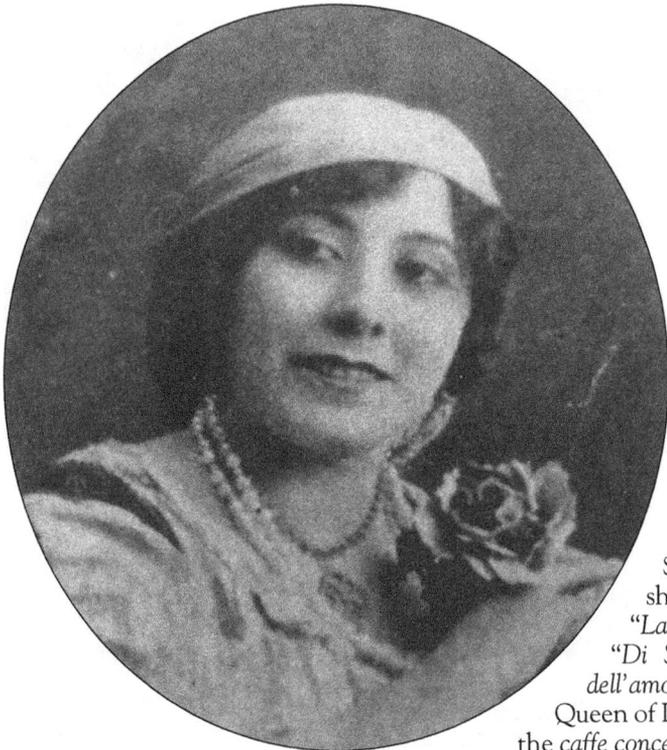

Gina Lilliam, another popular variety entertainer who performed in a Spanish style, had fiery eyes and movement and was full of mystery and passion. She sang marvelously; perhaps, she performed the popular folk song "*La Spagnuola*" (The Spanish Girl): "*Di Spagna sono la bella, Regina son dell'amor.*" (I am the beauty of Spain, the Queen of Love). She was the "*Idole*" (idol) of the *caffe concerto*.

Classical music and operatic selections were always a part of the variety show bill. The American-born opera diva Rosa Ponselle (really Ponzillo) and her sister Carmela performed just such an act (above) before going on to long careers at the Met. Their first vaudeville tryout in 1915 was in a rundown old motion picture theatre, Mrs. Mary Marino's Nickelodeon, at 2157 First Avenue between 111th and 112th Street (formerly Ricciardi's Grand Eden). Their program was a mixture of classical pieces and Italian and American folk songs. Angela Millitello, another singer on the concert circuit, made her debut at Town Hall with early Italian arias by Handel, Scarlatti, Torelli, and Pergolesi, Sicilian folk tunes, songs by Guarnier and Respighi, Puccini's *Vissi d'arte*, and *Pace, pace, mio Dio* from Verdi's *La Forza dell Destino*. Her singing had "warm and ingenuous qualities."

This caricature of a typical vaudeville audience and variety act is priceless for the accuracy of the images it recalls: the motley audience, all shapes, sizes, and attitudes; the oversized "acrobat" act; and the minuscule stage. The caption reveals the sometimes haphazard entertainment offered. "Esteemed audience, we will perform the most difficult acrobatic feat behind the screen; in this way, if we make a mistake, no one will know."

Il SETTEBELLO

– Rispettabile pubblica: il difficilissimo esperimento di acrobazia lo facciamo die il paravento, così, se sbagliamo nessuno se ne accorge.

ITALIAN-AMERICAN PHONOGRAPH CO.

367 Broome Street, NEW YORK Succursale 2263 1st Ave. Angolo 116 Strada

R. GERARDI, Proprietario

MACCHINE
"EDISON", "VICTOR" e "COLUMBIA"

VENDITA SPECIALE
di Cilindri e dischi dei migliori autori
a prezzi eccezionali

Ha sempre disponibile un grande assortimento di
→DISCHI←
di ogni grandezza che sorpassa i 100,000 dei più rinomati artisti di ogni genere

CATALOGHI "GRATIS" DIETRO RICHIESTA

Pagamenti a contanti o a rate mensili

Si spedisce qualsiasi ordine in tutti gli Stati Uniti e Canada per C. O. D. o dietro buone referenze.

The Italian-American Phonograph Company had two branches for their business in both Italian sections of the city: Little Italy and East Harlem. Many Italian-American music hall artists recorded for the major record labels, and their records could be bought here. Owner R. Gerardi promised "exceptional prices," a special sale on records and "cylinders" by the best artists, free catalog on request, and monthly rates.

85

Compagnia "FRONTE UNICO"
con la Più Grande Artista del Mondo: "PUNTO E BASTA"

★★★

Gilda Mignonette

★★★

Farfariello
Cardenia
–Amato–

Si darà il potente dramma

gilda
mignonette

Chi nun Tene
'a Mamma
Chiagne!!

— PROTAGONISTI —

Gennaro e Vincenzo Cardenia

coadiuvati da Esterina, Oscar Andreatini, Silvia Coruzzolo, Bandini, Allara, G. Di Giacomo, Tina Stefanelli

VARIETA' CON LA DIVA

★ **GILDA MIGNONETTE** ★

nel suo repertorio nuovissimo

Gilda Mignonette (1886–1953), considered one of the world's greatest interpreters of Neapolitan songs, was born in Naples and made a career recording Piedigrotta songs. She immigrated to the U.S. in 1926 and was noted for her voice and spectacular costumes. She was called "The Queen of Diamonds" and "La Carusiana," recalling Caruso. Brooklyn was the venue for her most popular performances, which once ended with crowds carrying her through the streets. Mae West was a fan. Here, she appears with Farfariello; the popular impresario, actor, and singer Gennaro Scognamillo Cardenia (also below); and his son Vincent Gardenia, who at age five began with his father's company until he made his entry into American theatre and films. Gennaro, a big, handsome actor, had a magnificent voice and performed both melodramas and musicals, frequently at the Brooklyn Academy of Music into the 1960s.

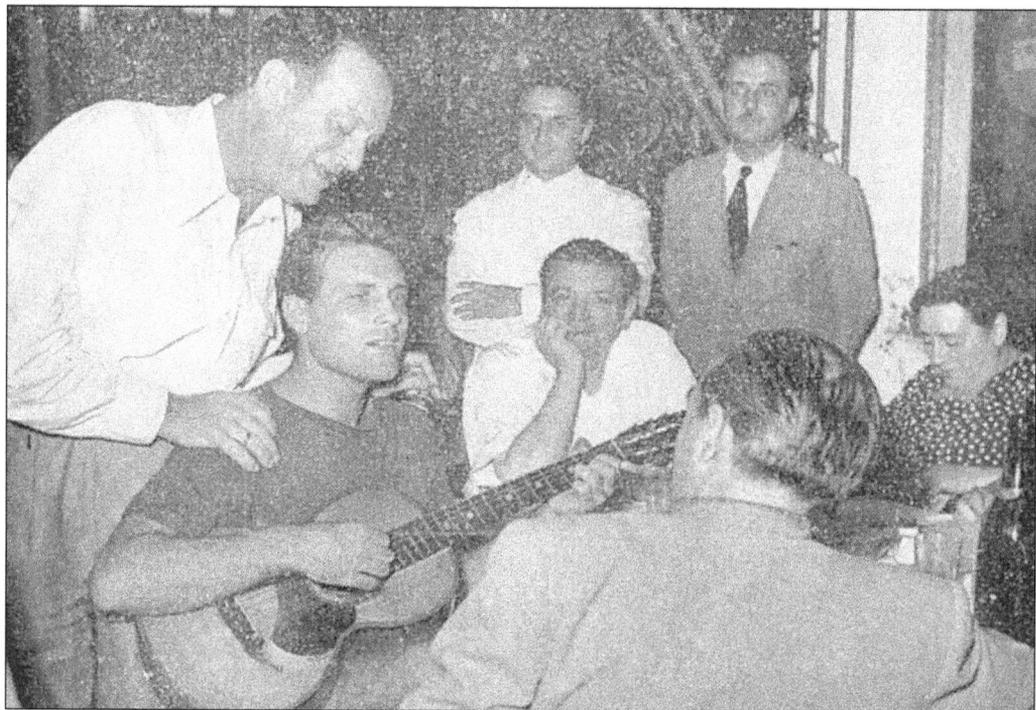

After seeing one of her shows in Italy, Gennaro Cardenia brought Rita Berti to America in 1953 to perform in his vaudeville productions (both plays and musicals). She was billed as "*la giovine ed elegante Stella*" (the young and elegant star) when she was featured in Gennaro and Vincent Cardenia's *Il Festival del Teatro Mediterraneo di Napoli* (*The Festival of the Mediterranean Theatre of Naples*) on Sunday, April 5, 1964, at the Brooklyn Academy of Music. In the picture below, she is performing on a typical vaudeville stage with a placard explaining the premise of the play, which in this case was *Tutta Colpa e da Famiglia* (It's all the Fault of the Family). The themes of generational conflict, struggles within the family, and children lost and discovered— structures of 19th-century bourgeois drama and melodrama—prevailed on Italian-American stages of the early 20th century.

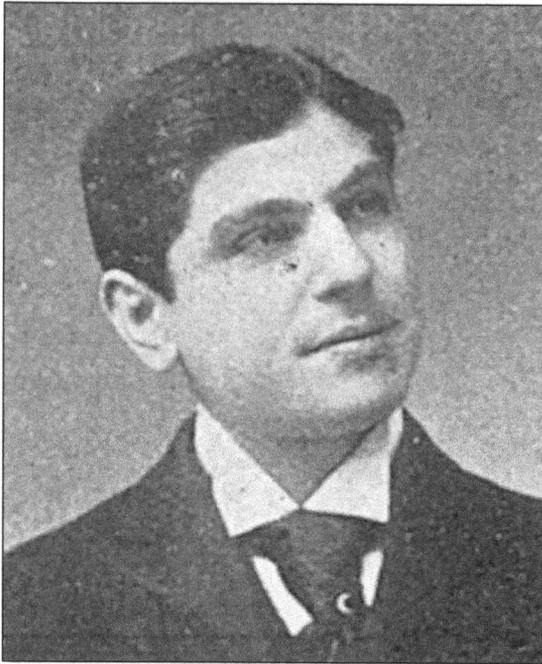

One of the most popular entertainers of the *caffe concerto* genre was the legendary Eduardo Migliaccio, whose stage name was Farfariello. The stamps he had made up for publicity purposes illustrate the dual identity: the large M stands for Migliaccio, the entwining E for Eduardo, and F for Farfariello. Migliaccio was born April 15, 1882, at Cava Dei Terreni, province of Salerno. He attended the Istituto di Belle Arti, in Naples where he studied design and plastic art. These skills served him well years later when he embarked on a theatrical career. In Naples, he also attended the Teatro Nuovo, where he observed the Neapolitan *macchiettista* (impressionist) Nicolo Maldacea, who was the model for the later comic style of Farfariello. In 1897, Migliaccio emigrated from Italy to join his father in Hazleton, Pennsylvania, but eventually made his way to New York City.

One Italian-American type Farfariello created was *Pazzy 'o pazzariello* (also *Pazzy 'o pazzo* or Crazy Patsy), with Migliaccio's lyrics and music by Russo. Patsy sings: "Since I have been in America I have gone crazy, there is nothing that impresses me, nothing at all. But this is an upside down world. But this is a crazy world, over here, my word, I really enjoy myself! I laugh like a madman, Ha! Ha! Ha! Ha! Ha! Ha!"

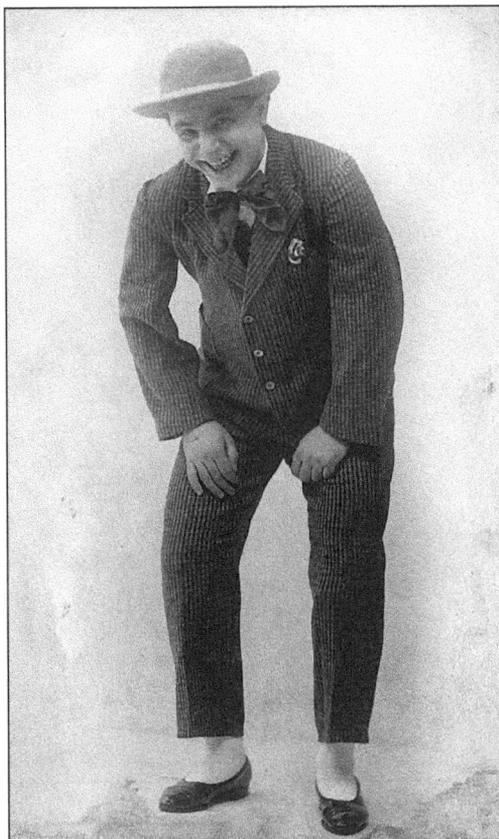

Armando Gildo (a.k.a. Gill, Gild), lyricist and composer of many popular songs, was also the U.S. distributor for the Italian music firm Casa Azzurra. Farfariello performed a number of Gildo's songs as *macchiette* or character impersonations; among them was "*Stornelli dell'Aviatore*" (The Aviator's Lament). A man has learned to fly to please his love. During flight, he feels no fear because he knows he pleases her. When he loses her, his courage fails him too.

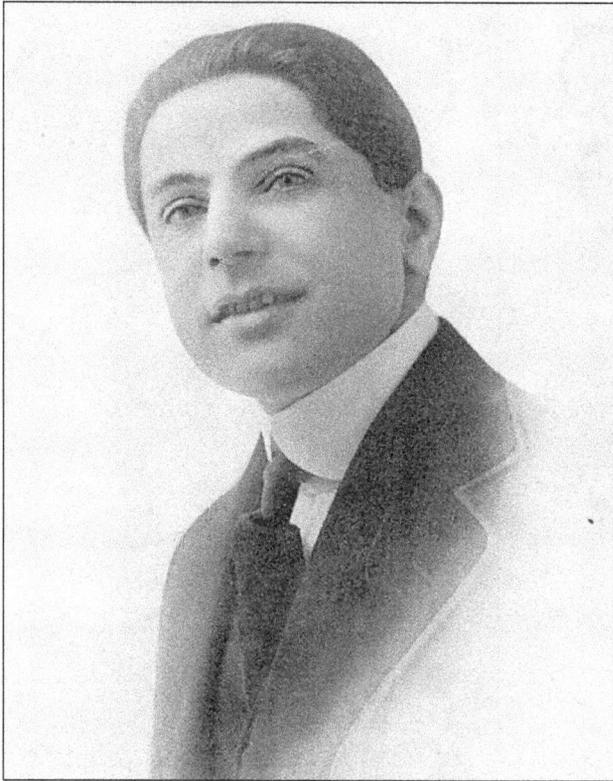

In New York City, Migliaccio got a job at a bank writing letters to relatives in Italy for the bank's immigrant clients, who were illiterate laborers. This job gave him an understanding of the psyche of the Italian immigrant, which lies at the core of the characterizations he created on the stage. The job introduced him to the population of the Italian community, the very subjects of the *macchietta coloniale* (colonial character sketch), which he invented and made famous. One of these characters was *Suldate Americane—Canzone Patriotica* (American Soldier—Patriotic Song) for which he wrote the lyrics. His brother Ernesto wrote the music for this piece and often led the orchestras for his shows. The soldier repeats a selfless refrain to his mother and to his love: "Don't cry. Don't forget me. First I serve America and after I will serve you."

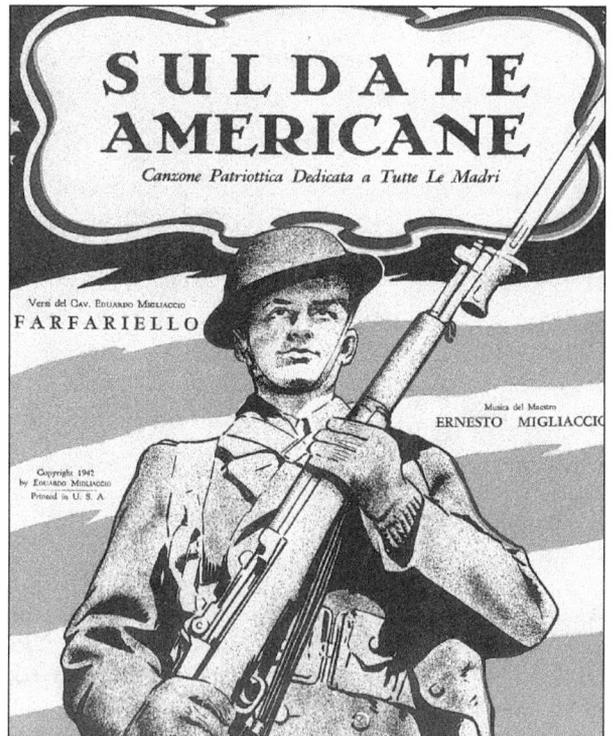

One of the best known characterizations was that of Farfariello's friend, Enrico Caruso, *Il Divo* (The Star). The accompanying song was "*'E lettere 'e Caruso*" (Caruso's Letters), written by Migliaccio and Domenico Jetti in 1910. Migliaccio himself made the mask for the Caruso impersonation. (Somewhere there must be a Caruso caricature of Farfariello.) The *macchietta* was performed with "Caruso" sitting under a spotlight reading his reviews. The journalist Italo Falbo saw it: "Farfariello portrays him in a hearty cartoon-like spirit in a sketch in which the star of stars leafed through his daily mail full of hyperbole declarations, of admiration, of appreciation, of love and also sometimes requests for money and threats of blackmail." When Caruso heard of the caricature, he attended one of Migliaccio's shows to see for himself. Caruso applauded this *macchietta* of himself and congratulated Farfariello on the resemblance.

The ad reads: "Societies who wish to supply themselves with good Banners, Flags, Badges, military uniforms and whatever additional accessories, should look for the Sign *FRANK DE CARO* 169-171 Grand Street." When Migliaccio first created the satirical *macchietta* where he appears ridiculously dressed as a general, *Il Cafone Patrioto*, also *Lu Cafone Patriotto* (The Italian Patriot), he ordered his costume from Frank De Caro, who specialized in military uniforms. Lyrics for the sketch were written by Migliaccio and Tony Ferrazano, and music by Maestro V. Napolitano. At the time, the officers of the mutual benefit associations wore military uniforms resembling the grenadiers and cavalrymen of the Italian army. Farfariello asked why all the members had to dress like officers. The tailor replied that no one was satisfied with less than the rank of captain. The more stripes on the arm, the happier they were.

Migliaccio may have gotten his uniform and badges from De Caro, but he augmented his costume with the accessories of his own making (pictured below). Another similar macchietta is *Il Presidente della Societa* or *Il President-Generale* (The President of the Social Club or The President-General). The journalist Giuseppe Cautela encapsulates the satire's effect: "Many Americans remember the sorry spectacle that many Italian immigrants used to make in those times. Still cherishing certain memories of their fatherland, they paraded through the streets of New York as caricatures of the Italian Army. Their honesty remains undisputed; but the result achieved in those uniforms was atrocious. If such well-meaning patriots have ceased parading with their gold laces dragging under their heels and carrying their sabers as so many broomsticks on their shoulders, it is due to the castigating *macchietta* that Farfariello drew of them."

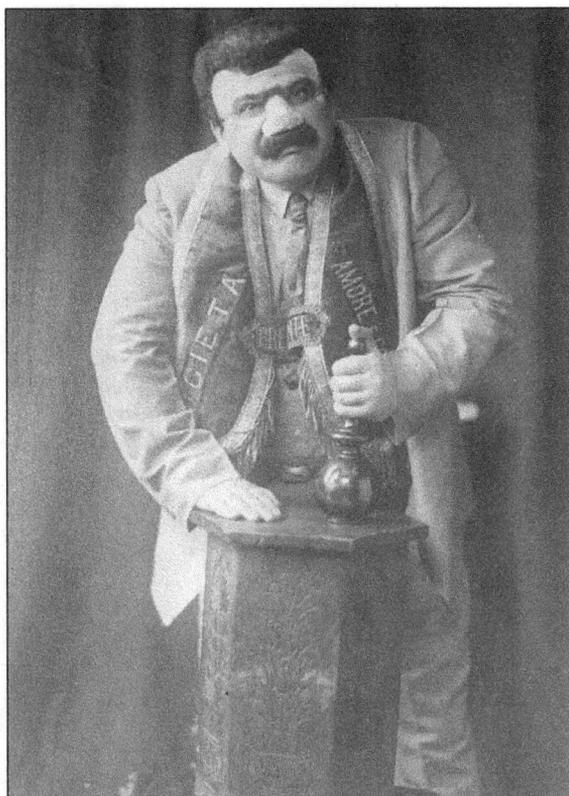

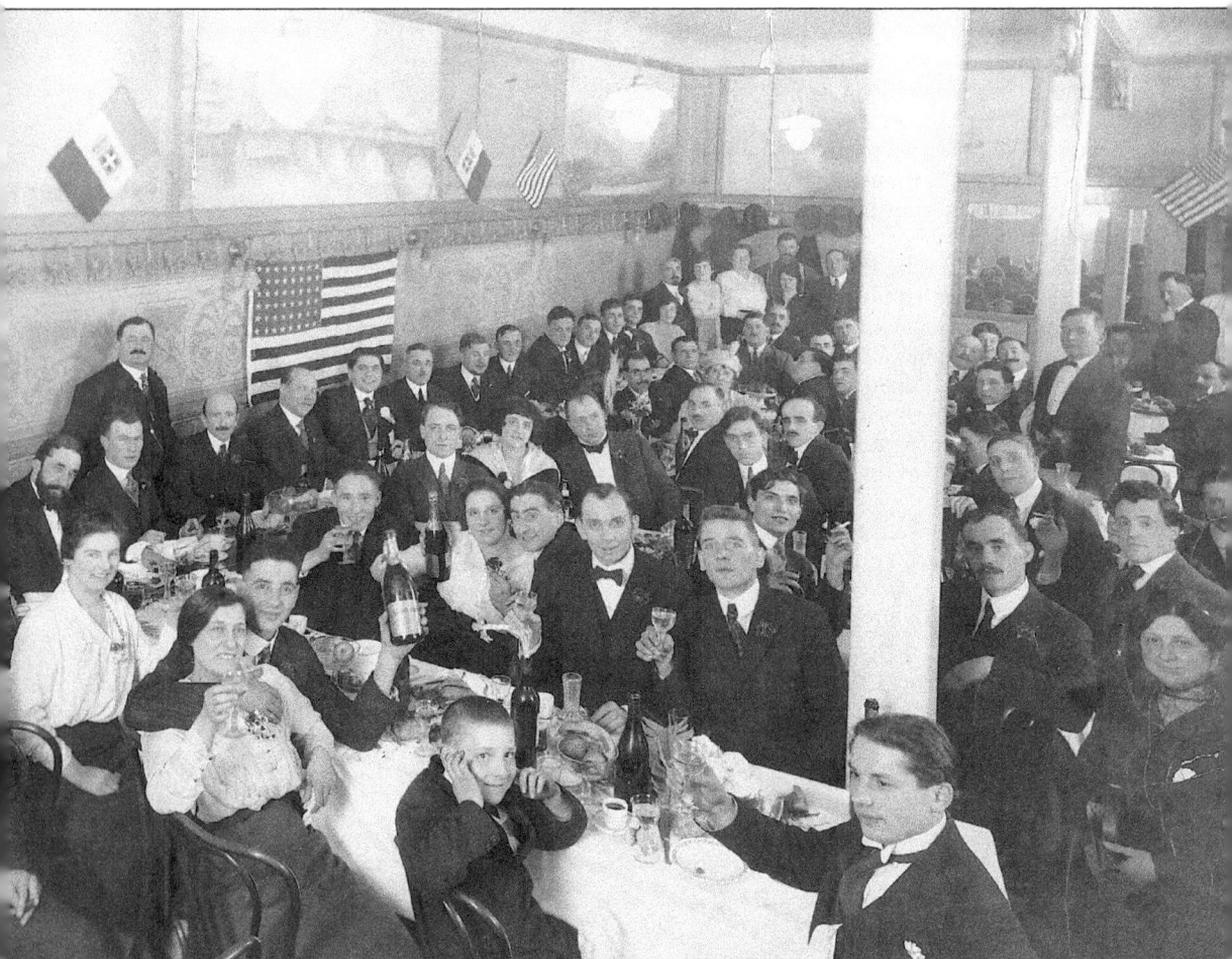

Eventually, Eduardo Migliaccio took Farfariello on the road and began to permeate the rest of Italian America. Here, he attends a banquet given in his honor by the Italian-American community of San Francisco on February 6, 1918, at the Milano Restaurant. The woman standing in the lower right corner carries a violin and must have provided the musical entertainment. Since she is standing, and mostly everybody else is sitting, she must have been a strolling violinist. He was invited by Mrs. Antonietta Pisanelli Alessandro to perform at the Circolo Famigliare Pisanelli (Pisanelli Family Circle), San Francisco's first professional Italian-American theatre company, located at Stockton and Union Streets. Migliaccio organized his own operetta company, which included his family and a repertory of Italian, French, and German operettas. Under various titles (The Eduardo Migliaccio Vaudeville Company, La Compagnia di Varieta' Farfariello, The Italian Comic Opera Company), his group went on a two-year tour of the U.S. The company's manager, Mimi Imperato, booked appearances in Philadelphia, Chicago, and various California coastal cities, including Los Angeles, Santa Barbara, Fresno, San Pedro, Venice, Stockton, and San Francisco during 1917 and 1918.

Gina Santelia accompanied Migliaccio's road tour. Toto Lanza observed: "The whole soul of poetry is in the song of this siren of the *caffe concerto*. She has in her voice such a treasure of passion that, listening to her, you seem to hear the echo of music from a far away place. She sighs, trills joyfully, like a lark in springtime." She was the mother of the film actor Vito Scotti.

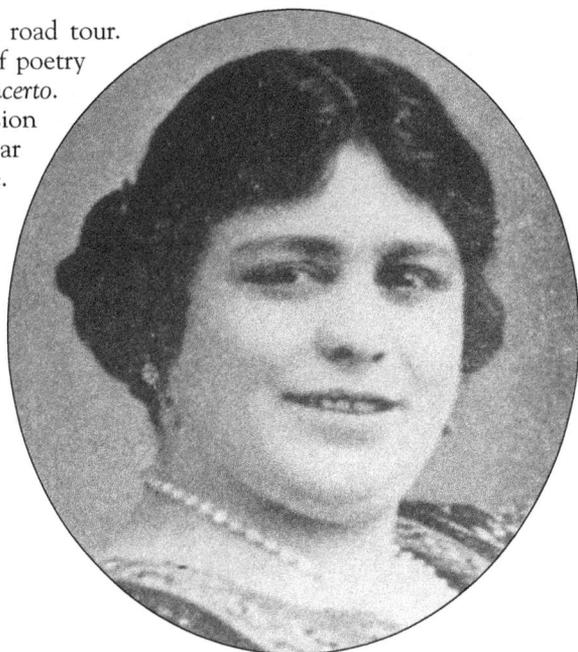

Ammore All'americana

Versi di E. MIGLIACCIO „Farfariello„ Musica di R. DE LUCA

III.

Chesta 'e n' ausanza tutt' americana:
doppo ca m' he, spurpato buono buono
me lasse; embe', strignimmece 'sta mana!...
Te voglio si e' accussi' cerca' perduono ?!.
 Io, a penzo a' taliana bella mia;
 tu a nienze comme a certe americane..

Migliaccio's *Ammore All'americana* (Love American Style), with music by Raffaele De Luca, captures the tensions of assimilation, using Italo-Americanese, the evolving jargon of the immigrant audiences. The Italian man asks the American girl, *"Ju love mi?"* (Do you love me?) She answers, *"Sciu gare mony? iu bai mi pere sciuse? l'aiscrimmia"* (Sure, you got any money? you buy me a pair of shoes? ice cream). Her answers confuse and disappoint the Italian.

Farfariello's son Arnold remembers how successful Farfariello's female impersonations were, partly because his father was not at all hirsute. The red dress (at left) is only one of his many female costumes, for which he had built special glass cases to protect them and make them easily visible. He performed in drag (below), *Maritem'e' nglese* (My American Husband) with lyrics by Tony Ferrazzano, whom Farfariello inspired, and music by Vincenzo De Crescenzo. This *macchietta* showed the other side, the point of view of an Italian woman undergoing assimilation. Her advice to other Italian-American girls: "better to stay alone than to have a husband like this." She too uses Italo-Americanese phrases: *stritto* (street), *airono* (I don't know), *naise falo* (nice fellow) and *iu no* (you know). The new jargon was a linguistic soup of English, Italian, and dialects.

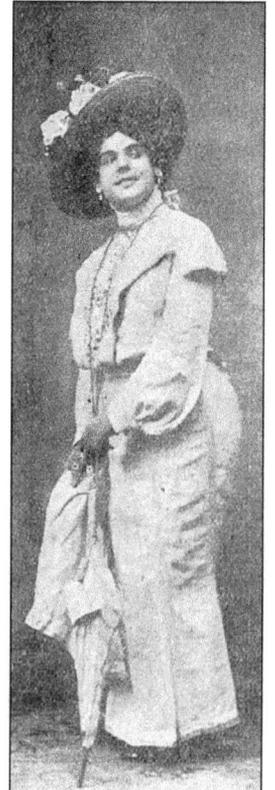

An anonymous news clipping from San Francisco reviews his parody of the opera diva, La Tetrazzini: "In his 'Luisa Tetrazzini' he was extraordinarily effective. With the most enviable artistic acumen he knew how to create the caricature of the trills, of the modulated high-pitched, temperamental songs of the great actress, with a comicality from an inexhaustible vein, with good humor that provoked laughter and that meanwhile made you reflect and think."

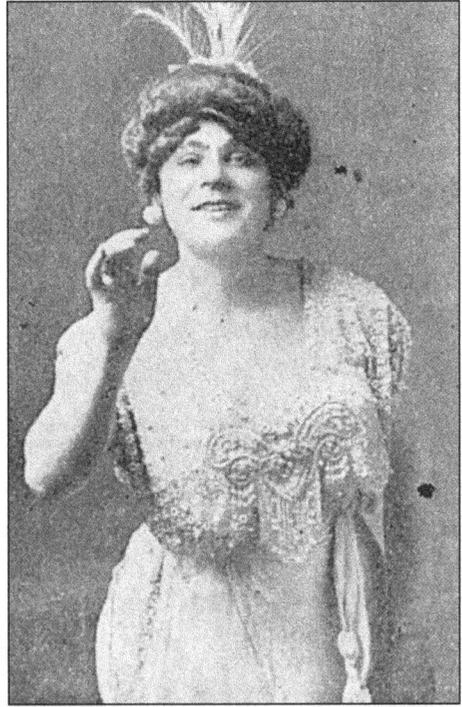

In Hoboken, Farfariello appeared (typically vaudeville) on the bill with a movie. The program featured the following: (left) *Pasquale Passaguai*; (right) Cowboy; (center) *La Parigina* (the French concert-hall singer). Carl Van Vechten reviewed *La Parigina* as follows: "From hair to shoes he is a French concert-hall singer of the type familiar at Coney Island.... He shrieks his vapid ditty in raucous falsetto; he flicks his spangled skirt; he winks at the orchestra leader and shakes his buttocks."

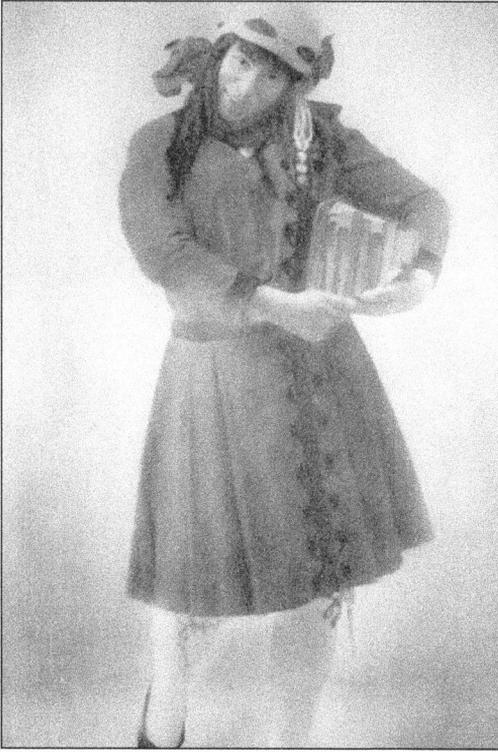

The title of *Scul-gherl* (The East Side School Girl) with lyrics by Migliaccio and music by Filipo Dato, is Italo-Americanese. Edmund Wilson described the *macchietta* for the *New Republic* in 1925: "The little girl from the public school whose attainments to American history are confined to a dubious statement about Washington but who has acquired a large repertoire of jazz songs which she can, and does, sing from beginning to end."

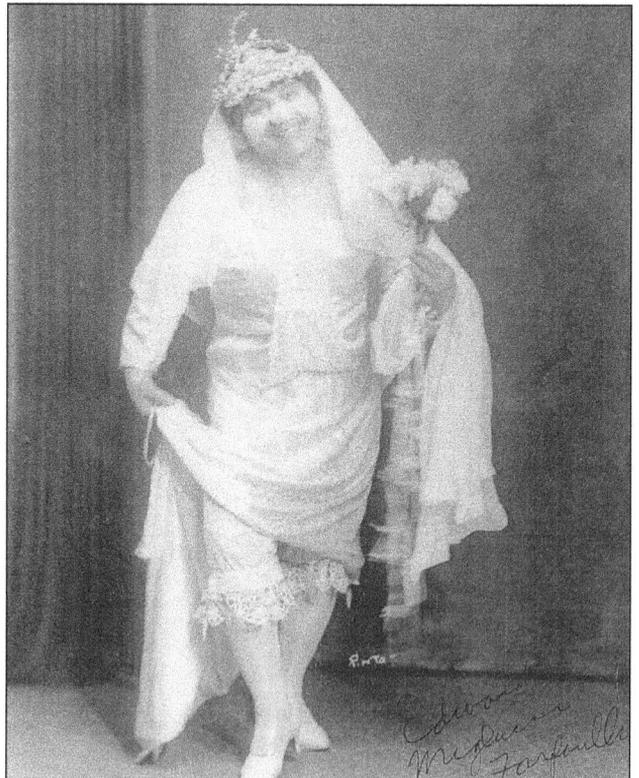

La Sposa (The Anxious Bride) was inspired by Eduardo Migliaccio's attendance at a wedding. His son, Arnold (Arnie "Mig") Migliaccio, remembers that at a wedding, Farfariello was so struck by the appearance of an ungainly, oversized bride that he decided immediately to make a *macchietta* based on his firsthand experience. The picture itself of Farfariello as a bride speaks eloquent volumes.

The song "'*E Cappielle d' 'e Femmene*" (Ladies' Hats), lyrics by D.C. Cafaro and music by E. (either Ernesto or Eduardo) Migliaccio, marvels at the current fashion of using unusual items to decorate ladies hats, as the illustration shows: "pots, pans, airplanes, vegetables, a bird in a cage, a tray of fish, a boat." A hungry cat attacked the woman in the fish hat. The iceman's horse ate the vegetable hat.

Farfariello certainly went to Frank De Caro for the uniform for *The Orchestra Leader*. This *macchietta* is an impersonation of the old-time *Maestro Professore*, who taught music to earn a living and whose students composed the orchestras that played for intermissions of plays in the Italian-American theatre and marched in the feast day parades.

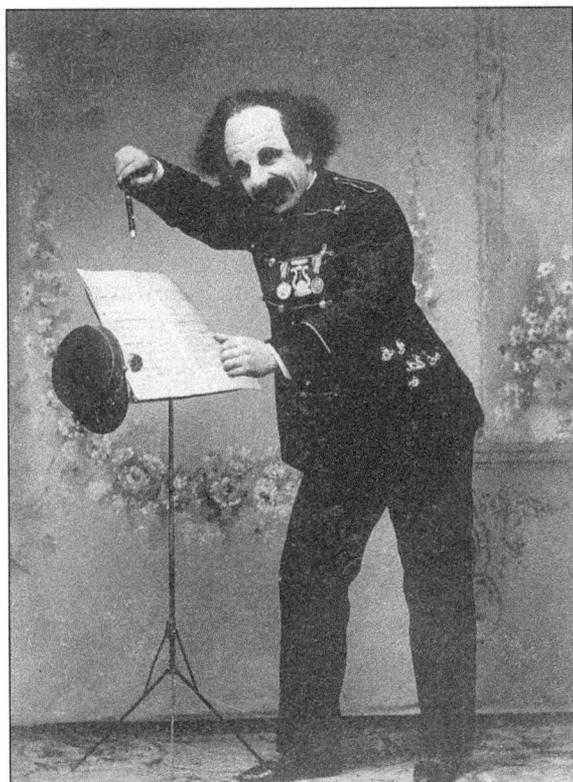

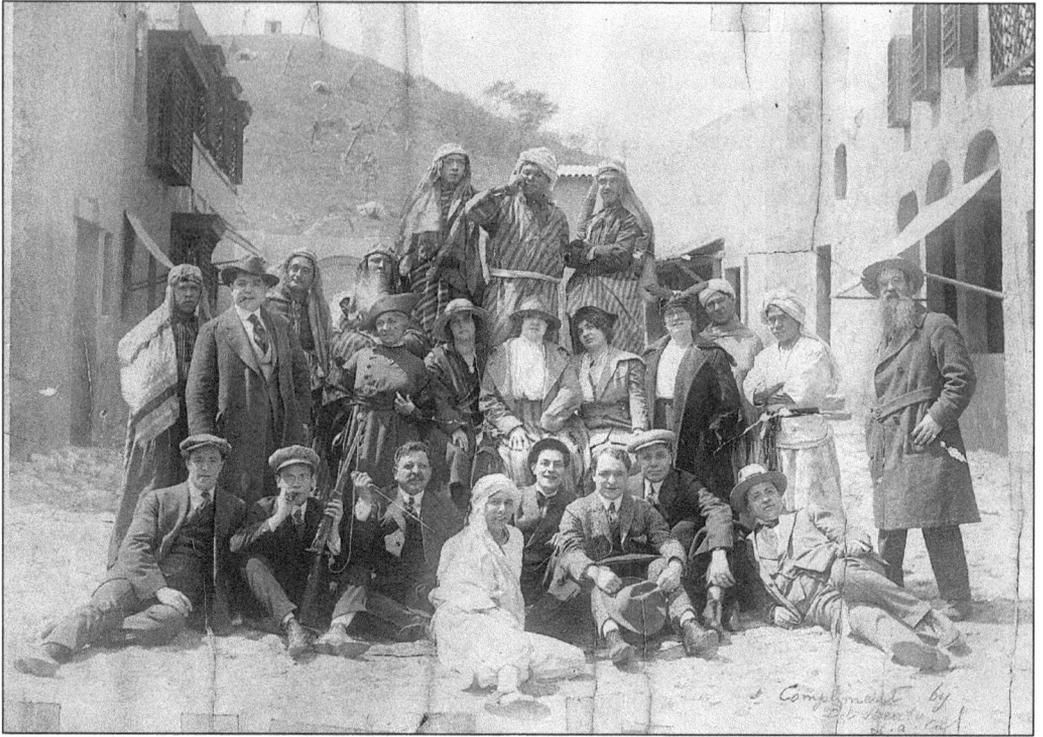

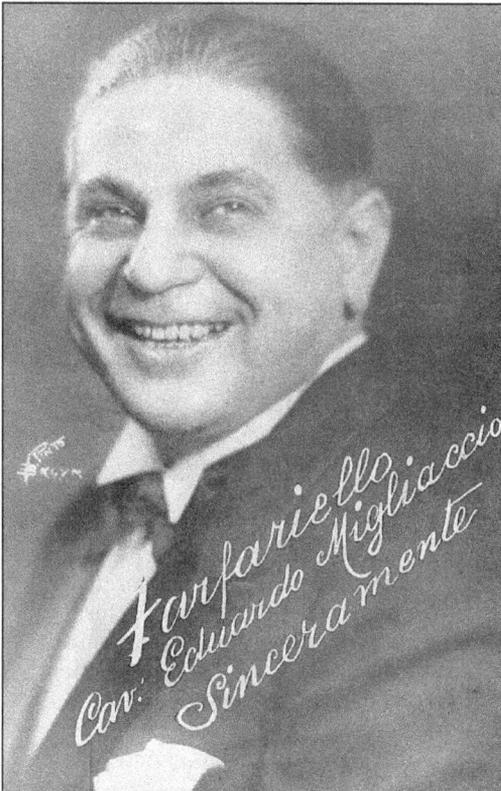

Farfariello / Cav: Eduardo Migliaccio / Sinceramente

While on tour in Los Angeles, Migliaccio was photographed on a movie set among Italian-American friends and actors who had gone west to work in movies. He was well received by Italian-Americans everywhere. In 1936, he toured Italy and King Victor Emanuel III named him a *Cavaliere dell'ordine della Corona d'Italia* in 1940. Eduardo Migliaccio died Wednesday, March 27, 1946, and with him died Farfariello, never to be seen again on the Italian-American stage. Other comedians tried to replace him, but his inimitable characterizations could not exist outside their creator. The entertainment he originated was a phenomenon that can never be repeated. What is left is the memory of the smiling man behind the big noses, funny costumes, and crazy wigs who found such an endearing way to make his compatriots, strangers in a strange land, feel at home.

Six

RADIO DAYS

Ascoltate Il Nuovo Programma

PARAMOUNT

CON

DONNA VICENZA

E

ATTILIO BARBATO

Emma Alba Gloria

Attilio Barbato

Dal Lunedi al Sabato

Dalle 4 P. M. Alle 4.15 P. M. Stazione Radio W.O.V.

The immigration quota laws of 1924 restricted the total new arrivals into the U.S. to 2% of those accepted in 1890. This meant that only one generation of Italian-speaking immigrant audiences remained; other factors intervened: the Depression, WWII, movies, and television. But radio in the 1930s and early 1940s gave the theatre a boost. Italian food companies determined that Italian language programs were excellent advertising vehicles. Sponsors included Paramount Spaghetti (pictured here), Mamma Mia Oil, Oxydol, Roma Macaroni, Caffe Medaglia D'Oro, Lazzara Bread, Ali D'Italia Oil, Olio Buon Pranzo, Olio Balbo, Olio Conti, La Gustosa, and Rabinovich Furniture. Every day had numerous hours of programming on an alphabet soup of radio stations: WOV, WFAB, WHOM, WINS, WEVD, WMCA, WHBI, WADO, WPCH, WBNX, WHAY, WAAM, WOR, WJZ, and WBIL. Italian-American actors were employed on a regular basis, and theatre audiences increased, since hearing the plays on the radio in serial or soap opera form made listeners want to see the shows live. Whichever story played on the radio during the week would be performed live in the theatre on the weekend. Mario Badolati used another trick; he would end the radio week with a cliffhanger and provide the ending live in the theatre. Eventually, advertisers realized that their Italian-American market needed no advertising, and the source dried up. World War II didn't help. During the period when many Italians who were not naturalized were interned, including journalists and broadcasters, signs went up in public places warning: "Don't Speak the Enemy's Language." Only pockets of Italian radio exist now, and the theatre is gone.

Angelo Gloria, who was born in Catania, Sicily, studied accounting, then immigrated to the U.S., where he formed the Angelo Gloria Theatre Company. He hired Emma Alba (then Barbato) to star in his productions, married her, and renamed his troupe the Donna Vicenza Company, after the radio program of the same name achieved popularity. He and Emma shared ideas for comedies any time of the day or night, but Gloria wrote and directed.

Olga Barbato was born in Sciacca, Agrigento Province, Sicily. She is fond of saying how she started acting "in the womb" since her mother was performing while pregnant with her. At the age of four, she debuted on the stage. In Italy, she was called the "Italian Shirley Temple." With her father Ernesto Barbato's traveling theatre company, she toured Italy, Africa, Tripoli, and Tunis. They immigrated to the U.S. when she was ten years old.

Emma Alba Barbato Gloria was born at Caltagirone, Catania, in 1893. Her father was a professor. As a child, she acted with the Giovanni Grasso and Marcellini companies. At the age of 18, she married actor Ernesto Barbato and toured in his traveling theatre company. In 1924, under contract with the Rosario Romeo company, they immigrated to the U.S. After her first marriage dissolved, she was hired to star in the company of Angelo Gloria, whom she later married.

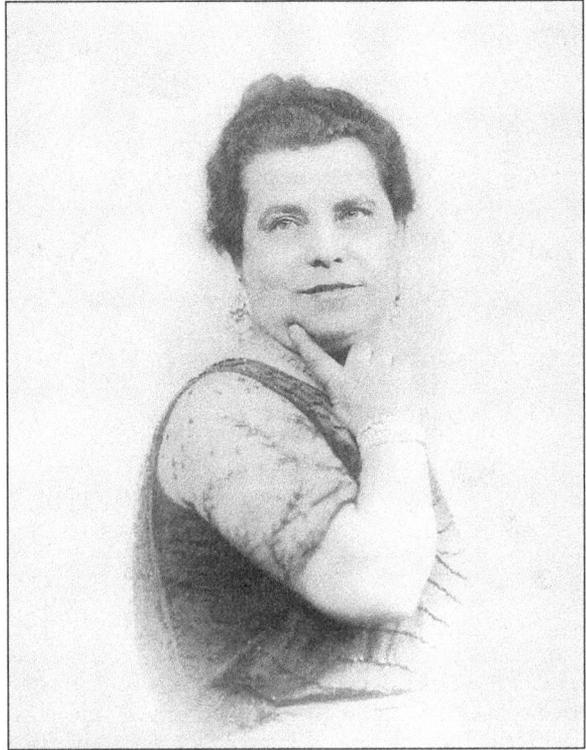

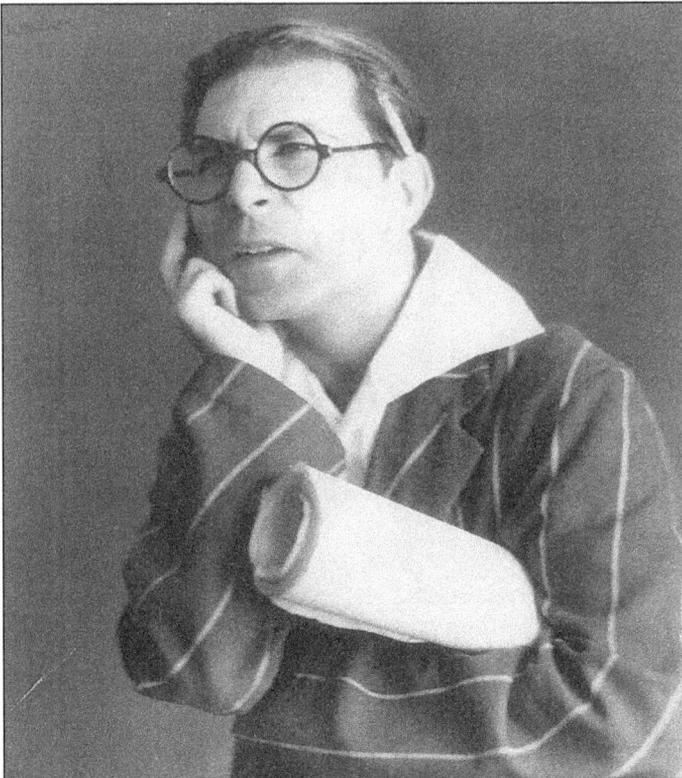

Attilio Barbato, born in Palermo, Sicily, worked in his father Ernesto Barbato's traveling theatre company; he immigrated to the U.S. in 1924. Under the early stage name Attilio Oltremare, he played the poet Sospirini on the 1934 radio program *Buon Pranzo* (Good Lunch) on Station WOV. He performed the role of Michilinu in *L'Aria del Continente* (The Continent Breeze) at Schwaben Hall in Brooklyn. He also directed and produced radio programs.

ARISTIDE SIGISMONDI
Frichino

EMMA BARBATO
Donna Vicenza

GINO FALCONI
Zio Nino

LA COLPA E' DELLA RADIO

PERSONAGGI

(Per ordine della loro apparenza)

Marietta	IDA ARATOLI	Anna	OLGA BARBATO
Donna Vicenza	EMMA BARBATO	Lauretta	MARIA GARUFFI
Tonino	GIOVANNI MONTALTO	Luisa	ROSA BARBATO
Frichino	ARISTIDE SIGISMONDI	Nando	CARLO GARUFFI
Luigino	ATTILIO BARBATO	Silvia	REA SILVA
Dottor Licurgo	CARLO GAUDIO		

La Colpa e Della Radio (It's the Radio's Fault), directed by Attilio Barbato as La Compagnia Medaglia D'Oro (after the coffee sponsor), played at the 5th Avenue Theatre in Manhattan in 1936. Gino Falconi, a lawyer whose family discouraged his theatre ambitions, played Zio Nino in the variety show that accompanied the play. He also played the role of Mr. Wilson in *Il Filosofo Coloniale* (The Colonial Philosopher) in 1934 on WOV.

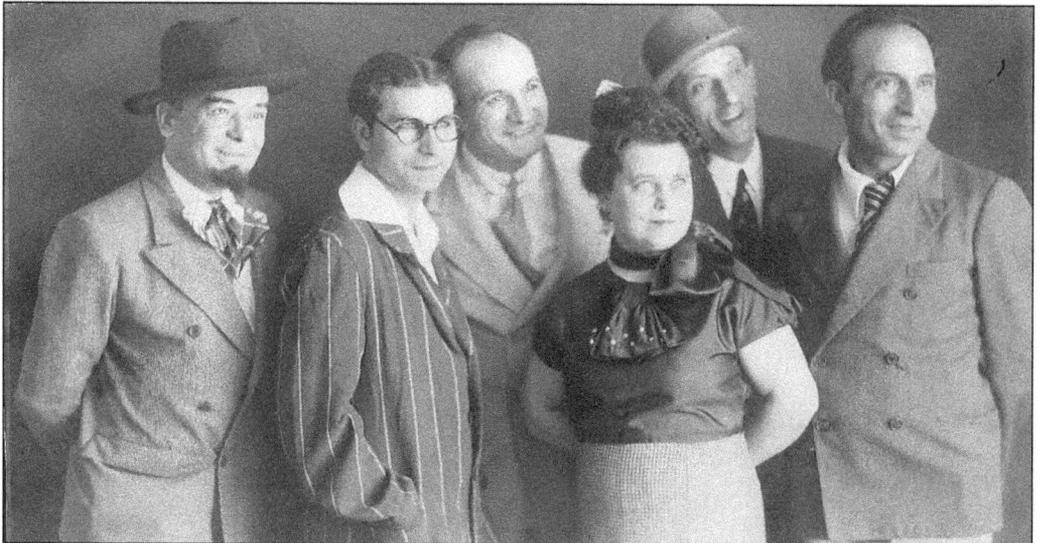

Emma and Angelo became the leading actors of their own company, which included her two children, Attilio and Olga Barbato. Here, they are assembled as the 1934 *Donna Billonia* radio program. The actors seen in the front row are as follows, from left to right: Aristide Sigismondi as the painter Pampaluccio Barbella; Attililo as the poet Sospirini; Emma as Donna Billonia; and Angelo as the businessman Toto Ballaro. Emma also created the hilarious, inimitable character of the bossy Sicilian housewife, Donna Vicenza.

No. 2

ANGELO GLORIA & CO.

" ORLANDO IL FURIOSO "

Sponsor:

Produced By:

Record No. 2 Time
MAY 19, 41

Broadcast Producers
OF N. Y., INC.
18 EAST 49th STREET, N.Y.
ELDORADO 5-9300
USE ONLY NEEDLES SUPPLIED

Orlando il Furioso (Furious Orlando), which has nothing to do with Ludovico Ariosto's epic, was the title role played by Gloria on the radio series surrounding Donna Vicenza. Orlando was her husband, always angry and always bickering. The program was five days a week and sponsored by Medaglia D'Oro coffee. The show was prerecorded on records almost 1.5 feet in diameter. They also broadcast the *Ave Maria Hour, the Lives of the Saints.* After Emma's death, Olga, as guest announcer, played the records on radio programs in Tampa, Clearwater, Sarasota, and Miami, Florida. A favorite radio comedy was *Le Classe degli Asini* (The School for Donkeys) with Donna Vicenza as a teacher and Olga as a student. Her 1939 *Diary of Donna Vicenza*, "the Italo-American family's friend and daily advisor" chronicled the milieu of the popular Italian radio shows of the 1930s.

105

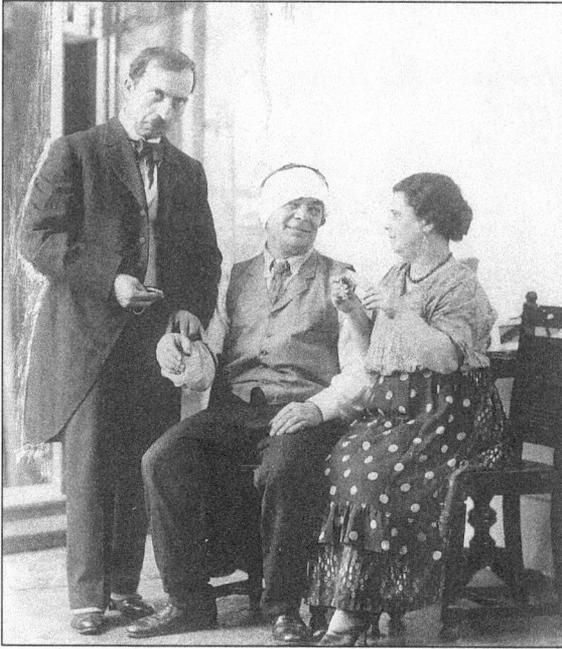

Orlando takes his pulse while Donna Vicenza medicates Aristide Sigismondi, with bandaged head, in this *Orlando il Furioso* episode. Sigismondi played the comic character Frichino on radio and also in the variety show that accompanied *La Colpa e Della Radio* (*It's the Radio's Fault*), directed by Attilio Barbato as La Compagnia Medaglia D'Oro at the 5th Avenue Theatre in Manhattan in 1936.

San Giovanni Decollato (*Saint John Beheaded*), a comedy in three acts by Nino Martoglio set in Italy, has Angelo as Mastru Austinu, Attilio as the student Don Ciccino, and Emma as Dona Lona, with Olga as Serafina, his daughter, in love with the medical student. Her father wants her to marry a street lamp lighter, but the couple elopes. Emma as Donna Vicenza played opposite Angelo as Joe in the title role of *Il Filosofo Coloniale* (The Colonial Philosopher) in 1934 on WOV.

Emma played the role of La Signora Marastella in *L'Aria del Continente* (The Continental Breeze). In 1933, with the Teatro D'Arte Italica on the same bill with the movie *Vita Passione e Morte di Nostro Signore Gesu Cristo* (Life Passion and Death of Our Lord Jesus Christ), she played the role of Rosina in *Ratto delle Sabine* (Rape of the Sabines), a comedy in three acts by D. Campagna. It was certainly an interesting combination of features.

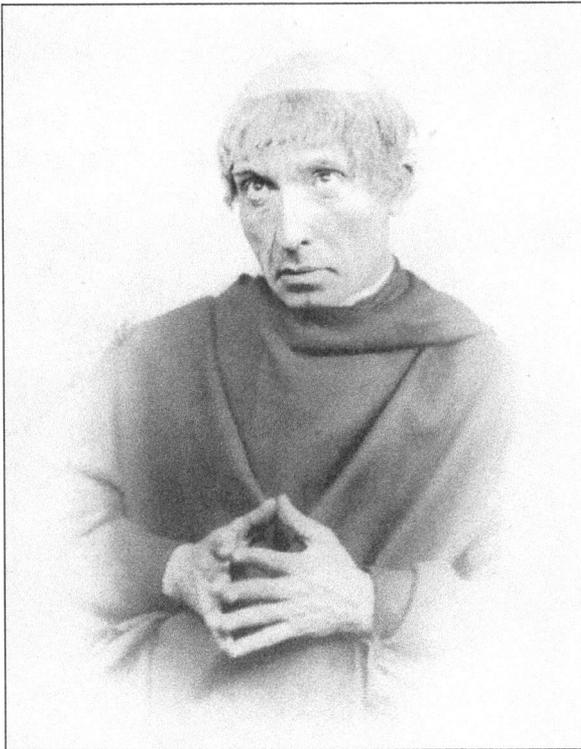

Angelo Gloria played Padre Attanasio in *Fiat Volonta Dei!—sia fatta la volonta di Dio* (May God's Will be Done), a comedy in three acts. He also created the leading roles of Nicola Trombone in *Ratto delle Sabine* (Rape of the Sabines) and Don Nicola Duscio in *L'Aria del Continente* (The Continental Breeze). Gloria directed the *Buon Pranzo* (Good Lunch) radio program on station WOV.

107

Aristide Sigismondi was born September 20, 1886, in Lanciano, Chieti Province. He immigrated to New York in 1904, where he worked at the Banca Pitelli until 1910. He performed with the amateur companies and successfully created *macchiette* for vaudeville and for the radio on station WMCA. His unique invention is a clownish character, Frichino, which he performed on the *Rabinovich Program* and *Buon Pranzo* on station WOV in 1934.

Licia Albanese, another diva of the Metropolitan Opera, performed with the Barbatos and their company. In addition to her appearances at the Met and her concert tours, she also sang on radio. Arturo Toscanini selected her to be the soprano star for his Annual Gala Operatic Broadcast. She recorded on Victor records. Today, she heads the Puccini Foundation.

For Easter 1938, Attilio Barbato directed *I Dieci Comandamenti* (The Ten Commandments), a religious radio drama in 15 scenes by Carlo Garuffi, adapted from the memoirs of G. Lo Presti, for Sunday, March 15, 1938. Attilio had a reputation as a meticulous worker. He married the amateur opera singer Rosa Buccheri. Angelo Gloria was also a poet and wrote lyrics for the barcarolle *Ucchiuzzi Chiari* (Clear Eyes) with music by Nicola D'Amico.

MAJESTIC THEATRE
651 FULTON ST., BROOKLYN, N.Y.
TEL. NEVINS 2720-2721

Domenica 15 Maggio 1938

Spettacoli Continui dalle 2 alle 11 P. M.

La Comp. Drammatica Italiana

GRANDI SPETTACOLI
diretta da

ATTILIO BARBATO

darà il grandioso radio-dramma-romanzo in 15 quadri

I DIECI COMANDAMENTI
di CARLO GARUFFI

tratto dalle memorie di G. LO PRESTI
- con -

Nera BADALONI

ed altri Rinomati Artisti

Parte Prima: L'orfanella del convento
il Santa Maria degli Angeli

Parte Seconda: Il Figlio della Colpa
Parte Terza: Angelo e Demonio

Precede Grande Varietà

EXTRA

EXTRA EXTRA
Angelo GLORIA
e Donna VICENZA

Nera Badaloni was featured in *I Dieci Comandamenti* (The Ten Commandments), and after the death of Emma Alba Gloria, the actress played some of her roles. She headlined the *La Rosa* program on WOV in 1934. In 1941, at the Jamaica Polish Hall, she starred as Signora Rinaldi in the emotional drama, *Inganno Crudele* (Cruel Deception), derived from *La Famiglia Rinaldi* (The Rinaldi Family), the Oxydol sponsored soap opera for WOV.

Emma and Angelo wait at a train station on one of their tours. The company traveled to Niagara Falls, Buffalo, Chicago, Boston, Philadelphia, cities in New Jersey, and various places in the Northeast. In 1938, they toured with the three act Sicilian comedy, *L'eredita dello Zio Buonanima* (Uncle Buonanima's Estate). *Buonanima* means "good soul." Emma played Mariantonia Filazza, Angelo played Antonio Filazza, Attilio played Mario Filazza, and Olga played Agatina Filazza. The formal pose (below) has them costumed for the comedy. The plot hinges on an expected inheritance that has relatives arguing, with the result that the entire estate goes to charity, leaving the heir with the tax bill. After Angelo Gloria's death, Attilio managed the company. He and Emma went to Argentina to perform, but unable to speak Spanish, she could not work there. Emma Alba Gloria died in 1956.

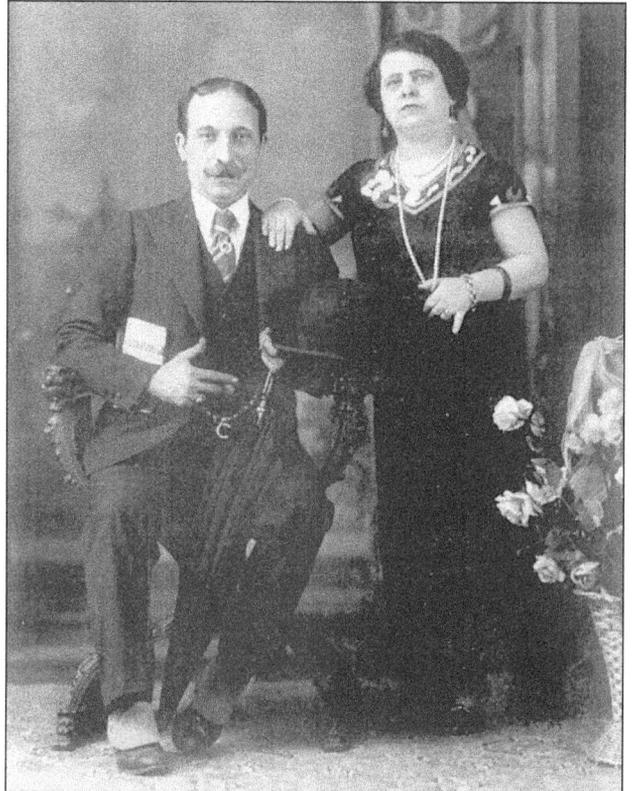

These two photographs of Olga Barbato show her at age 18 in a formal publicity photograph and in costume for the role of Santuzza in the drama version of Giovanni Verga's *Cavalleria Rusticana* (Rustic Chivalry), directed by Attilio Barbato. Olga spoke several dialects, including Sicilian and Neapolitan. Among her roles are the following: the ingenue in *Scampolo* (Remnant) by Dario Nicodemi; Clementina in *L'Aria del Continente* (The Continental Breeze); Santina in *Il Filosofo Coloniale* (The Colonial Philosopher) on radio station WOV in 1934; and Anna in *La Colpa e Della Radio* (It's the Radio's Fault). She crossed over into the American arena with her 1971 commercial for Aunt Millie's Tomato Sauce and as the voice of ATT. In films, she played Angelina the medium in Woody Allen's *Broadway Danny Rose*. She is a past president of the Italian Actors Union.

The stage setting represents Acts One, Two, and Four of *L'eredita dello Zio Buonanima* (Uncle Buonanima's Estate). We see that a typical stage set included the wing and flat system and the diminishing central perspective; however, what is most interesting about these photographs and the set is the prompter's hood visible downstage. The unrealistic convention of the prompter in Italian theatre is fascinating. The prompter simply reads aloud the entire play two seconds ahead of the actors. He was accepted by the Italian immigrant audience as a necessary intrusion, and his presence during the production can be likened to the black-hooded manipulators of the Bunraku Japanese puppet theatre. The actors are not expected to know their lines and use the prompter like television actors use the monitor. The audience can hear the prompter, but no one minds.

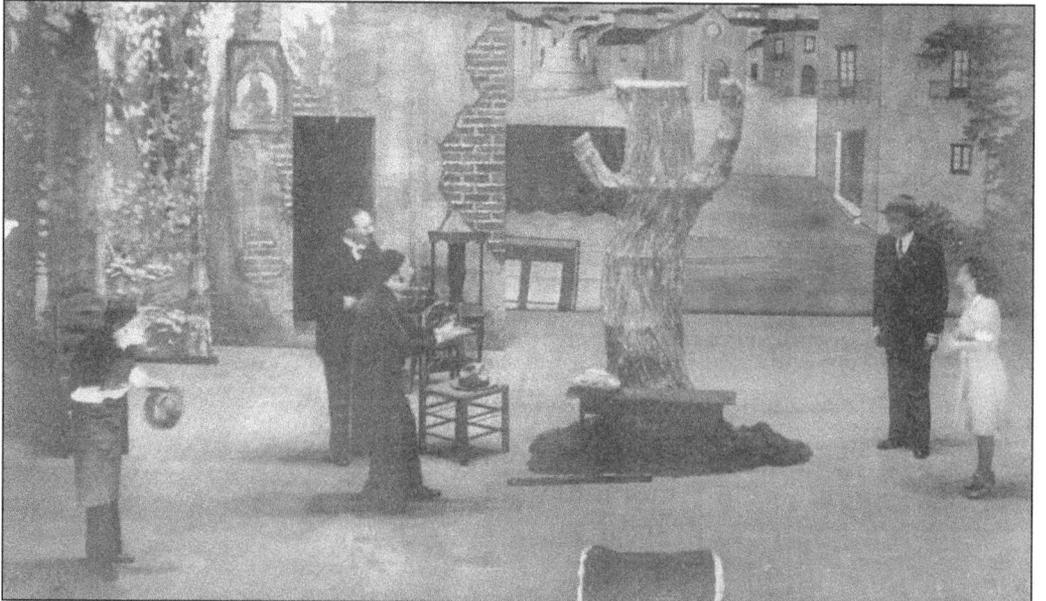

Orazio Cammi was another impresario who acted in, wrote, and produced dramas, often with religious themes, that played on both the radio and the stage. His plays often featured Marietta Maiori or Mila Lanza. Lanza sang on the *Ronzoni* program on WOV in 1934. In 1941, Cammi toured with *La Preghiera di Pompei* (The Prayer of Pompei) in collaboration with Gennaro Scognamiglio (read Gennaro Cardenia) as La Primaria Compagnia Radio-Dramma "Lazzara" (The "Lazzara" Original Radio-Drama Company) on WOV. Broadcasting on WOV, this show (sponsored by the Paramount Macaroni Company) starred Mila Lanza as did *Rosamaria* in 1943. *La Via delle 3 Croce* (The Road of the Three Crosses) featured Aristide Sigismondi as Giudice Cesari; *Il Ritorno* (The Return) was produced for the War Savings Committee for Americans of Italian Origin during wartime at the Tri-Boro Theatre on 125th Street in September 1942.

Attilio is shown here with actors from the Italian Actors Union at one of their meetings. Fluent in Spanish, he went to Argentina for two years and formed an Italian theatre company. When Peron passed a law prohibiting non-Spanish language plays, he translated Italian plays into Spanish and continued working. In Buenos Aires, he played the horse dealer in the 20th Century Fox film, *Way of a Gaucho*.

The Alba Bakery is located at 7001 18th Avenue in the heart of the Bensonhurst Italian section. Nicola Alba, the first cousin of Emma Alba Gloria, was born in Sicily and started his bakery when he immigrated to America with his wife Adele. The Alba Bakery was the Caffe Ronca or the Sardi's of Brooklyn's Italian community. It was a hangout where actors and producers met informally over *caffe*.

114

The whole family worked in the bakery; the younger members pitched in after school. Nicola's brother had a pastry store on New Utrecht Avenue in Brooklyn, but it was an unrelated business. Pictured here are Sal Alba, who now runs the store; his sister, then Bianca, now Blanche Alba (which means white on white); and younger sister Anna. As a result of Aunt Emma Alba's matchmaking, Blanche married Arnold Migliaccio, the son of Eduardo Migliaccio, Farfariello. Arnold, who used to play in his father's band, now is the bandleader for the Serenaders in Blue swing orchestra. The interior of the cafe had the requisite ice cream parlor chairs. Olga Barbato remembers that whenever the actors frequented the cafe, Nicola generously supplied them with free coffee and cake. Blanche remembers that as the family worked, the radio would be tuned to Donna Vicenza.

Another radio and theatre dynasty was the Cecchini-Aguglia-Romeo family. When Teresa Aguglia and Gustavo Cecchini married, their daughters were born while the couple was on tour, Alba in Buenos Aires and Mimi in San Francisco. Mimi Cecchini stands in the back row; Alba sits in the front row in a white dress next to Carmela Caracciolo Romeo, Mimi's mother-in-law; Carmela is seated in front of her husband, Rosario Romeo. Mamma Mia oil (in the Sicilian cart) is their sponsor.

Gustavo Cecchini was born November 13, 1882, in Florence, Italy. His mother was Albina Lotti, his father Salvatore Cecchini. He was a child and adult actor in the companies of his uncle, his father, and the actors Talli and Ermete Novelli. He also performed duets in the *caffe concerto*. In 1906, he met the Mimi Aguglia-Giovanni Grasso Company in Berlin and joined their 1908 and 1914 U.S. tours as an actor and booking agent.

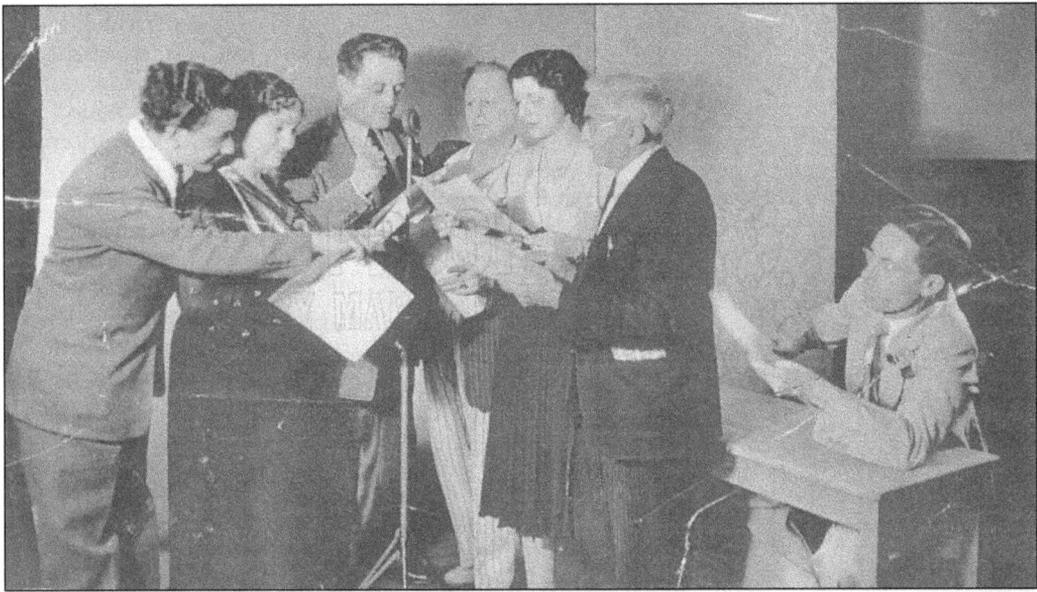

Several of the clan are gathered around the microphone for the *Mamma Mia* program. Seen here, from left to right, are as follows: Gustavo's oldest son Salvatore Cecchini, nicknamed "Toto" and "Chic," with the stage name "Mario Lotti;" Carmela Caracciolo; her husband, Rosario Romeo; Gustavo Cecchini; Alba Cecchini, stage name "Alba Di Lorenzo," who married professional musician John Carluccio; Giovanni La Cagnina, a theatre actor; and sitting, the announcer Cassano, who later entered the priesthood.

Gustavo married Teresa Aguglia, remained in the U.S., and directed his own theatre company, featuring himself and his family. He played the role of Ninu to Teresa's Jana in their production of the Sicilian drama in three acts, *Malia* (Witchcraft) at Maiori's Royal Theatre at 165-169 Bowery at Broome Street in the early 1900s. In 1934, *La Cieca di Napoli* (The Blind Woman of Naples), starred the actors of his radio program in person.

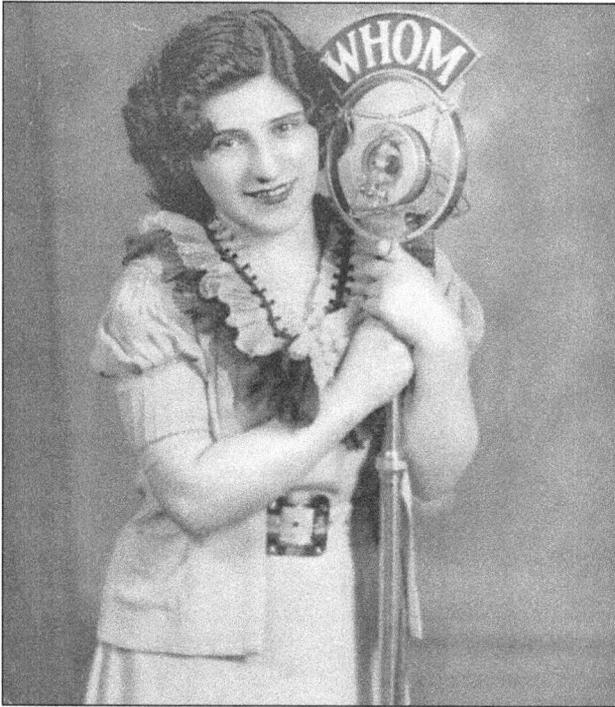

She was known as Perzechella, particularly in the stage act she had with her brother Sandrino. Children of Clemente Giglio, they were the third generation of show people. Her given name was Adele, named after her grandmother, the wife of the magician Don Alessandro Giglio, who was the first of the family to emigrate. As is evident, Perzichella, which means "little peach," also played on Italian radio on station WHOM.

Precede Concerto di Varietà con:

G. DE LAURENTIS **ITALA DEA**
(Don Peppe 'O Rusecatore)

J De Laurentis
DoN PEPPE O RUSECATORE

Chiuderà lo Spettacolo una Brillantissima FARSA

In 1941, radio performers Giuseppe De Laurentis and Itala Dea were the featured stars for the variety show that accompanied the emotional drama, *Inganno Crudele* (*Cruel Deception*). De Laurentis created the comic character Don Pepe 'O Rusecatore. Itala Dea was an opera singer who worked with Angelo Gloria in *L'eredita dello Zio Buonanima* (*Uncle Buonanima's Estate*). She was the wife of Antonio Maiori. Their son Renato is an actor.

The radio vaudeville genre featured such acts as the lyric soprano Maria Celia (below), who sang on station WEVD for Ettore Manfredi's program in 1939. The Amauli comedic team, Giulio and Ada (right), of the popular Italian *Rabinovich* program on WHOM in 1934, were also sponsored by Ali d'Italia oil. He wrote lyrics for their comic musical duets, among them the parody, *Otello e Desdemona*, music by E. Serpone, and *L'Ultimo Tango* (The Last Tango), music by Maestro Giuseppe de Luca. They performed these on the vaudeville circuit in full costume and makeup. They were featured in the variety show for the Sicilian comedy *L'eredita dello Zio Buonanima* (Uncle Buonanima's Estate) with Angelo Gloria in Philadelphia in 1938, and for the War Savings Committee for Americans of Italian Origin during wartime at the Tri-Boro Theatre at 165 East 125th Street on Wednesday September 16, 1942.

Rosario "Saro" Romeo, appearing on horseback in his movie, *Amore e Morte* (Love and Death), is another giant figure of the era. He was born in Sicily, where he acted in his own theatre company. He was also a mandolinist. He married actress Carmela Caracciolo. His company contracted for a limited engagement at a Broadway theatre and arrived in New York. The tour manager reportedly absconded with the proceeds, leaving them stranded. Luckily, they found work and a home in Little Italy but eventually moved to Brooklyn. In 1932, *Amore e Morte*, a "talkie" he produced, directed, and starred in along with his company, opened at the Selwyn Theatre in Times Square. *Amore e Morte* is the only record of this first, and possibly only, film in Italian to emerge from the immigrant theatre milieu. Sadly, it has disappeared, or disintegrated.

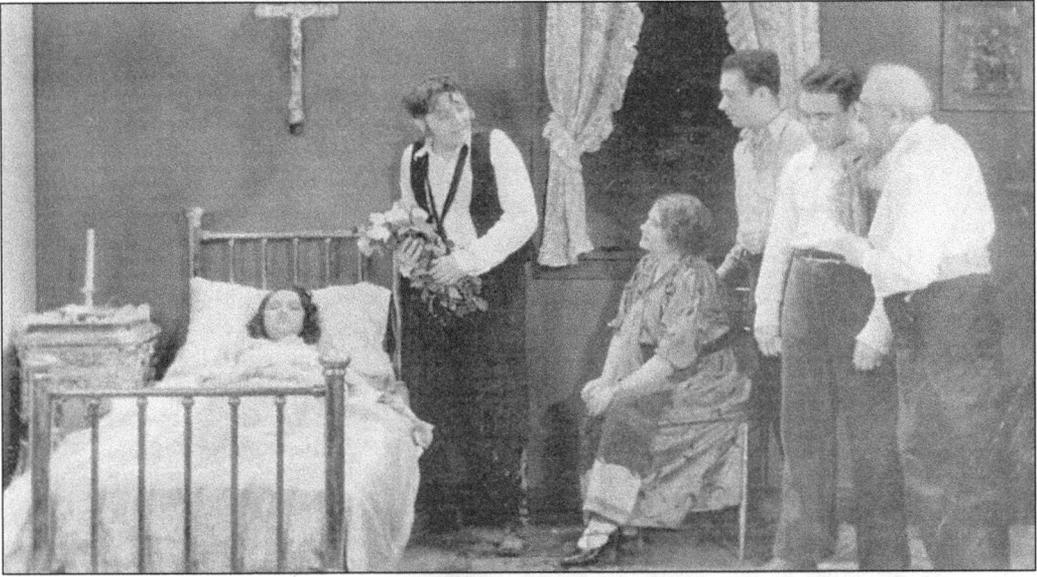

Romeo, with his associate J. Lombardi, established the Aurora Film Corporation to produce *Amore e Morte*. Aurora was the first motion picture organization dedicated exclusively to the production of all-talking pictures in Italian. The publicity campaign initiated a nationwide search for the lead with a beauty contest in New York for girls of Italian descent, 16 to 25, on September 6, 1931. The winner, Clara Diana of 1933 Watson Avenue, the Bronx, was named "Miss Italy 1931" and played the female lead, seen below with Carmela Caracciolo, as her mother. Carmela was born in Naples but grew up in Sicily. When very young, she eloped with Rosario and worked her whole life in his company. Once, not wanting to cancel a play, she almost gave birth onstage. Carmela arranged for home-cooked Sunday family dinners backstage between shows at the Brooklyn Academy of Music.

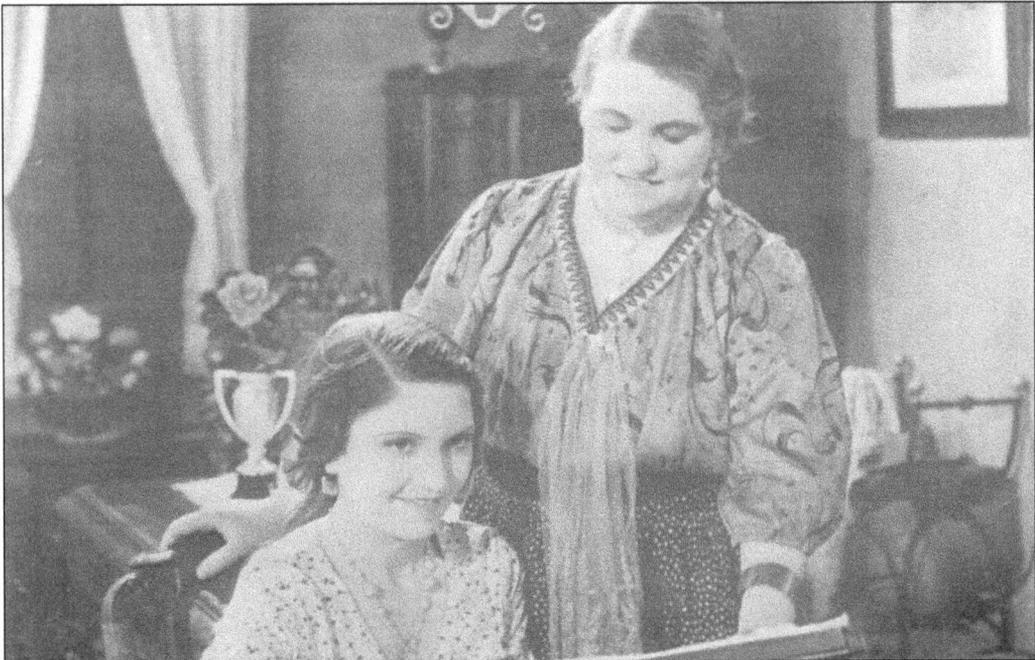

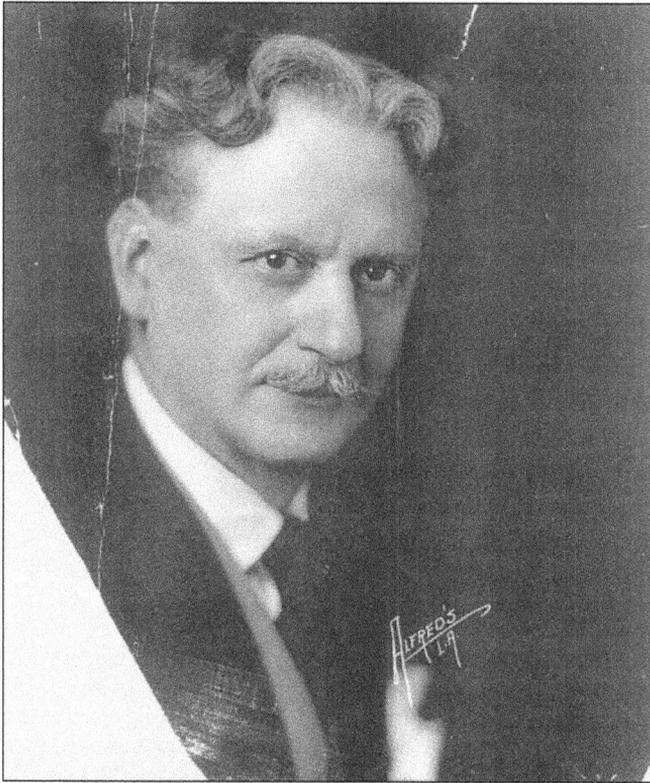

Gustavo Cecchini toured in California but eventually settled in Brooklyn at 205 Bay 29th Street. He continued to write, direct, and work in the Italian-American theatre and on Italian radio on the *Ronzoni Radio Program* with Teresa Aguglia in the late 1930s, until he retired. Gustavo is shown below with Molly Goldberg in his later years, rehearsing the role of the shoemaker in a scene from the radio show, *The Goldbergs*. He spoke several languages and dialects but thought English was illogical and insisted that his children speak Italian in the home. Gustavo is the father of Mimi Cecchini Romeo, one of the well-known Italian-American actresses who managed to cross over into the American film, television, and theatre arena.

The cast of a Romeo production in 1952 (possibly after one of Carmela's home-cooked dinners) poses backstage with friends. Among them is a visiting priest, Father Francesco Conti (standing center), from the Parish of Santa Maria Delle Grazie in Catania, for which Romeo raised money by mounting theatrical benefits, continuing the tradition started in the 19th century. Rosario and Carmela stand to the left; their son Anthony Romeo is at the extreme right.

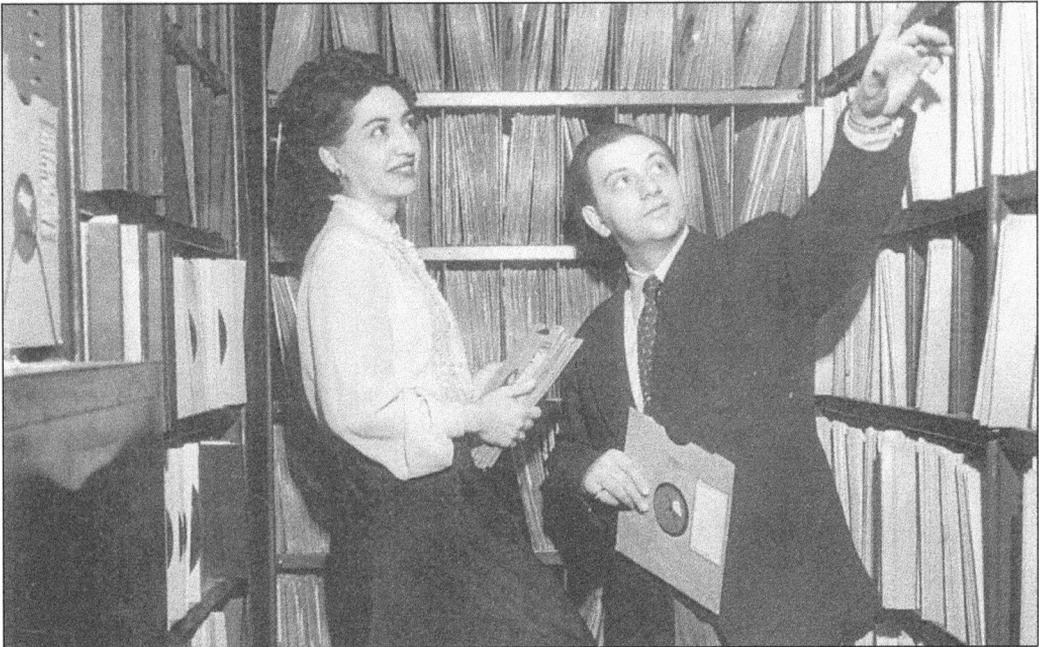

Anthony, "Tony" or "Nino", Romeo organizes his huge record collection at WOV. He was raised in the theatre and worked as stage manager and lighting director for his father's company. He was a radio producer, recording engineer. He was married to Mimi Cecchini and produced her popular Italian radio show. Tony also engineered and recorded for the Italian news agency *RAI*. The Italian government named him a *Cavaliere*. He died in 1976 at the age of 52.

Nicola Paone was born in Altoona in 1915. In 1930, he began singing folksongs and writing original songs. In 1940, to get his songs published, he started his own label, Etna. His first record, "*U Sciccaredu*" (The Little Donkey), was a big hit on the radio, followed by many others, among them "*Ue Paisano*" (Hey Pal). He toured all over the country singing his music in vaudeville and was a big success in Argentina.

The Brooklyn Academy of Music was a favorite venue for the combined dramatic and musical productions that made up Italian-American vaudeville. Most major impresarios produced shows there. In the twilight years, impresarios like the Gardenias brought in stars from Italy because the pool of young Italian-American entertainers performing in Italian was drying up. These shows appealed to the diminishing older audiences, but younger crowds were drawn to American entertainments.

Younger performers are not visible at this dinner meeting of the Italian Actors Union Board in October 1963. The meeting planned their gala of November 8, 1963, at the Sheraton-Atlantic Hotel in Manhattan. Standing, third from the right, is Tony Romeo; seated, second from left, is today's vice-president Lea Serra; beside her in white is Mimi Cecchini, who served as president of the union until she died in 1992 at age 69.

Mimi Cecchini and Attilio Barbato are formally costumed for one of the skits they created together, which were always based on her dignified character pitted against his *cafone* (hick, country bumpkin), full of the double-entendres of Italo-Americanese. Mimi was born in San Francisco in 1923 and named for her aunt, Mimi Aguglia. She started acting at age three and progressed to her family's theatre and Italian radio. She had her own radio show for many years.

One of the last dances of the Italian Actors Union is pictured here in the lobby of the Manhattan Center at 34th Street and 8th Avenue, Christmas, *c.* the late 1960s. Olga is at the apex in black, Lea Serra is at the extreme right in a gown, Mimi Cecchini is front center in brocade, and beside her is Attilio Barbato, who also served as president. Attilio and Olga had a humorous radio program about travel in Sicily called *Sicilian Travelogue.*

Mimi Cecchini was a cross-over artist. Her photograph is the typical composite used in the American industry. On the left is the real Mimi that family and friends remember. Mimi disliked having to play the stereotypical Italian Mama in black that producers and casting directors mistake for the Italian-American woman. Mimi appeared in commercials, soap operas, and movies, such as *Cadillac Man, Wise Guys,* and *Dominick and Eugene.* She also dubbed English films into Italian.

126

Here, Mimi is dressed for a comedy skit with Attilio Barbato (not shown) about Italian astronauts landing on the moon, c. 1969. Mimi conscripted her daughter Rita into the show to play a trick on Attilio. With them is an unidentified ancestor of Spock. Rita acted as a child in *Figli di Nessuno* (No One's Children) with her grandfather's company. Sporadic performances like these were all that was left in the twilight years.

The Italian Actors Union organized this 1976 *caffe concerto* in Lincoln Center's Damrosch Park Bandshell, one of the last events of this type. Mimi, in later years, made a career as MC for the shows that starred visiting performers from Italy and entertainment at local *festas*. Here, she sings at extreme left (wearing the floral gown). Then Executive Secretary of the Italian Actors Union, Sal Carollo, stands at extreme right.

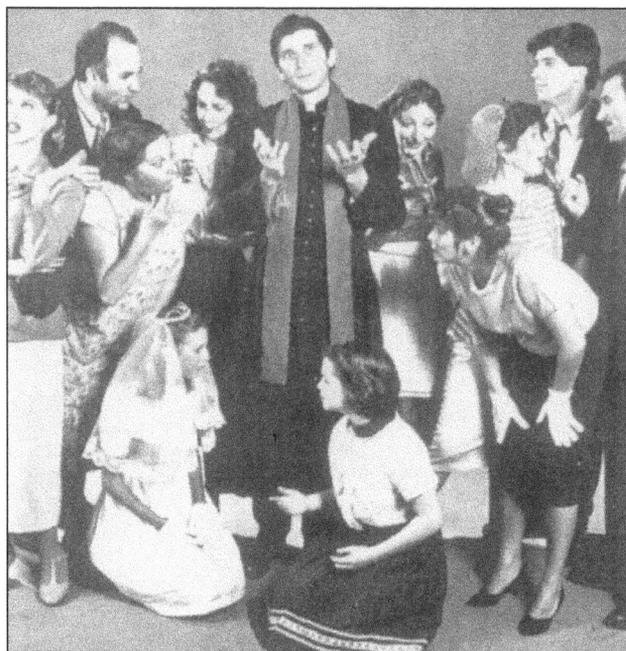

Today, Italian-American theatre is represented in two ways. A new generation of playwrights, composers, and comedians celebrate in English the contemporary Italian-American experience. Playwright and screenwriter Jo Ann Tedesco's award-winning memory play, *Sacraments* (above), depicts young Ginevra's coming of age against the backdrop of the two major influences of her life—her family and her church. Below, Frizzi & Lazzi, the Olde Time Italian-American Music & Theatre Company, perform *La Signora No.6* (The Lady on the Trolleycar No. 6). Frizzi & Lazzi (which means "Sparkling Theatre") is a professional troupe of actors, singers, and musicians dedicated to reviving the turn-of-the-century *caffe concerto* entertainments. Original songs and skits by immigrant writers and composers, as well as traditional music, are performed in English and Italian. The company is sponsored by the New York Metropolitan Chapter of the American Italian Historical Association and the Italian Actors Union.

Visit us at
arcadiapublishing.com

www.ingramcontent.com/pod-product-compliance
Lightning Source LLC
Chambersburg PA
CBHW080858100426
42812CB00007B/2078